IMAGES
of America

TROY

A CITY FROM THE CORNERS

IMAGES
of America

TROY

A CITY FROM THE CORNERS

Troy Historical Society
Loraine Campbell, Editor

ARCADIA
PUBLISHING

Published by Arcadia Publishing
Charleston, South Carolina

Library of Congress Catalog Card Number: 2004110517

For all general information contact Arcadia Publishing at:
Telephone 843-853-2070
Fax 843-853-0044
E-mail sales@arcadiapublishing.com
For customer service and orders:
Toll-Free 1-888-313-2665

Visit us on the Internet at www.arcadiapublishing.com

In memory of Sgt. Major Jack Turner USMC (Ret.)
for his dedicated service to the City of Troy.

CONTENTS

ACKNOWLEDGMENTS

This project reflects the talents and contributions of many people and the incredible dedication of the editorial staff at the Troy Museum & Historic Village. The efforts of William Boardman, who scanned and formatted all of the photos, and Gillian Ellis, who researched and wrote many captions, were critical to the quality of the book. The other members of the editorial staff, including Ray Lucas, Viola Aspinwall Smith, Anne Partlan, and Oakland University interns Elizabeth Pellirito and Teresa Henry Saigeon, discovered wonderful images, delightful anecdotes, and interesting facts. I am equally grateful to participants in Roots 2005, whose community outreach and painstaking research uncovered important information. This group included: Gloria Anderlie, Jack Burns, Joan Larson, William Lynch, Daniel McCarville, Karen Rudnicki, Pat Shepich, Della Sullivan, Phil Webb, and Peggy Youngs.

Many past and present Troy residents contributed photographs for the book and have been credited in the captions. In particular, I appreciate the generosity of the members of Fire Station 2, including Terry Smart and Ronald "Moose" Marceau. Images without photo credits are from the Troy Museum archive. In addition, Cindy Stewart, the City of Troy Community Affairs Director, promoted the project, and city photographer Laura Freeman provided many photographs of recent events.

The partnership between the members and directors of the Troy Historical Society was consistent and greatly appreciated. I am especially grateful to President Vera Milz, John and Sue Lavender, and Ward Randol for their editorial review and diligent proofreading. Finally, the entire museum staff provided their support and assistance to those working on the book. I am most grateful to Diane Behrendt, Julie Davidson, Darrien Howze, Nancy Jones, Karen Koch, Tim McGee, and Jeanetta Miller.

For more information on the Troy Historical Society and the Troy Museum & Historic Village, visit http://www.troyhistory.org.

INTRODUCTION

Small knots of buildings at simple crossroads called Troy Corners, Big Beaver, and Halsey Corners defined Troy Township for many years. The scattered population, descended from strong-willed and hard-working pioneers, was remarkably stable. The landscape of pasturelands, cultivated fields, and old woodlots reflected a rural lifestyle that was at once demanding and rhythmic. The pace of life was slow, punctuated by school bells, church socials, and seasons that dictated when farmers planted and harvested.

The first settlers emigrated from upstate New York after 1819. Johnson Niles, S.V.R. Trowbridge, Riley Crooks, and Solomon Caswell were among the earliest settlers to clear land, sow their crops, and establish a community. Johnson Niles purchased the land in Section 9 that he named Troy Corners. By all accounts, Niles was a dynamic and respected figure. He advised other settlers, built an inn and trading post, and was active in local political decisions. Niles envisioned a prosperous community with a bustling downtown. However, while the farms were successful, the central business district never evolved. There was no permanent sawmill or gristmill in Troy because the streams were too small and slow to provide hydropower. Economic hardships between 1837 and 1843 left a number of businesses bankrupt. Then, in the early 1840s, the Detroit and Milwaukee Railroad from Detroit to Pontiac was routed through Royal Oak, bypassing Troy Corners. This community and the other small crossroad settlements in the township remained commercially undeveloped. The social life of the citizens revolved around churches and schools. Farming remained the primary source of livelihood and Troy gained a regional reputation for its superior corn, wheat, melons, fruits, wool, and dairy products.

Change began with construction of the Detroit United Railway in 1898. The electric trolleys rattled up and down Livernois up to 60 times each day. Until 1931, the DUR transported passengers, milk, and freight from Detroit to Flint with stops in Royal Oak, Clawson, Troy Corners, Rochester, and Flint, with a branch to Romeo and back again.

Troy remained a quiet, rural community through 1945. The Depression caused hardships, and some farmers lost their land to foreclosures. Yet there were opportunities for inexpensive fun. A salt-water swimming pool filled from natural brine springs at Rochester Road and Long Lake Road was a favorite summer hangout. In the evening, folks danced in May's Barn.

Following World War II, Troy Township changed rapidly. The population of the community increased as Detroiters fled the cramped, deteriorating conditions in that city. Developers purchased farms and the open fields sprouted subdivisions. Companies that supported the automobile industry purchased large tracts of land in the southern sections of the township and built manufacturing plants. The size of the township was reduced, however, when the neighboring cities of Royal Oak, Birmingham, and Clawson annexed parcels of land.

In 1955 Vickers Inc., a division of Sperry Rand Corp., proposed to build a $2 million office and engineering facility in Troy. The company wished to annex its site to the City of Royal Oak to gain access to city water, sewers, police, and fire protection. Troy Township leaders

reacted quickly. They met on March 5, 1955 in Township Supervisor Norman Barnard's living room to prepare maps and petitions for the incorporation of Troy as a home rule city. Sixty citizens circulated the petitions on Saturday, asking the residents to keep the plan a secret until Monday. Two Troy Township delegations drove to the County Clerk's office in Pontiac at 6:00 a.m. on March 7, 1955 to file the petitions requesting the establishment of a home rule city before Royal Oak could file petitions for annexation.

Vickers Inc. filed suit in Circuit Court challenging the validity of the petition. The company contended that the township census was 533 residents short of the minimum population required by the state for incorporation. Judge H. Russel Holland refused to stop the election and on June 7, 1955, men with bullhorns cruised the dusty township roads urging citizens to vote in favor of incorporation. The citizens responded. The ballot tally was 2,111 in favor of, and 254 against, incorporation. Vickers Inc. and the township subsequently negotiated a settlement. The charter for the City of Troy was developed through that summer and fall. It was approved on December 12, 1955.

Within 30 years, rural Troy Corners was transformed into the City of Troy, a modern suburban community strategically located along planned elbow curves in Interstate 75. Gleaming skyscrapers, corporate headquarters, gracious homes, and elegant stores quickly replaced the clusters of clapboard structures. References to old township family names all but disappeared with the influx of new, culturally diverse residents. Troy Corners is now the name of a suburban strip mall.

This story of metamorphosis is not unique, but it is dramatic. It is also a vivid example of the changing face of many American communities in the 20th century. The year 2005 marks the 50th anniversary of the City of Troy. The Troy Historical Society and the staff of the Troy Museum & Historic Village hope that this book, which marks that occasion, will provide perspectives and insights that expand your understanding of the individuals and organizations that contributed to this great city. We hope the images presented paint a comprehensive picture of Troy's rural past and the growth and expansion that led to the exciting and vital city it is today.

Editor's Note: Almost all of the east-west mile roads in Troy have two names. They are as follows:
14 Mile Road
15 Mile Road or Maple Road
16 Mile Road or Big Beaver Road
17 Mile Road or Wattles Road
18 Mile Road or Long Lake Road
19 Mile Road or Square Lake Road
20 Mile Road or South Boulevard (When named, South Boulevard was the southern boundary of Avon Township to the north!)

The three commercial corners in Troy Township were:
Troy Corners at the intersection of Square Lake Road and Livernois Road
Big Beaver at the intersection of Big Beaver Road and Rochester Road
Halsey Corners at the intersection of Maple Road and Livernois Road

One

THE EARLY YEARS
1820–1899

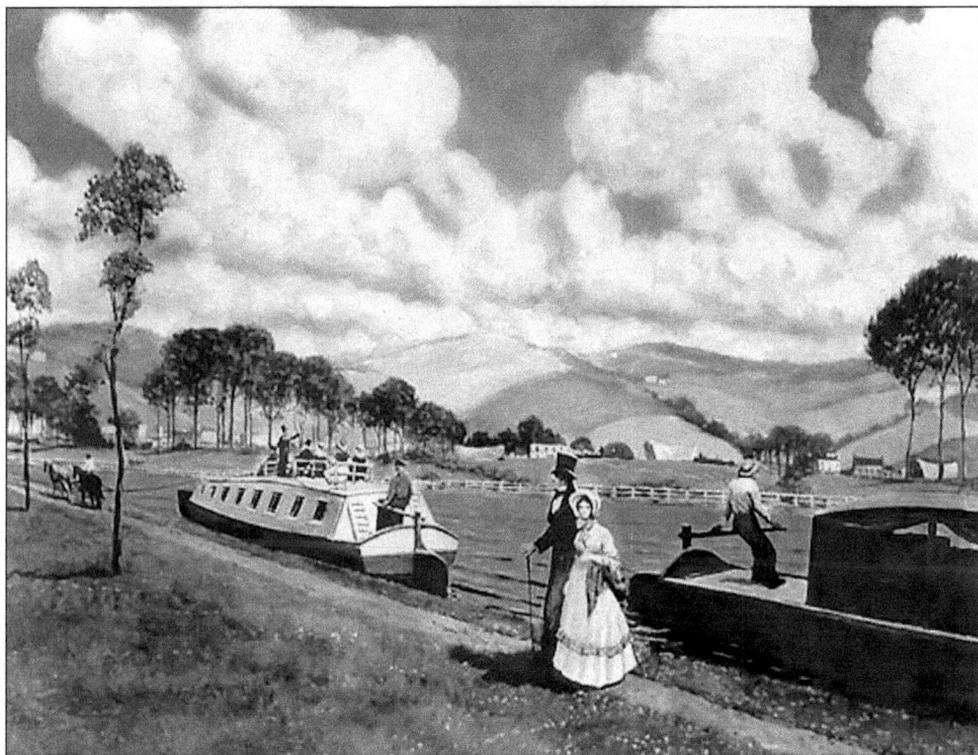

A BARGE ON THE ERIE CANAL. The first settlers who came to Troy in the early 1820s had a long arduous walk, but after the Erie Canal opened in 1825, the journey between upstate New York and Lake Erie could be made by barge. From there Lake Erie was crossed by steamboat; *Walk-in-the-Water* had gone into service in 1818. Many pioneers were native New Yorkers and they often named their new settlements after their old hometowns, Troy being only one example. This is a painting by Carl Wakeman.

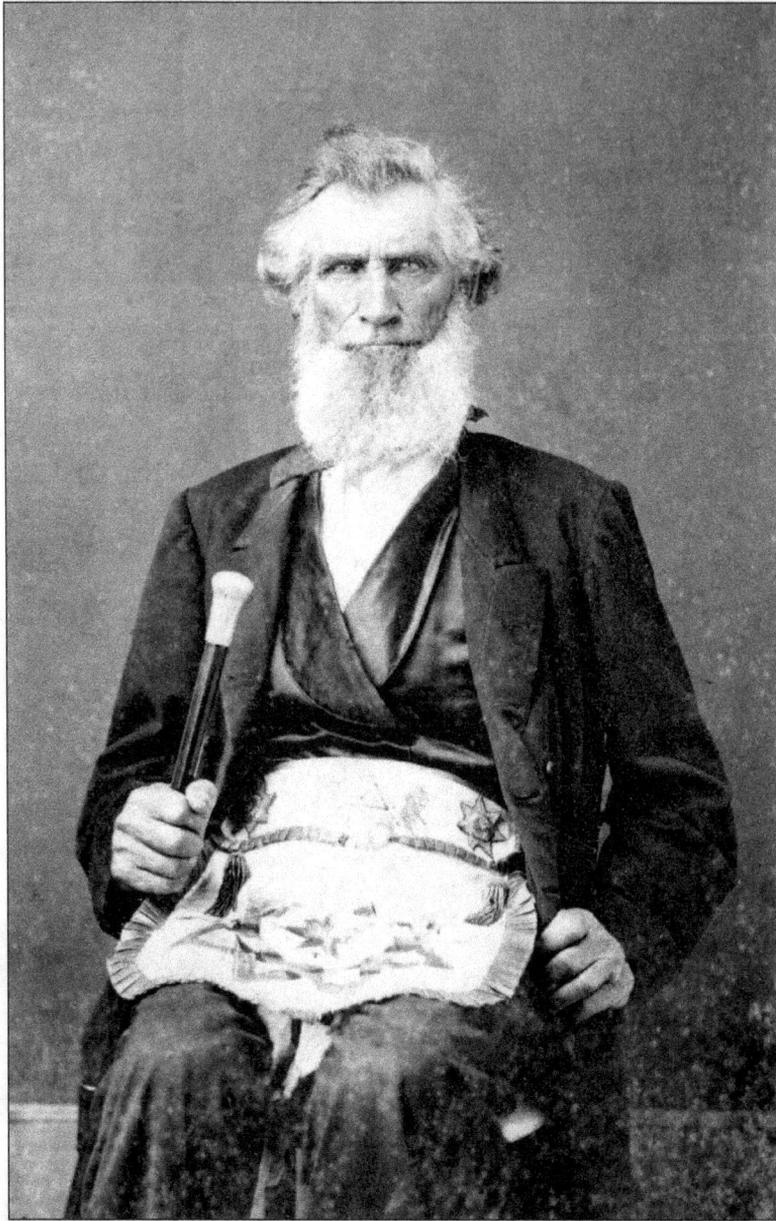

JOHNSON NILES, 1794–1872. Niles, who was born in upper New York, is truly one of Troy's founding fathers. He and his wife Rhoda Phelps settled in Troy in 1822 and began to farm. The area around his land was known as Niles Corners and then Troy Corners. He opened a hotel there, was appointed Troy's first postmaster, was a leading light of the Democratic Party, a county justice of the peace, and a county commissioner. After Michigan received statehood in 1837, he was a representative in the first state legislature and later a state senator. As this photo shows, he was also a Mason. This paragon did once run afoul of the law. In the very earliest days he was brought before the grand jury for selling whiskey to an Indian. He escaped punishment when it was remembered that the *Nippising* tribe had made him an honorary chief named *Ken-ne-dunk*. It was not illegal for one Indian to sell whiskey to another. (Image donated by Viola Aspinwall Smith.)

RHODA PHELPS NILES. The wife of Johnson Niles was born in Pittsfield, Massachusetts. The couple had two sons, Orange and George, and a daughter, Julia. The family's schooner trip to Detroit from the port of Dunkirk on the New York shore of Lake Erie took them 14 days. Established finally in her new home, Mrs. Niles found herself among only 15 settler families in the whole county.

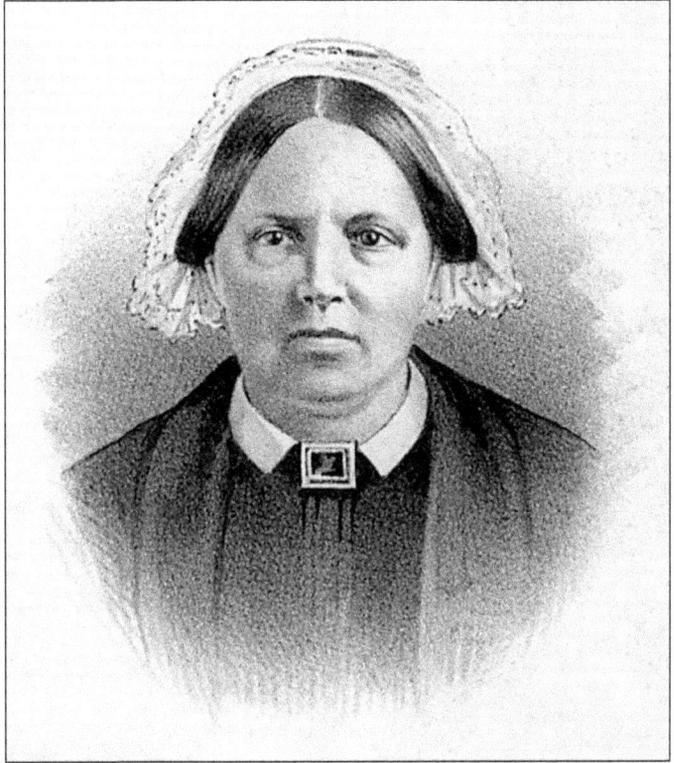

KATE STEELE. Mrs. Niles died in 1861 and Johnson then ran his home with the help of Miss Steele, his housekeeper. Neighborhood gossips said that she was perhaps more than her title suggested. The only evidence that this may be true is this *carte de visite*, which was taken at the same time as Mr. Niles' own picture. (See page 10.) (Image donated by Viola Aspinwall Smith.)

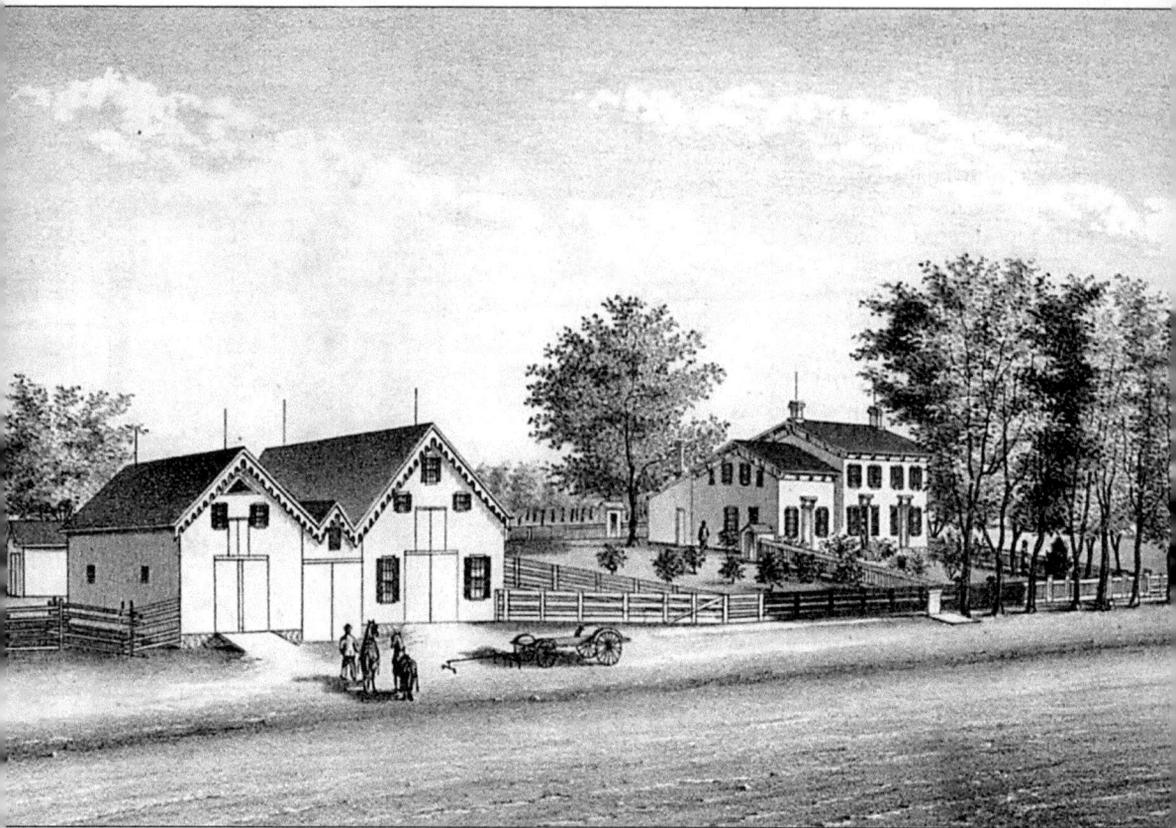

THE NILES FAMILY HOME. The family built this Greek Revival wood frame house to replace their log cabin, which had been very primitively furnished with ironwood, elm, and cordage table, chairs, and bedsteads. Shown here in a drawing from the 1877 *History of Oakland County*, the house is still standing, south of what is today the intersection of Livernois Road and Square Lake Road. Other settlers soon followed the Niles family into this area; Guy Phelps opened a shoemaker's shop, John Miller established a blacksmith shop, and in 1831, Edward Peck began a general store. A store of some kind remained in that location for around 130 years. Professional men followed; there were three doctors in the area and a brilliant young lawyer, George A.C. Luce, who married Julia Niles.

HASTINGS.

« Village »

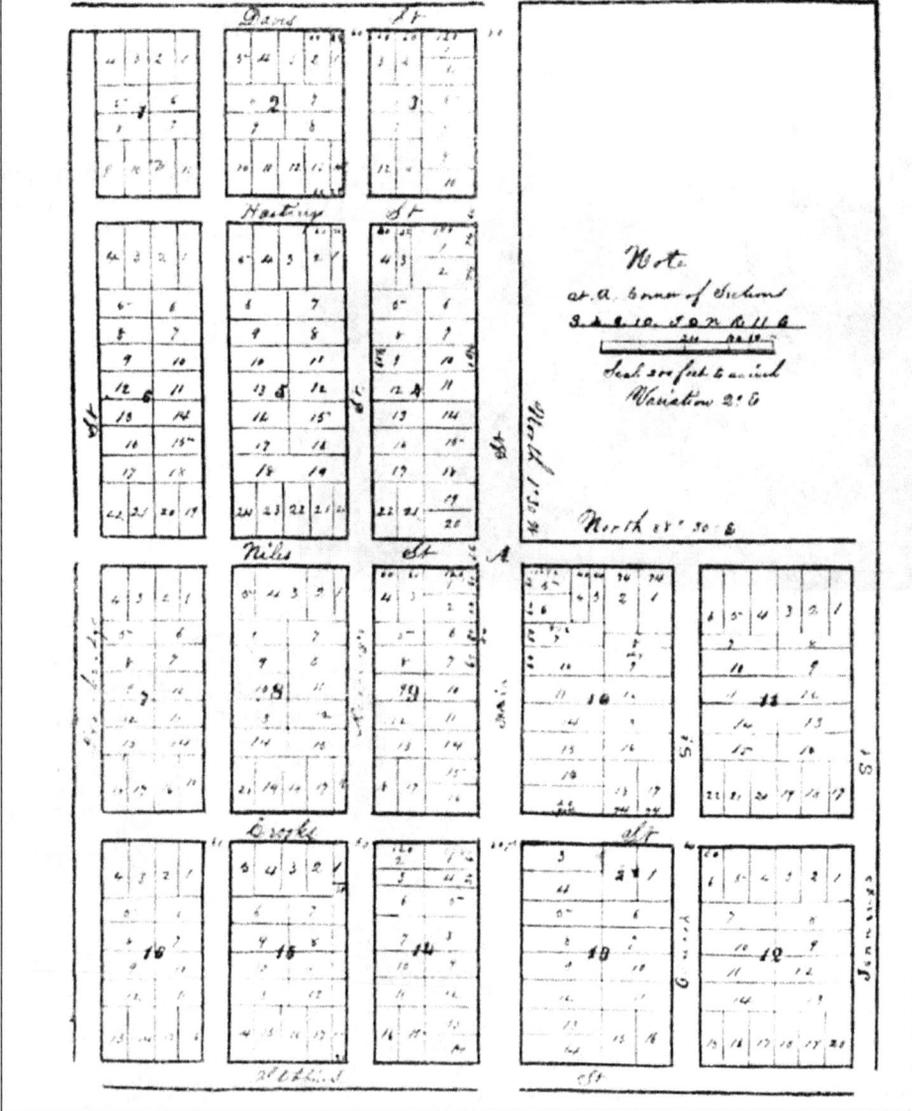

PLAT MAP FOR THE VILLAGE OF HASTINGS. In 1838, encouraged by the growth of the area in which he had settled, Johnson Niles platted out 16 blocks around the corners of sections four, nine, and ten to form a village he named Hastings, in honor of Eurotas P. Hastings, then president of the Bank of Michigan in Detroit. Mr. Hastings had financed many of the early settlers. Unfortunately, the launch of Hastings came hard on the heels of the nationwide bank panic of 1837. This fact, coupled with development of the railroad north from Detroit on a route that bypassed Troy, led to the decline of the Corners. Businesses closed and people moved away, so that by the 1870s there were only about 60 people living there. Niles' dream was not to be.

13

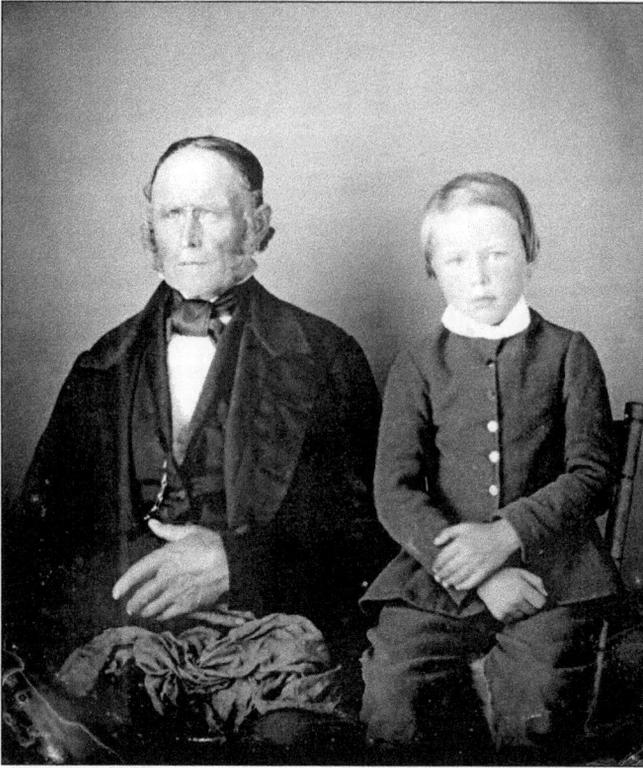

SOLOMON CASWELL AND HIS SON, GEORGE, c. 1853. Solomon Caswell and his wife Huldah settled on the western edge of Troy in May of 1823. Sons Sylvester, Zephaniah, and Eli, as well as a daughter, Clarissa, were all born in Michigan. When Huldah died in 1844 Caswell quickly remarried. His son, George, shown in this photo, was born to his second wife, Melinda Marvin, in 1845.

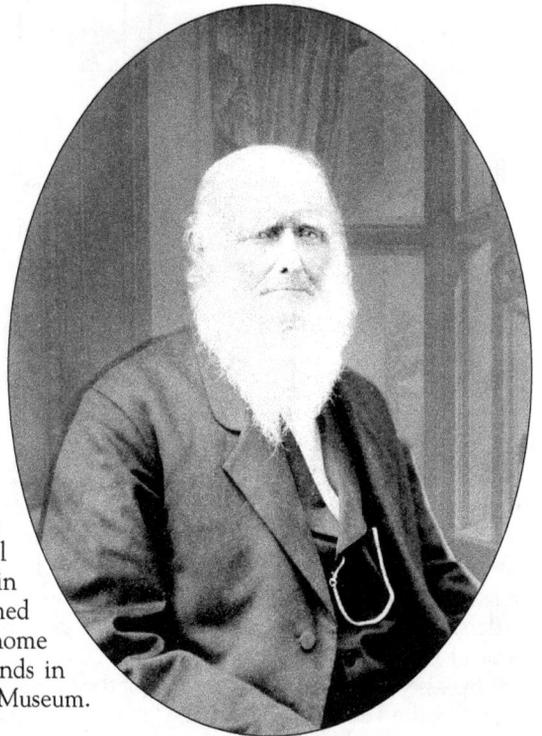

SOLOMON CASWELL IN LATER YEARS. Caswell died in 1880, just one month short of his 84th birthday. The 1832 Greek Revival home he built to replace his log cabin remained in the family until the death of his last grandchild, William, in 1965. The North Hills Christian Reformed Church bought the property and gave the home to the Troy Historical Society. It now stands in the Historic Village behind the Troy Museum. (Image donated by John Angelosanto.)

ALVA BUTLER. Leaving New York in the fall of 1822 in company with four other young men, Mr. Butler walked to Buffalo with a pack on his back and then took a ship to Detroit. He settled 80 acres and married Hulda Bissel in 1824. At Troy's first election in 1827, Mr. Butler was named as road overseer for his district. The roads at that time were little more than mud paths; settlers were assessed days of labor to help ditch and corduroy them. (Image donated by Viola Aspinwall Smith.)

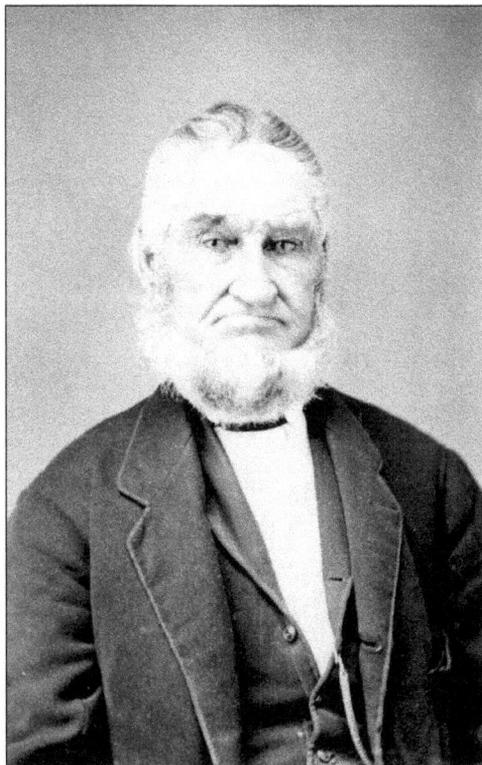

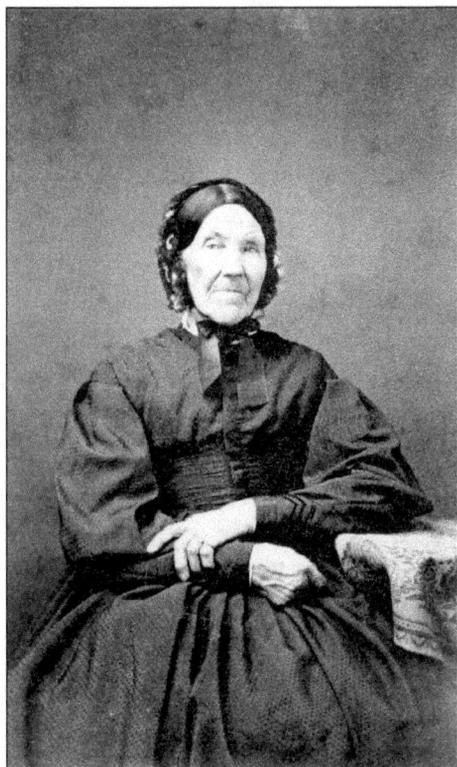

HULDA BISSEL BUTLER, D. 1886. Mother of six children, Mrs. Butler was the daughter of Daniel Bissel, the first recipient of the Purple Heart. Mr. Bissel was given the award by General Washington for his efforts as a spy during the Revolutionary War, and especially for a mid-winter swim across a river to deliver vital information. The Butlers' log cabin in Troy was reportedly on an Indian path. Mrs. Butler always baked extra bread and left one loaf on the table so that the Native Americans could help themselves. (Image donated by Viola Aspinwall Smith.)

LAND GRANT SIGNED BY JAMES MONROE. This grant was issued to Robert Parks, a captain in the War of 1812. He settled on his 400 acres in 1822. He made his payment for the land at "the Land Office at Detroit, Territory of Michigan" making full payment "according to the provisions of the Act of Congrefs [sic] of the 24th of April 1820, entitled An act making further provision for the sale of Public Lands." The president signed the grant in Washington on February 3, "in the year of our Lord One thousand eight hundred and twenty four and of the Independence of the United States the forty eighth."

WILLIAM POPPLETON, 1795–1869. Mr. Poppleton came from New York to settle in Troy in 1825. He and his wife made the journey with two children under age ten entirely by wagon. It took them 32 days. By 1845 he was one of the area's most prosperous men with 1,200 acres. He was supervisor of the town for two years before being elected to the state legislature in 1842.

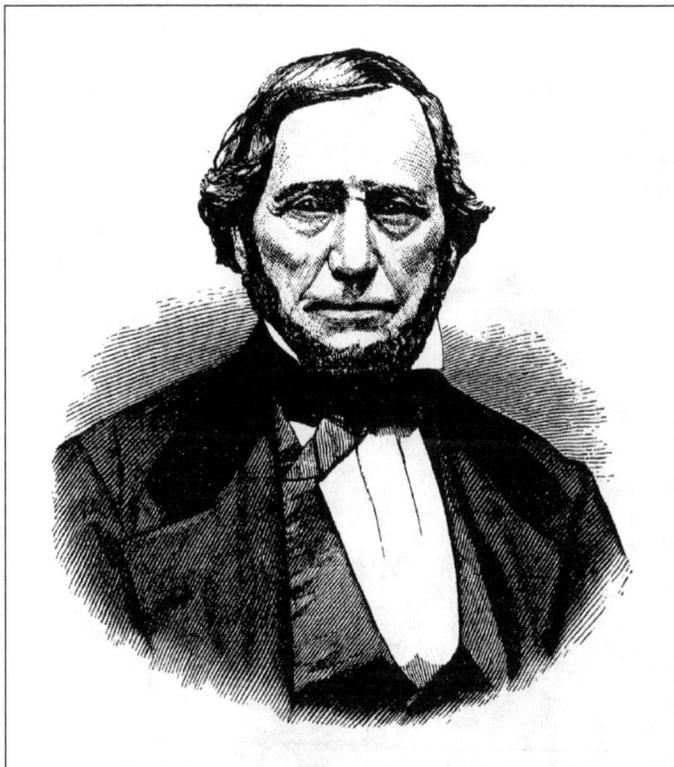

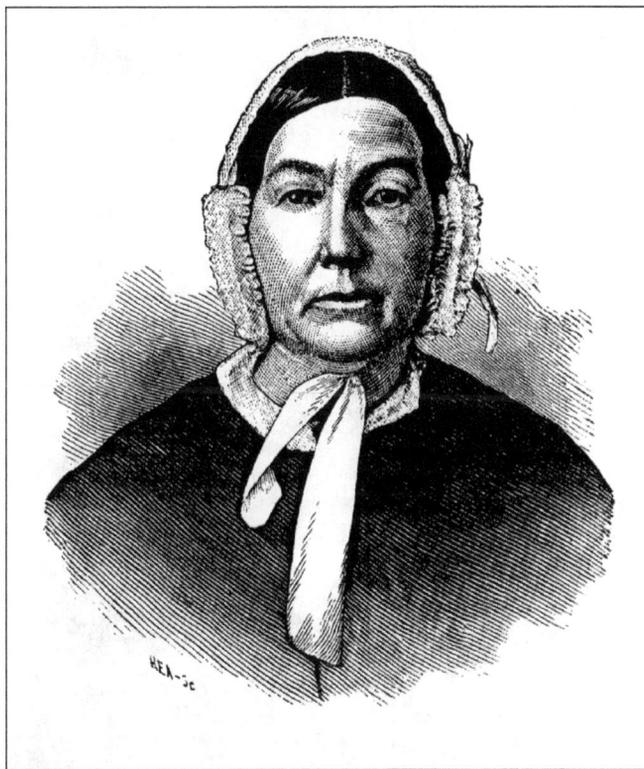

ZADA POPPLETON, D. 1862. Along with her husband, Mrs. Poppleton opened her home for the town's first recorded Fourth of July celebration in 1826. After a fusillade of all the firearms they could muster, the Declaration of Independence and Washington's Farewell Address were read out loud. A dinner of pork and beans and pumpkin pie was followed by a "base-ball" game.

17

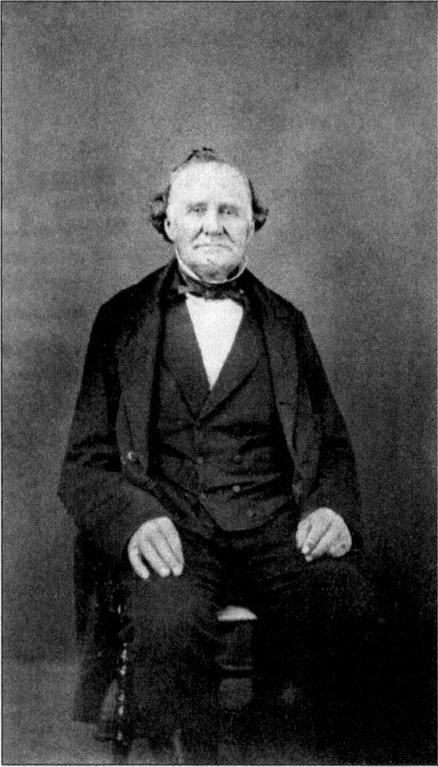

SILAS SPRAGUE, 1785–1862. Silas Sprague came to the area in 1824 with his father, also named Silas. The senior Sprague had served as a private in a Massachusetts regiment in the Revolutionary War. To the junior Sprague and his wife Amanda went the honor of the first girl, Sarah, to be born in Troy, on Christmas Day, 1824. The Troy Spragues were descendants of some of America's earliest settlers. Their ancestors arrived on the shores of Massachusetts on the ship *Anne*, shortly after the *Mayflower* landing.

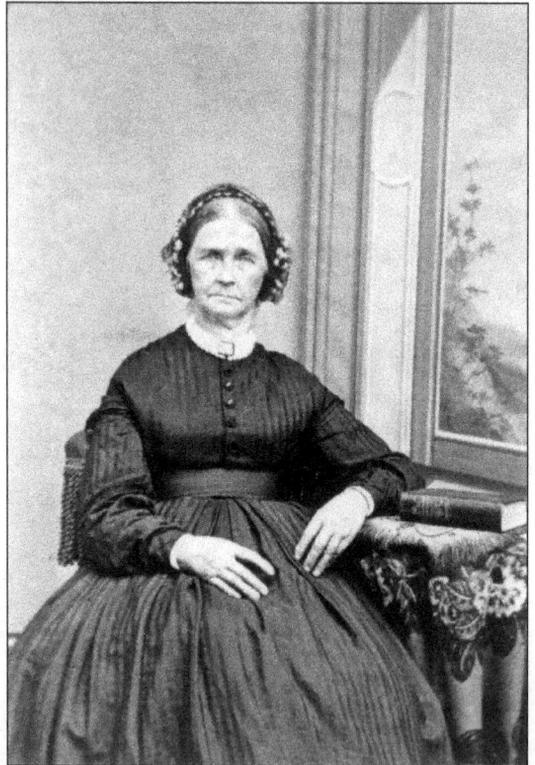

MARIETTA ANN DAVIS BEACH, 1804–1890. Marietta came to Michigan Territory in 1820 with her family, crossing Lake Erie on *Walk-in-the-Water*, the first steamboat on the Great Lakes. She married Reuben Castle Beach who had bought land in Troy as early as 1820 or 1821; he gave his name to Beach Road. Family lore claimed that in 1796 Reuben was found as a baby on the Connecticut shore, the only survivor of a shipwreck. Hence the spelling of the family name.

WASHINGTON STANLEY, 1807–1873.
After growing tired of working in the
mountains of his native Vermont,
Mr. Stanley finally made his way
to Troy in 1826. He bought land
near what is now Big Beaver Road,
and in the 1850s built a stone
farmhouse. When he died, his
daughter Elizabeth and her husband,
Frank Ford, inherited the farm.

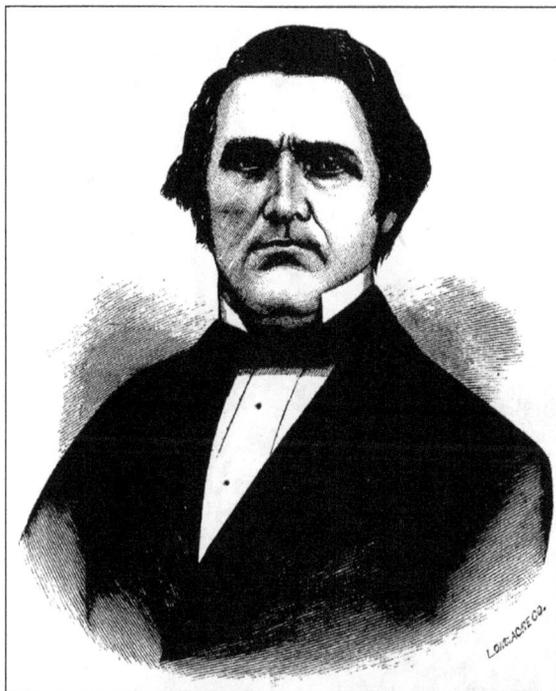

FRANK AND ELIZABETH FORD. This photo is believed to show the Fords with their children.
Frank, the son of English-born parents, married the daughter of Washington Stanley and took
over the Stanley property. Stanley's stone farmhouse still stands close to Somerset Mall on
Big Beaver Road. It was left to the Fords' daughter, Alta Ford Peabody, who sold it in 1911 to
William Brooks. The Brooks and their 11 children ran a large dairy operation. The home is
today the headquarters of the Kresge Foundation, and one of Troy's most important remaining
links with its pioneer past.

19

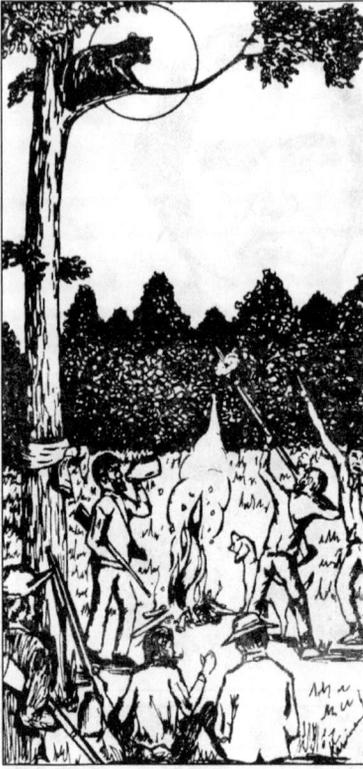

A Bear Party, 1829. While looking for his cows, Samuel Williams encountered a black bear and her two cubs close to the property of Alva Butler. His dog treed the bears and Williams roused some 15 or 20 neighbors. They brought with them two gallons of whiskey from Johnson Niles' distillery. Soon, all were "capable of shooting straight enough to miss the bear" allowing the mother and one of the cubs to escape. They agreed to enjoy the night and await morning for the final kill, but at dawn Luther Webster left his friends and brought down the final bear.

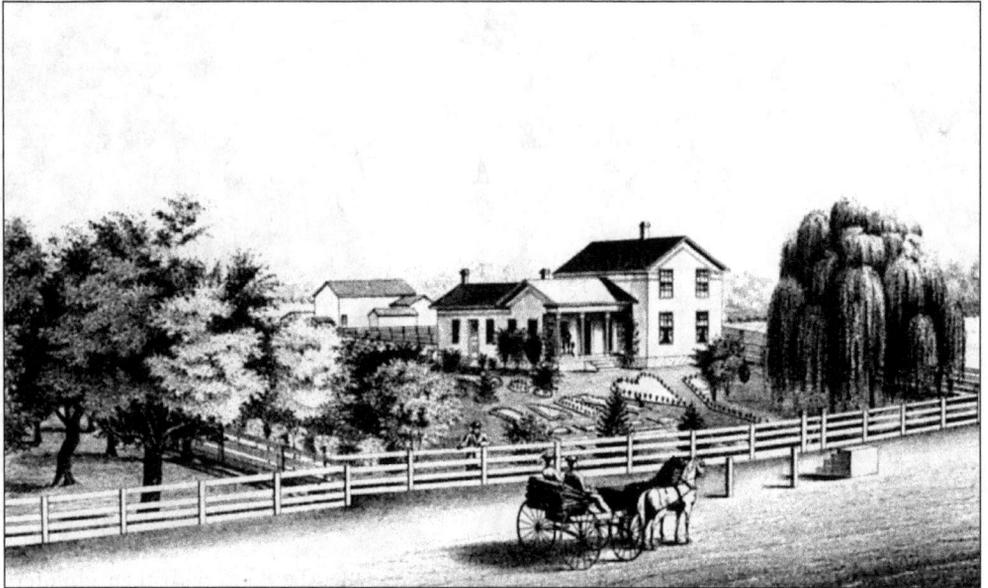

The Home of A.C. Trowbridge. Leaving his parents' farm in New York at the age of 25, Amaniah Trowbridge set out for Michigan in 1831. At Troy Corners he became a clerk in Edward Peck's general store. In 1836 he married Rhoda Postal and bought a farm in the northeast corner of Troy from Zadock and Aaron Wellman. Zadock had been a Revolutionary War soldier and was settled in Troy as early as 1819. Aaron was his son. A.C. and Rhoda raised five of the eight children born to them. Trowbridge was an early member of the Republican Party.

JESSE LEE STOUT, 1805–1874. The Stout family traces its ancestry to an Englishman, Richard Stout, who lived in what was then New Amsterdam (New York City) before 1640. He married a Danish woman, once shipwrecked, and then left for dead after an Indian attack on the shore. Jesse and his wife, Olivia, arrived in the Michigan Territory in 1831 and settled in north central Troy. They farmed and raised four children. One son, Byron, was nominated for governor and served in the U.S. Congress. A window in the church at the Troy Historic Village is dedicated to Jesse Lee Stout.

A.J. CROSBY, B. 1815. Andrew Jackson Crosby and his wife Lurania came to Michigan in 1844 and to Troy in 1855, buying land in the southwest corner. His farm was famous for his Spanish merino sheep and Berkshire hogs. Two of his sons, Andrew and Tertullus, served in the Union army during the Civil War.

21

JOSEPHUS SMITH, B. 1822. The Smith family came to Troy in 1829. Father Hiram Smith was the original purchaser of the family land, which stood right in the center of Troy. It was said that the family's cabin was rather finer than the norm because it was made from dressed logs and had a stone, not a stick, chimney. Josephus farmed, dealt in insurance, served a term as town supervisor, and was a justice of the peace. He also taught in a log cabin school.

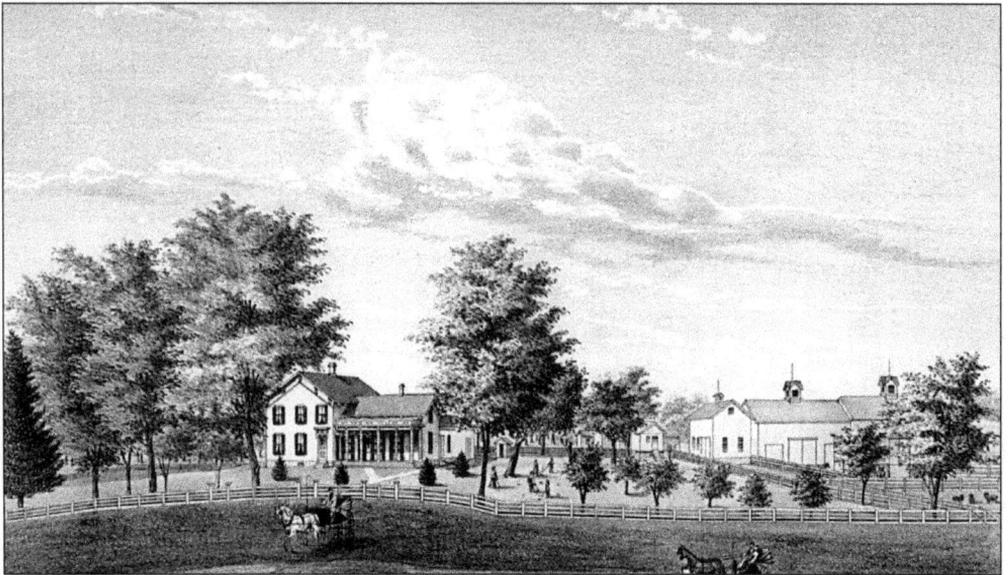

RESIDENCE OF SILAS B. WATTLES. John Wattles was a Scottish political prisoner sent to the colonies in 1652 as an indentured servant. The first Wattles in Troy was Alexander, who bought land east of present day Rochester Road in 1837, the year Michigan became a state. The home pictured here belonged to his younger son, Silas, born in 1827, who bought land in northwest Troy along present day Long Lake Road, some time in the 1850s. With his wife Helen Silas raised a son, Harry. The house was later rented, fell into disrepair, and demolished to make way for the Northfield Hills Development.

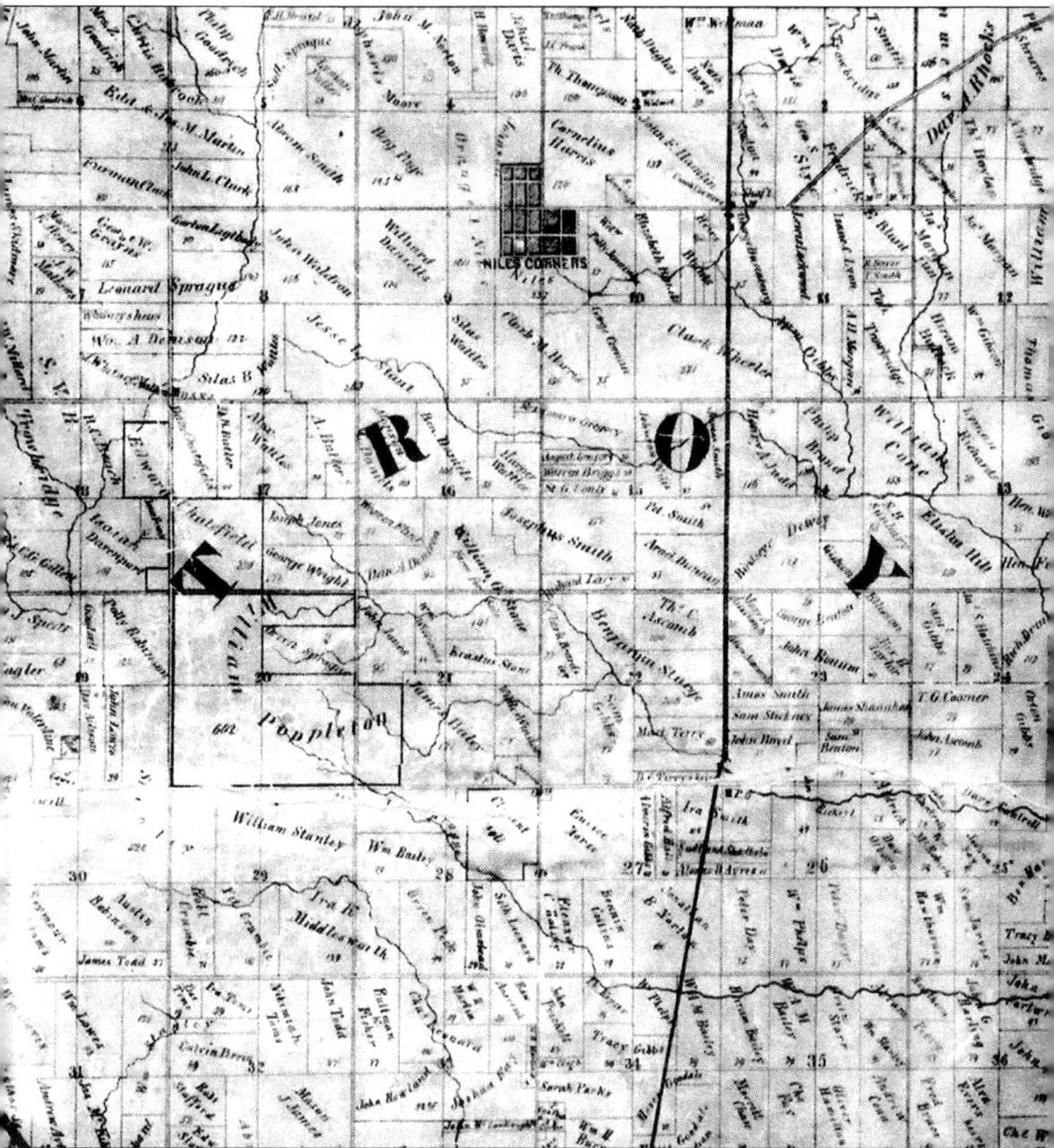

MAP OF OAKLAND COUNTY, 1857. This lithograph by Klauprech and Menzel of Cincinnati, published by S.H. Burhans, shows all the townships of Oakland County. Section lines are marked on the map and the names of the landowners are clearly readable. The only real road marked is the one to the right of the letter O in Troy; it was a plank road, the main toll road between Royal Oak and Rochester. Both of those settlements were more important than Troy and had bigger populations. (Image donated by Robert Huber, former mayor of Troy and U.S. congressman. Photo by Laura Freeman.)

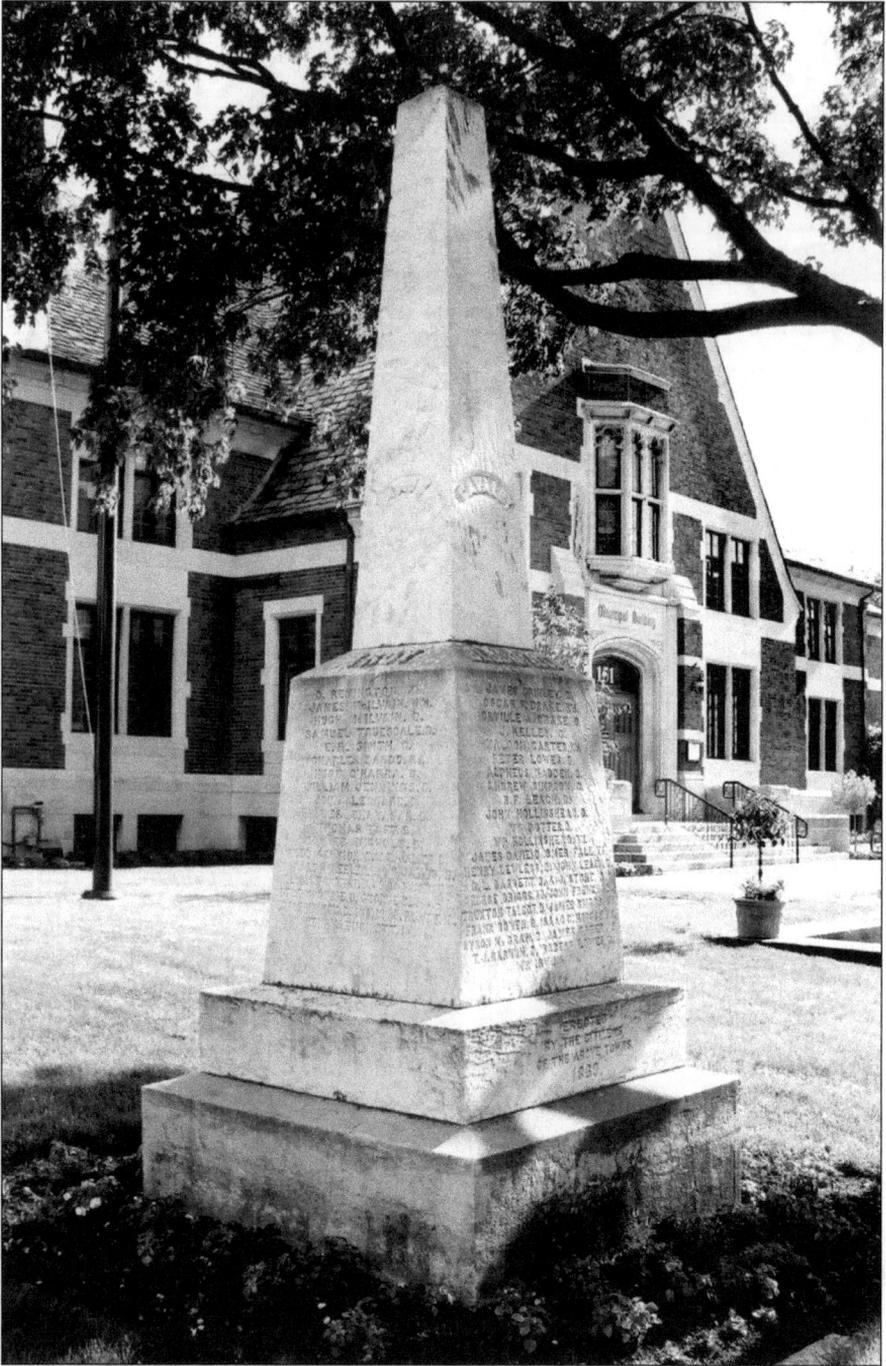

MONUMENT TO TROY'S CIVIL WAR DEAD. In 1869 the citizens of Troy, Bloomfield, Royal Oak, and Southfield jointly raised this monument to the servicemen who had perished in the recently concluded war. Each township listed its fatalities on one side. Troy listed five killed in action and 17 who died of their wounds or while in a Confederate prison. Originally situated in the Birmingham cemetery, the monument now rests outside Birmingham City Hall. (Photo by Laura Freeman.)

CLARK M. HARRIS. Clark Harris owned 150 acres just south of Troy Corners according to the 1857 plat map. On May 28, 1861, he enlisted in Battery A (Loomis' Battery), First Michigan Light Artillery. His artillery uniform shows sergeant stripes in this photo, but by the end of the war he was commissioned a senior second lieutenant. Among the other Troy residents who enlisted that day was Frank Cutting, who served in the same battery. After the war he opened a blacksmith shop and then a general store at Troy Corners. He and Harris may have been friends. They certainly were close in age.

WALTER BLOUNT, 1829–1905.
Walter's father Henry bought land
in Troy in 1823. Henry's father, also
named Walter, accompanied the
family. He was a Revolutionary War
veteran, and the Daughters of the
American Revolution marked his
grave in Union Corners Cemetery.
The Blounts can trace their descent
from William, who settled in
Massachusetts in 1634. The Walter
shown here remained unmarried.
(Image donated by Ypsilanti
Historical Society.)

GEORGE OSCAR BLOUNT, 1834–1897.
Brother to Walter, George Oscar married
Cordelia Brown. Their two sons, Harry and
Frank, continued to farm the family land
which today is Sylvan Glen Golf Course.
Part of the old homestead was incorporated
into the clubhouse. Another Blount brother,
Henry Chatfield (Chat) was reputed to
drive the stage coach between Detroit and
Romeo. There is a memorial window to the
Blount family in the church at the Troy
Historic Village. (Image donated by Ypsilanti
Historical Society.)

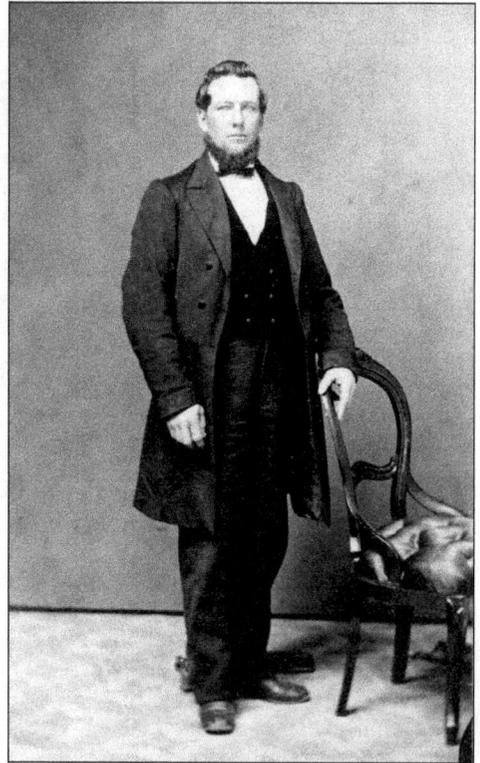

Russell Photography Studio Card Mounts. Listed in the 1880 census as a "Dagurain Artist," living with his divorced mother Charlotte, J. Henry Russell, Troy's first known photographer, apparently supplemented his income with other skills. He is listed in various places as a tinsmith, hardware merchant, and wood turner. Divorce was very unusual at this time but his father, physician John Russell, lived in Royal Oak.

J. H. Russell,

Photographer,

Troy,

MICH.

Good Photographs $1 per Dozen.

FRAMES OF ALL KINDS.

May Cutting

Troy

Library Association.

No. 491

RULES:

Library open from 2 to 5 and 7 to 8 o'clock p. m., Saturday only.
No more than one book can be drawn at a time.
No book can be kept more than two weeks.
No book applied for by another, can be drawn the third time by the person returning it.

FINES:

Members or Subscribers detaining books longer than two weeks shall be subject to a fine of fifteen cents for each week that such book is detained.

If a book is lost or destroyed, the person to whom it is charged forfeits the retail cost of the book, if it is an odd volume; the retail cost of the set, if the volume cannot be replaced. Damages assessed by the Librarian and Book Committee. All persons refused the privilege of the library whose fines or dues remain unpaid.

J. H. Russell, Printer, Troy. Oct. 1888.

Troy Lending Library Label. Before free public lending libraries became commonplace, people could borrow books from subscription circulation libraries. Frank Cutting's general store at Troy Corners had a supply of books for loan. Several of the surviving titles are in the collection of the Troy Museum. The Russell Studio printed the bookplate shown here. (Image donated by Glen Brackenbury.)

27

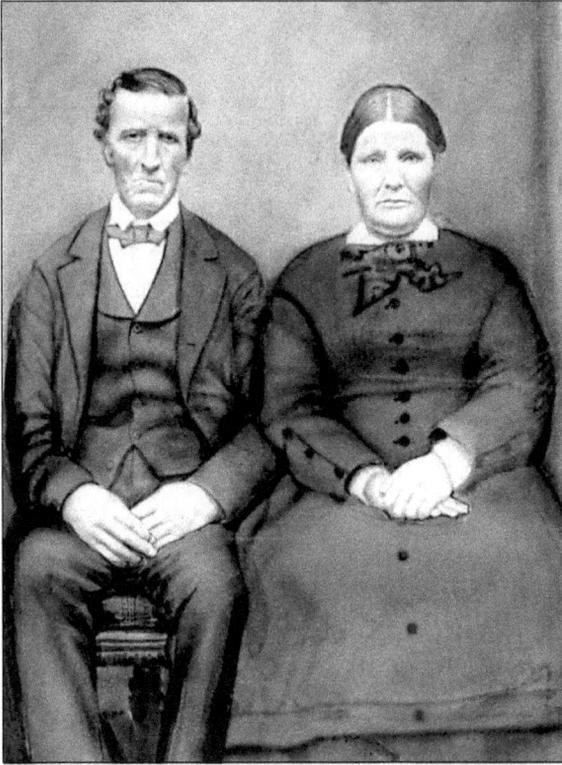

JAMES AND MARY ANN LOVELL.
The original of this photo has been hand-tinted with pastels. Both Lovells were born in England. The date of their arrival in Troy is uncertain, but in the late 19th century they were holding land at what is now Rochester Road and South Boulevard, the town's northern boundary. Together they raised 11 children, among them John. John married Eliza (Elizabeth) Parmenter. One of their daughters, Hannah Lovell Clark, born 1898, left charming handwritten reminiscences of her life, now in the files of the Troy Museum.

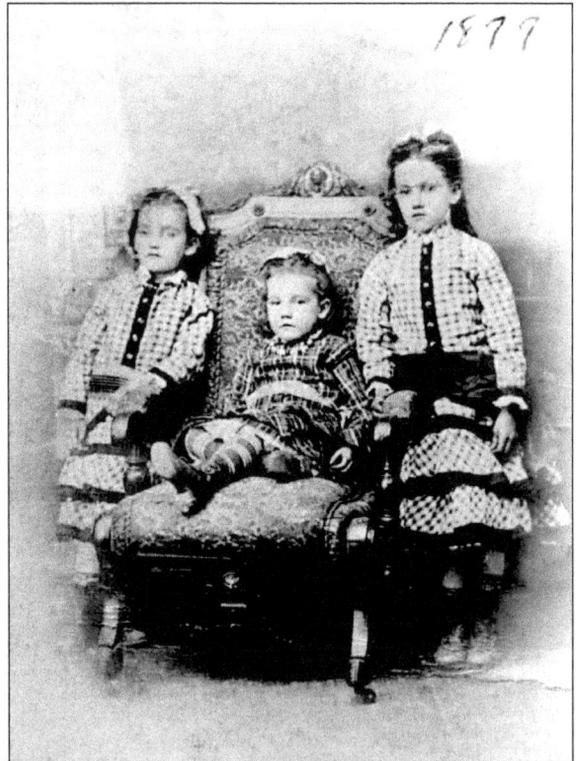

THE DODD SISTERS, 1879. Shown left to right are Mary, born 1876, Lydia, born 1877, and Elizabeth (Lizzie), born 1874. The family apparently lived in the southern part of the township, on 14 Mile Road, then known as Townline Road. A brother, Samuel, was born in 1880. The children's father, William John, and mother, Sarah (Truesdell), were both Irish immigrants. (Image donated by Marilyn Miller.)

THE DENISON FAMILY, c. 1880. Pictured left to right are members of the Denison family: (front row) William, holding baby, wife Clarissa, and son William; (back row) Frank Wheeler, Jennie Denison Wheeler, Clara Denison Shannon, and George Shannon. The Denisons farmed around present day Long Lake Road and Coolidge Road from the mid-1840s. William came to Michigan with his father, a Baptist minister, and mother. Before farming he worked as a bridge builder and as a salesman, selling surgical instruments. Clarissa was the daughter of James Bayley, one of Troy's first settlers and later superintendent of the Agricultural College in Lansing, which became Michigan State University.

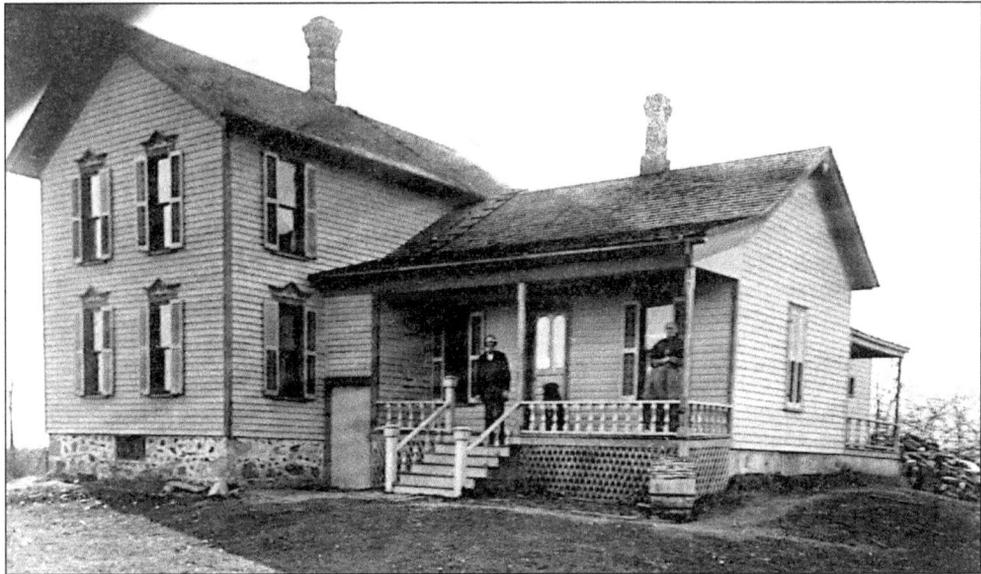

THE MAGEEHAN HOME, c. 1887. In front of their home that was on present day John R Road and 14 Mile Road stand Robert Mageehan and his wife Esther, who were both born in Ireland. The Mageehan farm celebrated its centennial in 1962 but was sold to developers shortly thereafter. Oakland Mall now stands on the site. (Image donated by Marilyn Miller.)

29

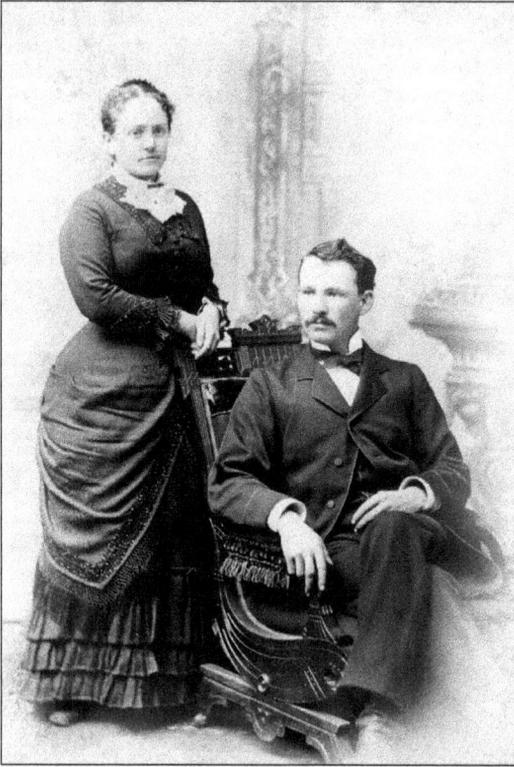

CHARLES AND NELL (ELLA JANE TROWBRIDGE) ASPINWALL, c. 1880. One of four children of Edward Aspinwall, an early Troy settler, Charles farmed for many years near Troy Corners. The couple is shown here in their wedding photo. Brides at this time wore their best dresses; it was not considered essential to wear white. Nell died in childbirth, a common occurrence. She and her baby daughter, Frankie, were buried together at Union Corners Cemetery. (Image donated by Viola Aspinwall Smith.)

BELLE JENNINGS. In 1886 Charles Aspinwall married Belle, his second wife. They had six children. Belle was a descendant of the first Purple Heart recipient. (See page 15.) She survived Charles. A classified advertisement from a 1931 newspaper has her listing a "3-acre garden farm at Troy Corners" for sale. At that time Livernois Road was still referred to locally as "Main Street." (Image donated by Viola Aspinwall Smith.)

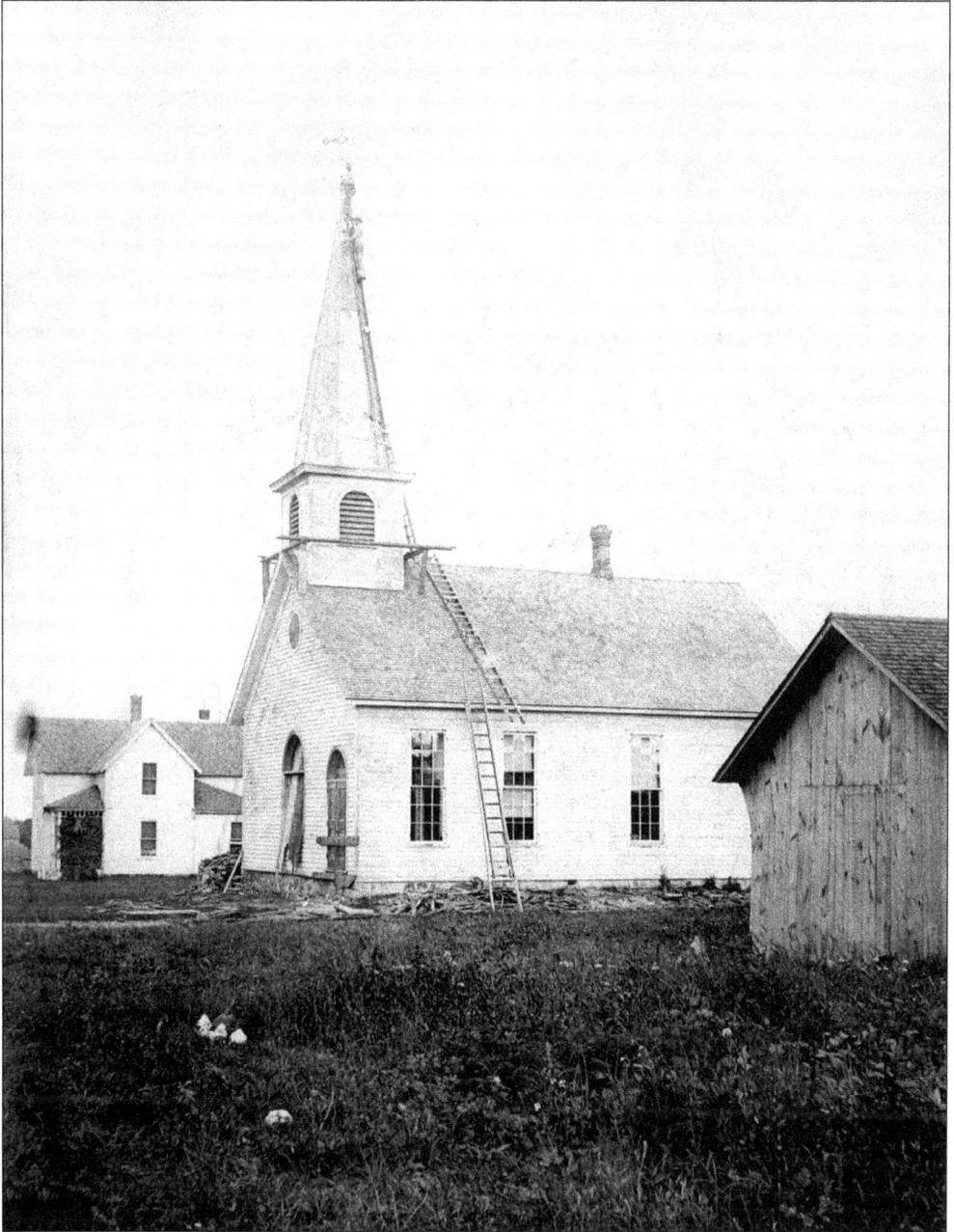

TROY METHODIST CHURCH, 1890. This heart of Troy Corners was built in 1837 as an Episcopal church on land bought from Johnson Niles for $1. The Methodist congregation purchased the building around 1868. This picture shows John McCulla and George Scott, contractor and employee. See the church, see the steeple, follow the ladder, find the people! (Image donated by Barbara Harris.)

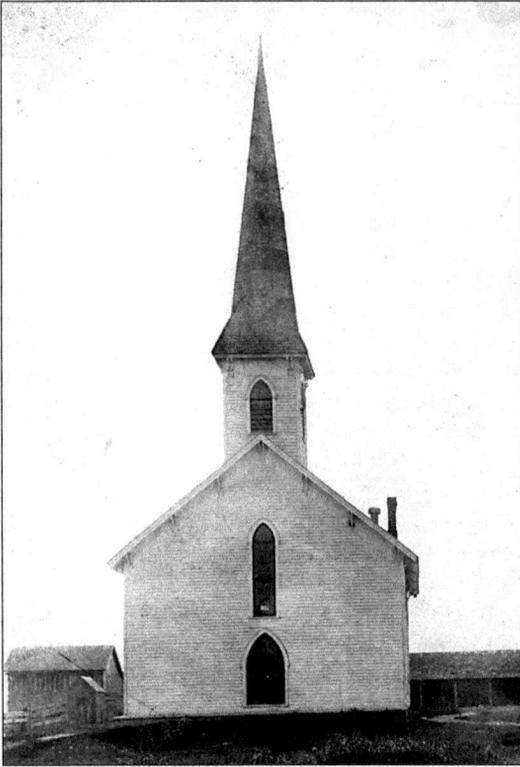

BIG BEAVER METHODIST CHURCH, 1890. In February of 1875 the Methodists in the Troy area numbered nearly 60, and it was determined that Big Beaver Village could support a church building of its own. In this postcard, a person appears to be entering what may be the outhouse to the left. Stables are visible to the right; they sheltered horses during the services.

MORRIS WATTLES AND HIS MOTHER, MATTIE AXTELL WATTLES, 1895. Mattie was the second wife of Harry Wattles and Morris was their only child. He would live in the family home on present day Livernois Road south of Wattles Road until his death in 1988, and play a prominent role in the development of Troy. (Image donated by Morris Wattles.)

Two

THE D.U.R. ERA
1900–1929

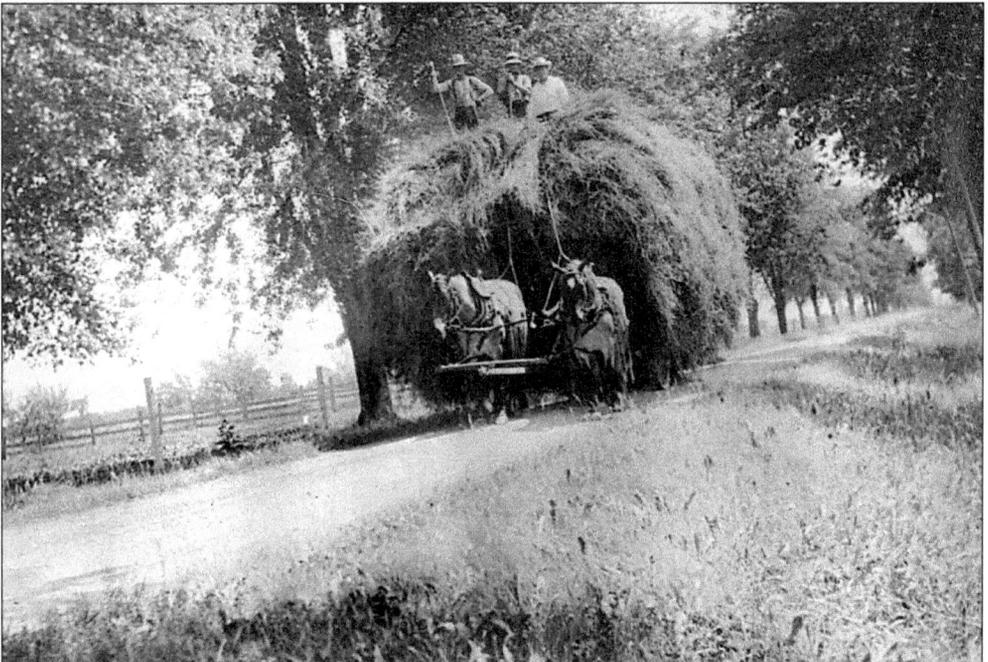

CROOKS ROAD, c. 1920. A matched team of plow-horses travels south on Crooks Road, half a mile north of Maple Road, pulling a load of hay from the fields. The men are identified as "Edward B. Haag (white shirt), Clifford, and Earl." The sight of winter fodder on its way to storage in a local barn was a familiar one for decades on the roads of agricultural Troy. (Image donated by Clara Strong Haag.)

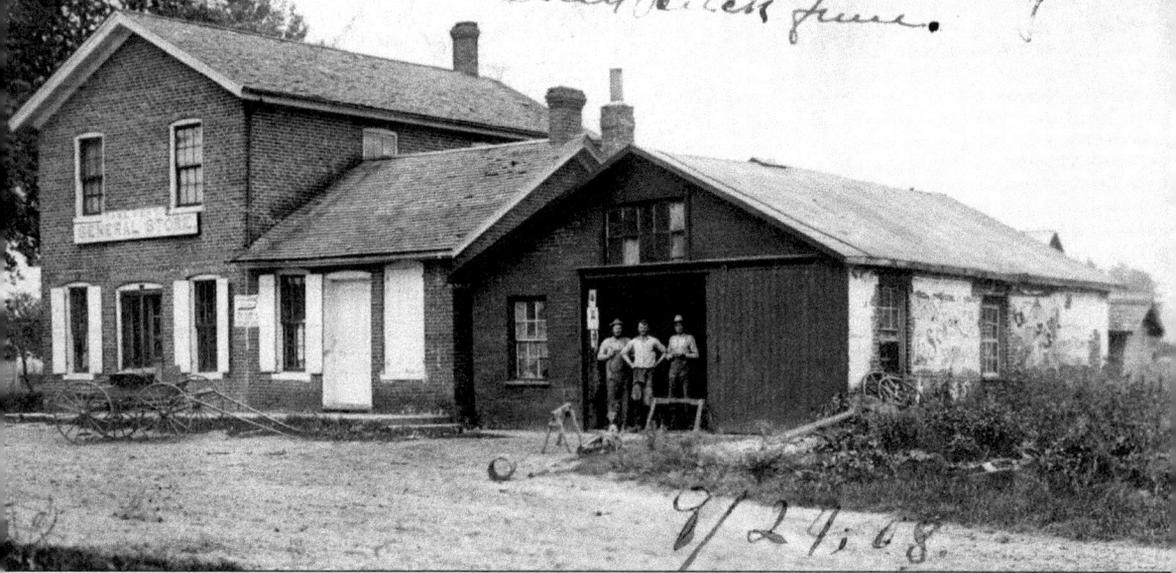

SAMUEL LEVY'S STORE, 1908. Pioneers established a trading center around present day Rochester Road and Big Beaver Road. Known as Big Beaver Village, supposedly after a large beaver dam in the area, there was little more than a tavern, a blacksmith shop, and a post office until the middle of the 19th century. This store stood near the northwest corner. Later the Lamb family sold their store south of the village and bought this one. At that time it was also both the post office and the home of the area's first telephone. The three men in this postcard stand in front of the adjacent blacksmith shop.

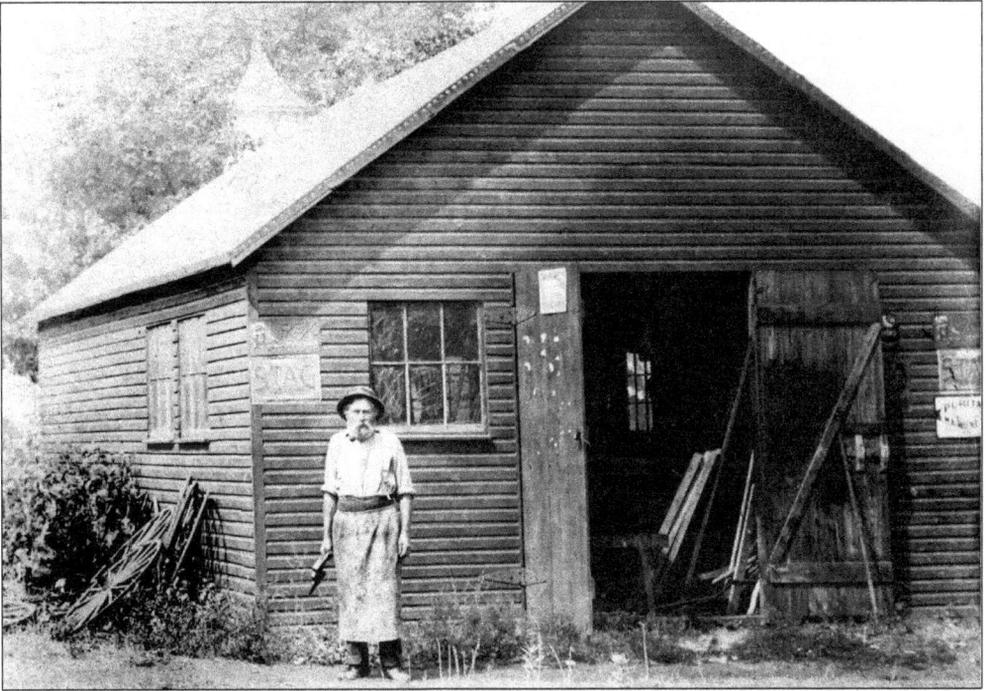

DADDY SCHULTZ'S WAGON SHOP. This is one of the earliest photographs we have of the Big Beaver area. A blacksmith by trade, August (Daddy) Schultz built the shop in 1907 just north of the intersection. During recess, children from nearby Big Beaver School would gather in front of the shop and watch "Daddy" shoe horses.

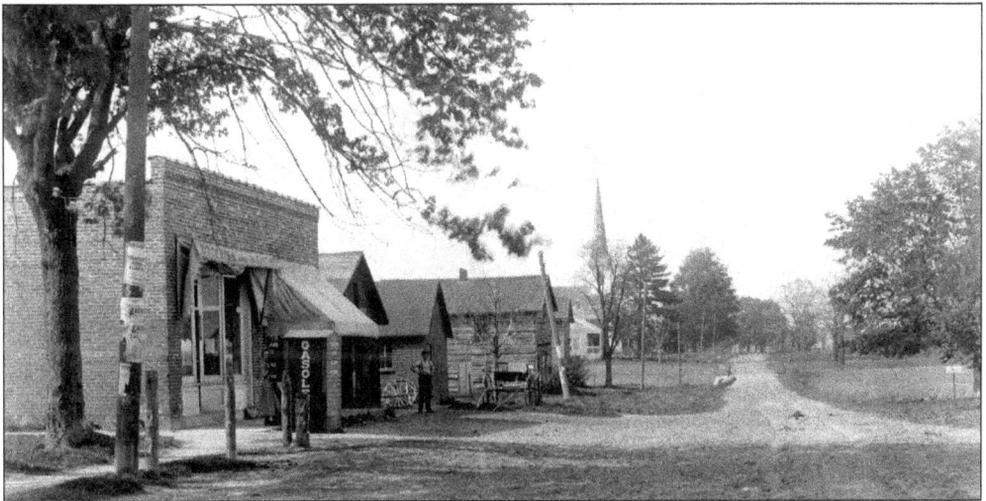

LOOKING NORTH FROM BIG BEAVER, c. 1914. This view looks north up present day Rochester Road. In the foreground is the general store built to replace the one on page 34 that was destroyed by fire. It's now Lamb's store with an awning advertising groceries and meats. A woman out front stands by the door of a gasoline pump. A man is outside the blacksmith shop. The wagon beyond him is "for sale." The posters on the pole in the foreground advertise auctions and "Toasted Corn Flakes Kelloggs." The steeple of Big Beaver Methodist Church is visible in the background. (Image donated by Ron Bernard.)

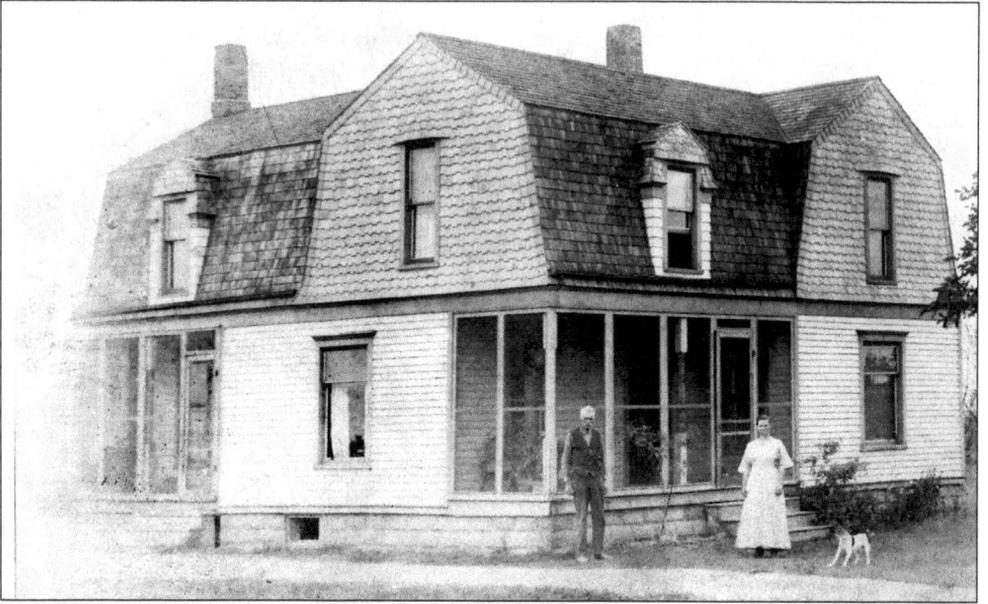

LAMB FAMILY FARM, c. 1910. Shown in front of their farmhouse on present day Rochester Road south of Big Beaver are Sam and Sarah Stevens Lamb. After losing a husband and two children, her entire first family, to tuberculosis, Sarah went on to become a major landowner in Big Beaver. Records show she purchased this house for less than $500. Today, I-75 crosses Rochester Road at this location. Perhaps Sarah would have approved; she bought an automobile from the Schroeder dealership for $700. (Image donated by the Stevens family.)

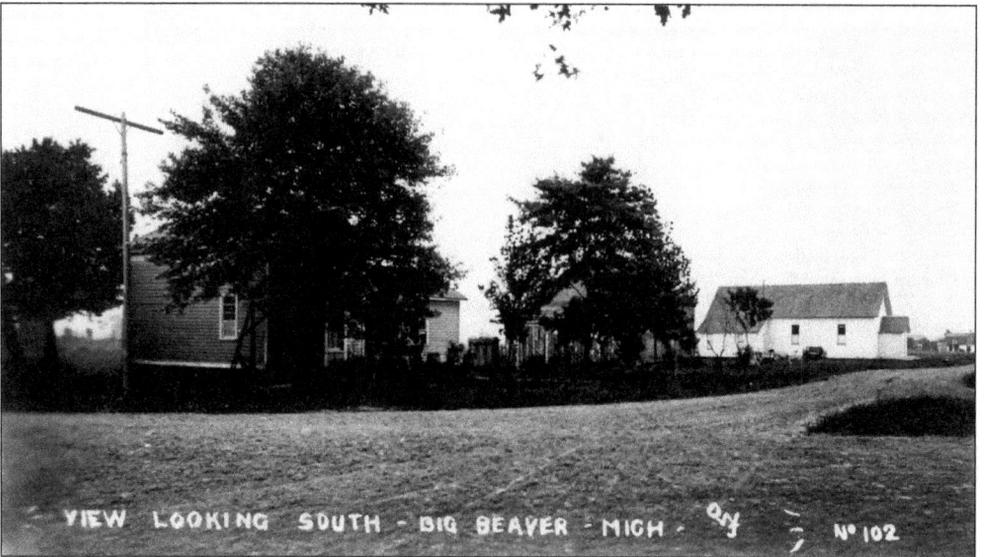

LOOKING SOUTH FROM BIG BEAVER. The date of this photo is unknown, although clearly it was taken sometime after electricity came to the area. According to a 1916 map, the Aldrich family owned the house on the corner. Later it became Miller's Bar. The white building to the right was the Maccabees Hall; the Maccabees organization was an international fraternal order that provided sickness and death insurance to their working class members. The building later became King's Hardware. (Image donated by David Tinder.)

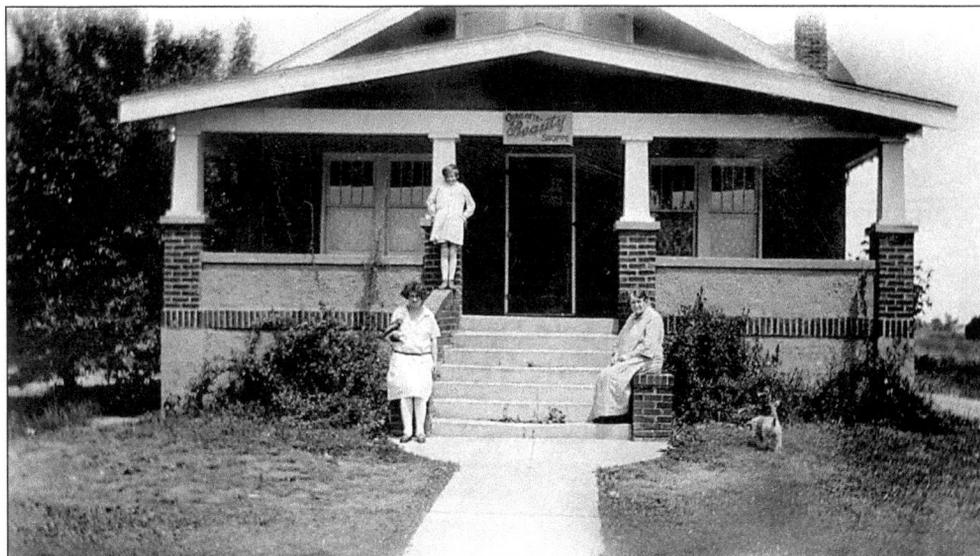

BIG BEAVER BEAUTIES. Charlotte (Lottie) Miller opened Big Beaver's first beauty shop in her home, as shown on the sign over the door in this photo, which appears to be from the 1920s. Shown from left to right in the front are neighbor Mrs. Woolery and "Grandma" Miller; standing in back is Mildred, Lottie's daughter. (Image donated by Ruth Wass.)

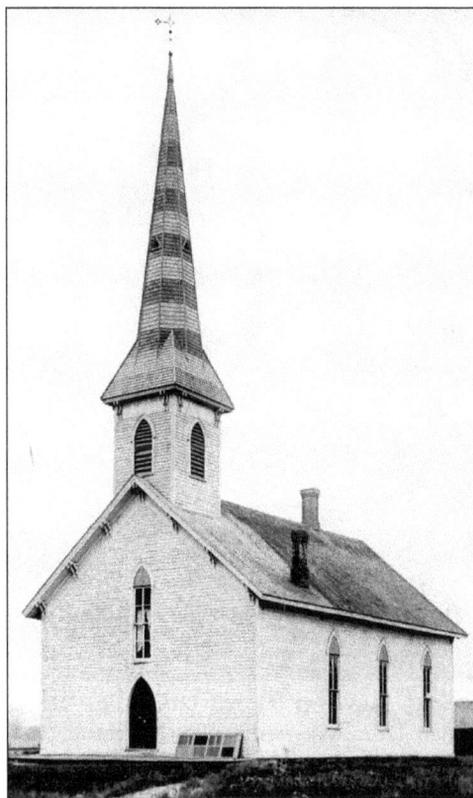

BIG BEAVER METHODIST CHURCH, c. 1910. Early meetings of the Methodists in Troy were held in schoolhouses. With the congregation approaching 60 by 1875, it was determined that a second church at Big Beaver be added to the one that had been purchased from the Episcopalians at Troy Corners. A "very fine frame church, 34 by 52 feet, with a spire containing an excellent bell" was dedicated on October 17, 1875. The cost was $3,600. An unusual feature of the building was the two-color spire. (Image donated by David Tinder.)

PRESBYTERIAN SUNDAY SCHOOL. Shirley Giles Brown (third from the right, front row) remembers Sunday school being held at the home of Mrs. Neill (second from the right, back row) on the southeast corner of Rochester Road and Wattles Road, because the church was so far away. The children of the Osborne, Morris, Kasten, Bayliss, and Brown families are also in the photo. (Image donated by Shirley Giles Brown.)

SAMUEL JARVIS AT TROY CORNERS, c. 1910. This view looks southeast and shows present day Square Lake Road running east, with the Troy Methodist Church and parsonage at the left of the row of buildings, and the stable of the old Niles Tavern at the right. The handwritten caption on the photo identifies Jarvis by his nickname, "Shorty." (Image donated by Joyce Harrison.)

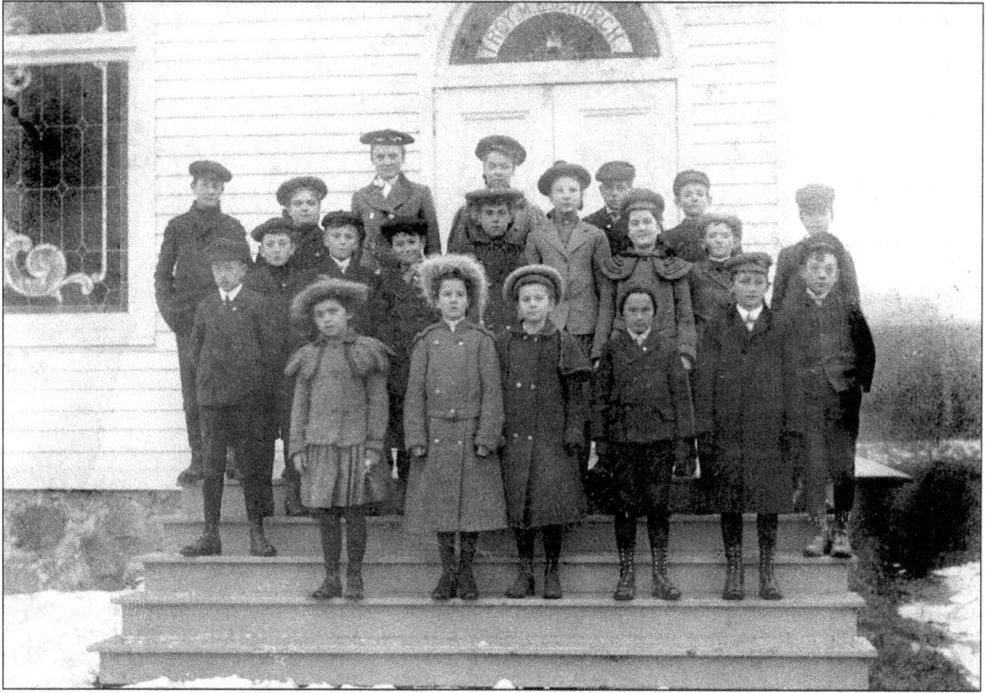

JUNIOR LEAGUE TROY METHODIST CHURCH, c. 1907. Several familiar Troy families are represented here. The young people met in the evenings for Bible study, and to raise money and organize charitable work. The group evolved into the Methodist Youth Fellowship and the Troy branch is still going strong. (Image donated by Morris Wattles.)

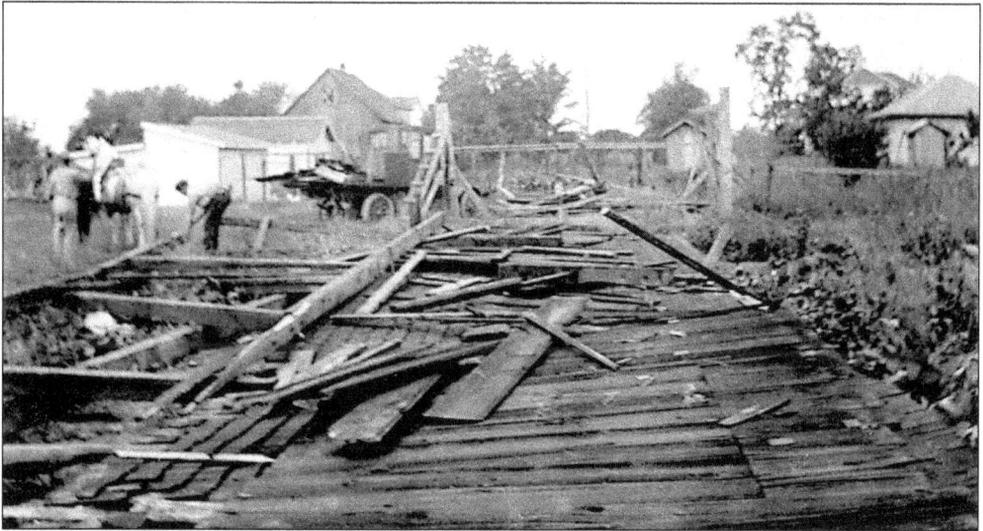

"AFTER THE BLOW," 1923. A handwritten caption on this photo identifies the subject as "church sheds after the blow." In 1923 a fierce windstorm swept through the area, damaging many homes and other buildings, including these outbuildings behind the Methodist Church on Square Lake Road. A similar storm of an unknown date in the early part of the 20th century blew the steeple from the church. During a 2004 restoration at its new home, the Troy Historic Village, the church received a new steeple. (Image donated by First United Methodist Church of Troy.)

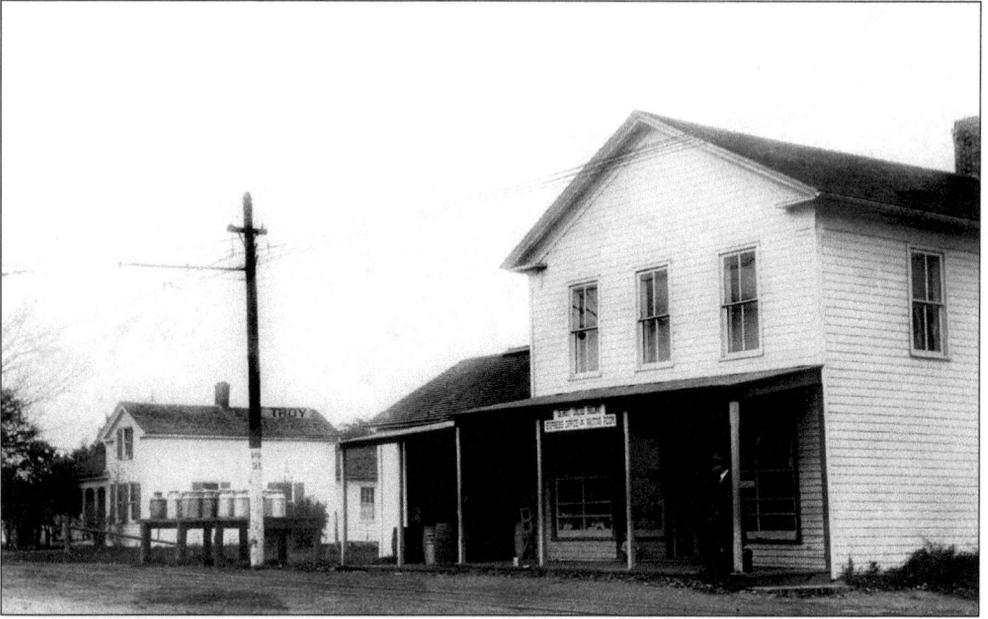

CUTTING'S GENERAL STORE, 1912. A store stood at Troy Corners, the intersection of Square Lake Road and Livernois Road, from 1832 onwards. The first was owned by Edward Peck. Franklin Cutting was listed as the owner after 1882, but it's believed he had managed the store for some years before that as the son-in-law of the previous owners, the Goodman family. The unidentified man leaning against the post is presumably waiting for the Detroit United Railway (D.U.R.) car, as are the milk cans on the platform. The platform sign identifies this as "Stop 35."

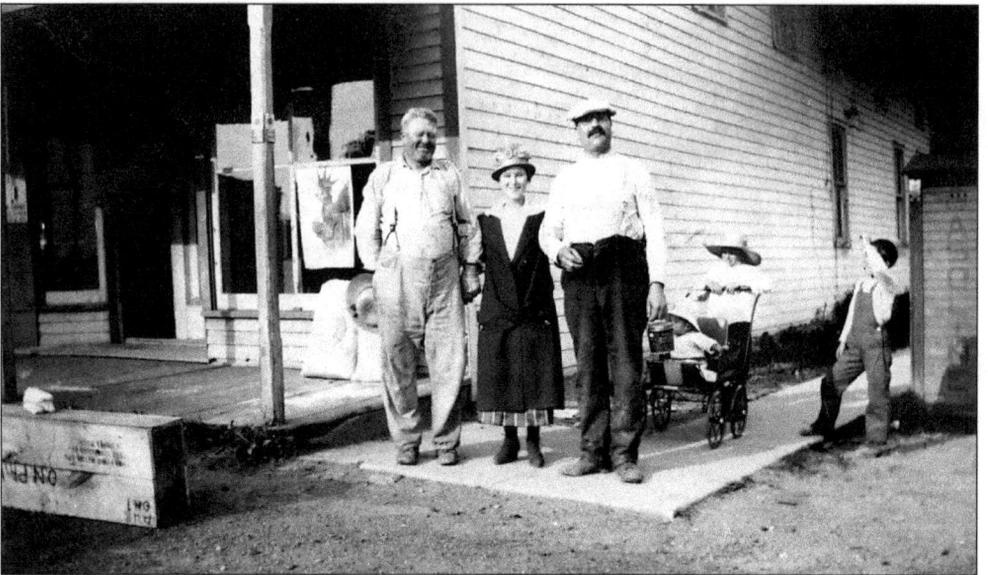

"A CHICKEN SANDWICH," 1917. Shown, from left to right, standing outside Cutting's store are George Maitrott, Jessie Aspinwall, and Reverend Belgoulian, minister of the Troy Methodist Church, and three unidentified children. The month is June, shortly after the nation's entry into World War I. Note the Statue of Liberty poster selling bonds in this Troy Corners store window. (Image donated by Viola Aspinwall Smith.)

ON THE PORCH, 1920. On the porch of the Aspinwall family home at Troy Corners sit brothers Charles and Harry Aspinwall, presumably relaxing after the day's labors. In the background is the general store with the sign "Detroit United Railway, Express Office & Waiting Room." A child petting a dog has also been captured for posterity. (Image donated by Viola Aspinwall Smith.)

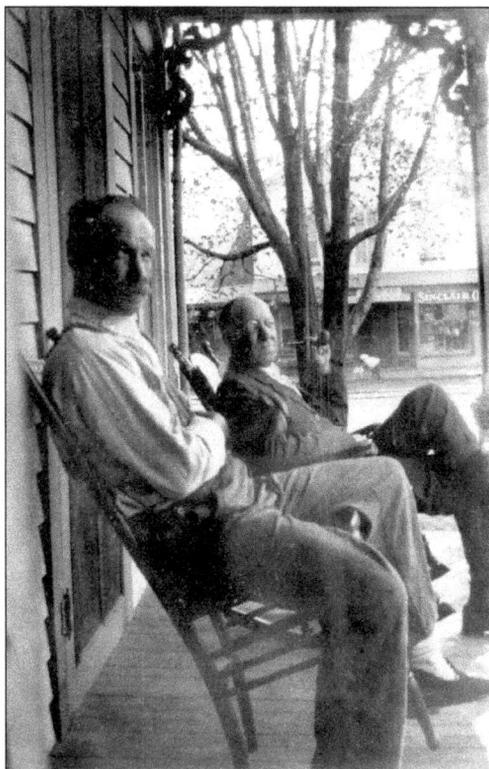

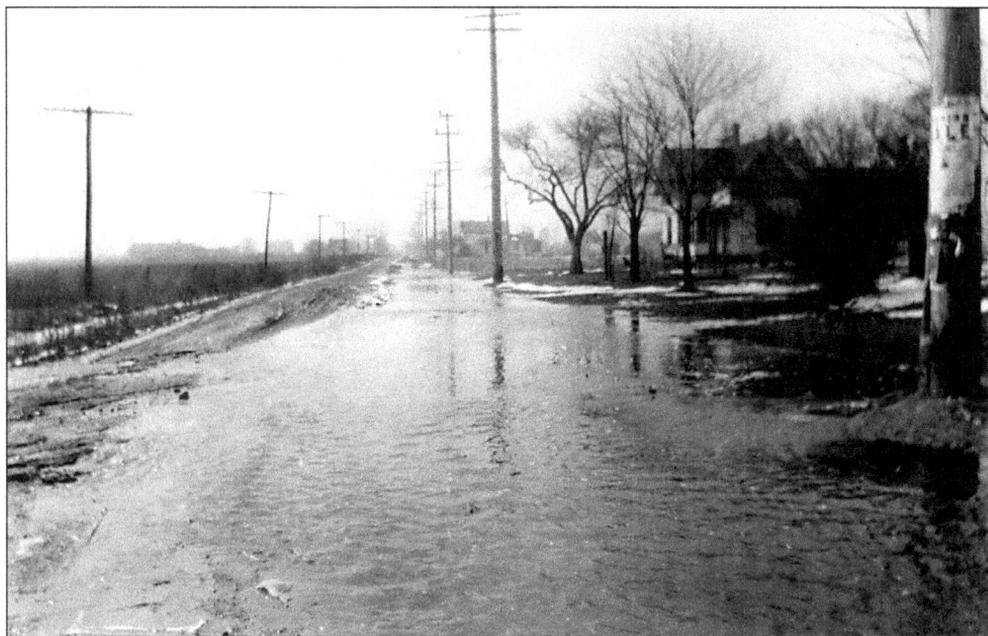

FLOODING AT TROY CORNERS. This photo was taken on April 18, 1921, looking west along Square Lake Road from Troy Corners. Most areas of Troy have an exceptionally high water table and flooding was a common problem after heavy rain, and remains so in some areas today. (Image donated by Viola Aspinwall Smith.)

—COME—

TO

Squire Judkins' Apple Bee

AT

THE TROY HALL
WEDNESDAY EVENING, DEC. 16, '08

A bright and successful picture of the festival it celebrates. It will be given
under the auspices of the

TROY LADIES' AID & EPWORTH LEAGUE SOCIETIES

-Family-

Squire Judkins, a farmer	Louis E. Becker
Mrs. Judkins	Carrie M. Bingham
Elizabeth Judkins, the daughter	Mrs. F. Williams
Ezekiel Judkins, who plays the fiddle	Parke F. Cutting

-Apple Parers-

Hester Watkins	Miss Elda Aspinwall
Eliza Doolittle	Miss Agnes Parker
Peter Milliken	Percy J. Lamb
Jane Jenkins	Miss Clara Bayley
Obadiah Higgins, the conundrum propounder	Silas H. Wattles
Hiram Wade	Willie Bayley
Susan Brown	Miss Rhobie Niles
Amanda Smith	Mrs. L. Becker
Sally Hoskins, village poetess	Mrs. C. Aspinwall
William Hines	Edward Williams
Seth Dusenbury	Floyd Lawrence
Mary Ann Johnson	Miss Julia Lakie
Samantha Cooper	Mrs. W. Jennings
Herman Hines	Howard Miller
Simon Livermore	Frank Leonard
Benjamin Stebbins, who laughs last	Elton Miller
Moses Hoff	Ferry Houghton
Sophronia Weatherby, "who electrocutes"	Mrs. H. B. Wattles

Drill of the "Teddy Bears"

Arvilla Bayley, Drusa Davenport, Hazel Lovell, Hildreth Cross, Bertha
Schultz, Hazel Bayley, May England, Hattie Lovell.

The Entertainment Will Begin at 8 o'clock, Local Time.

Admission 25c Children under 12 years of age, 15c

Rochester Era Print

A NIGHT AT THE THEATER, 1908. In country areas friends and neighbors often provided their own entertainment. This charmingly titled play depicting a typical farming activity, the apple bee, was held in Troy Hall, which stood at Troy Corners. *The Drill of the Teddy Bears* was perhaps an entertainment provided by the children. Troy Hall was a Grange Hall, a meeting place for members of the social and fraternal society founded by Oliver Hudson Kelley in 1867. The Epworth League was a junior Methodist group. (Image donated by First United Methodist Church of Troy.)

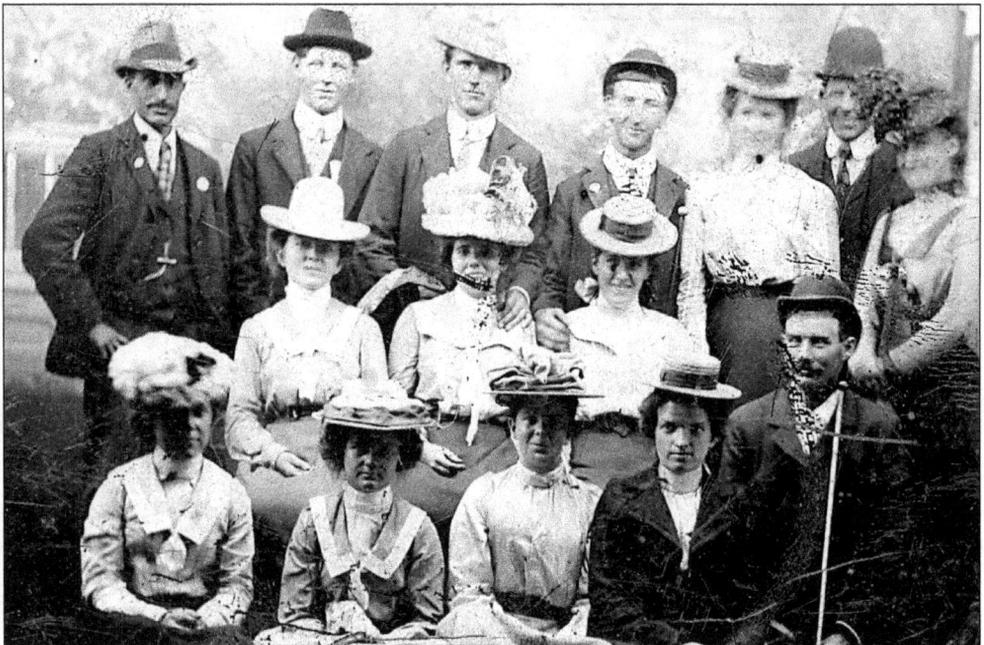

FOURTH OF JULY PICNIC, c. 1910. The family and friends of Mary Mageehan (front row, right) gather to celebrate Independence Day. Typically the day featured picnicking and pealing bells, flag waving, firecrackers, and the singing of hymns and patriotic songs. As night fell, there would be fireworks to dazzle the crowd. (Image donated by Marilyn Miller.)

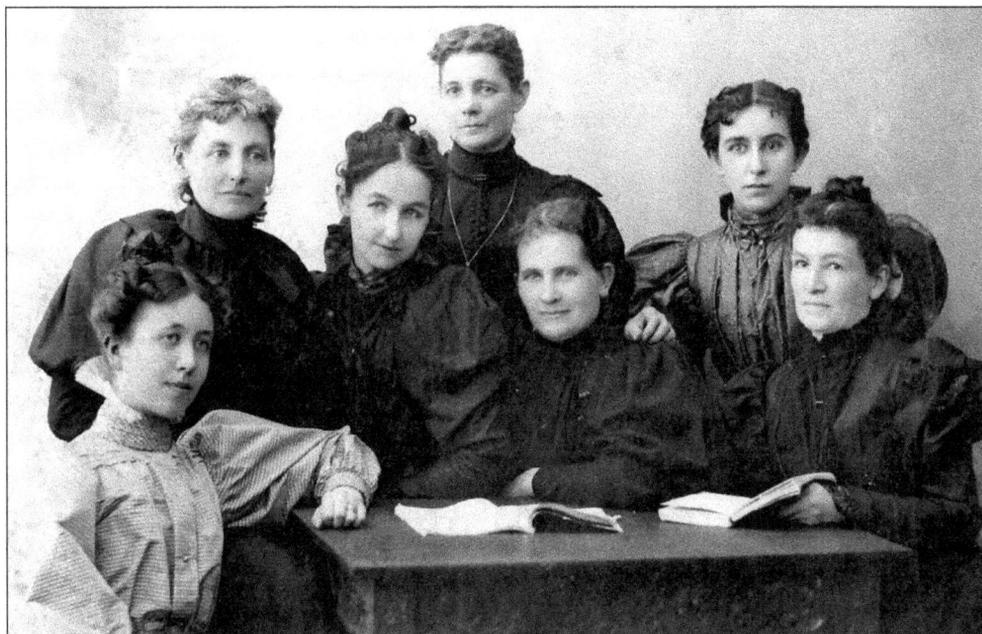

THE BAY VIEW READING CIRCLE, c. 1905. Reading circles first became popular in the years following the Civil War when women had few social outlets considered respectable, except church activities. Shown from left to right are Mae Cone, Mrs. George Elliott, Mrs. Harry Wattles, Mrs. Butler, Mrs. George Jennings, Mrs. Grace McCarter, and Mrs. Sommers. (Image donated by Morris Wattles.)

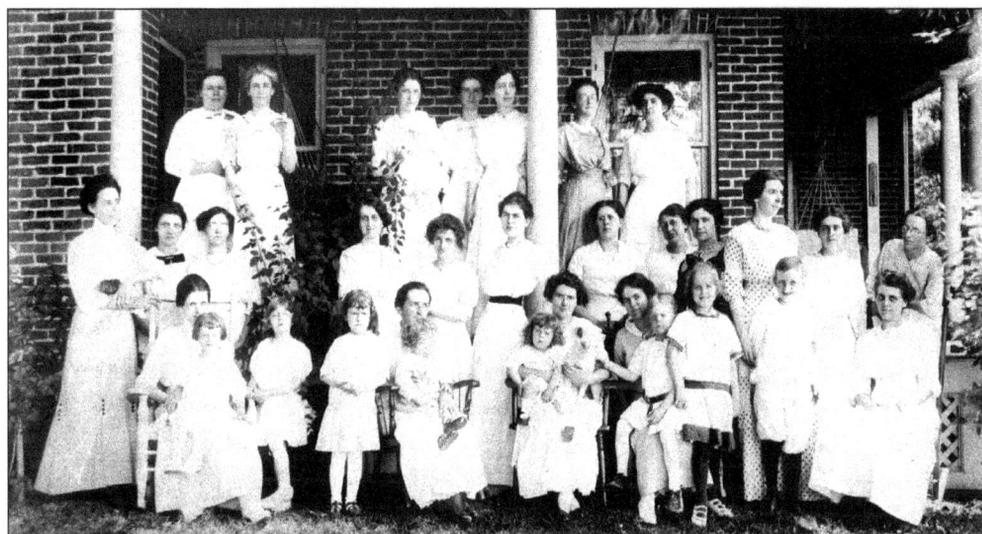

TROY FARMERS CLUB, c. 1912. This photo shows the club meeting at the home of Grace Elliot on Livernois, south of Long Lake Road. The Farmers Club, formed in 1897, met monthly to discuss farming techniques and innovations. It was also a social gathering for hardworking farm families. A 1901 clipping from Jennie Niles' scrapbook described a typical meeting: Families gathered midday for a dinner prepared by the club's female members. Afterwards, all enjoyed music, games, a "literary program" consisting of papers and recitations, a "Question Box" full of philosophical questions, and a "Buy and Sell talk."

43

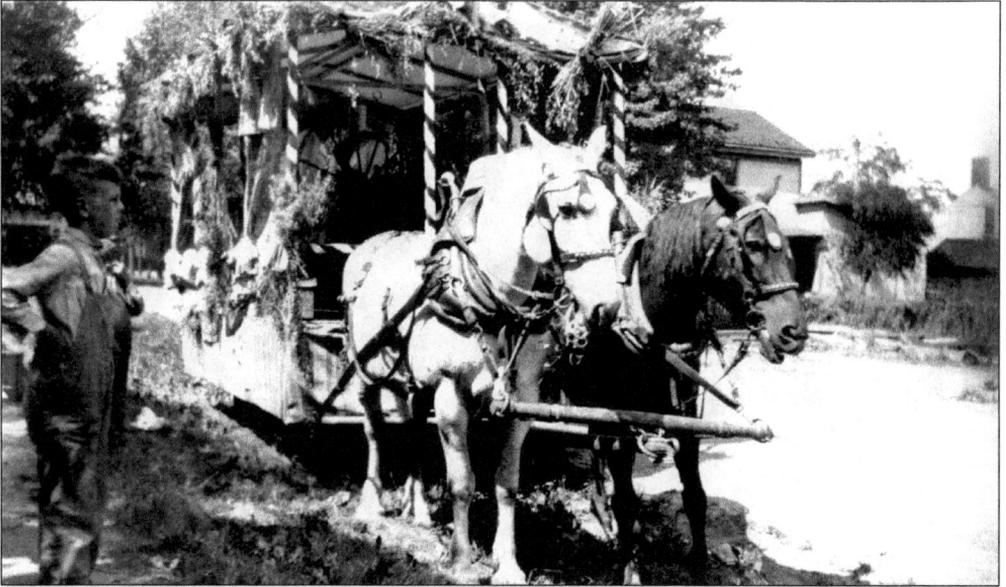

TROY FLOAT, 1916. An unidentified boy surveys Troy's float for a local parade. Perhaps one or both of the horses belong to his family. The reason for the celebration is unknown, perhaps Independence Day or harvest, but whatever the occasion, the float certainly reflects Troy's agricultural ethos. (Image donated by Viola Aspinwall Smith.)

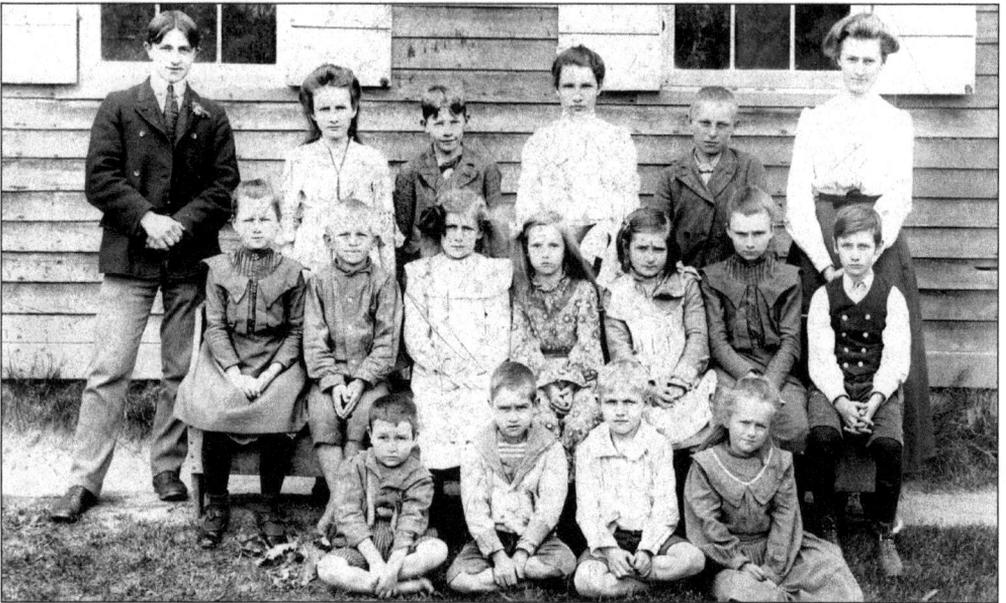

TROY UNION SCHOOL, 1902. The pioneers held school from the earliest days in their homes but the first school board was elected in 1831 and by 1833 the town was divided into school districts, seven whole and six fractional. According to the 1877 *History of Oakland County*, the first teachers were chosen because they were, "the possessors of good moral characters and the ability to instruct in the common branches." Log cabin schools were gradually replaced with wood frame or brick buildings. The man shown first left in the back row is teacher William Anger, who donated the photo in 1976.

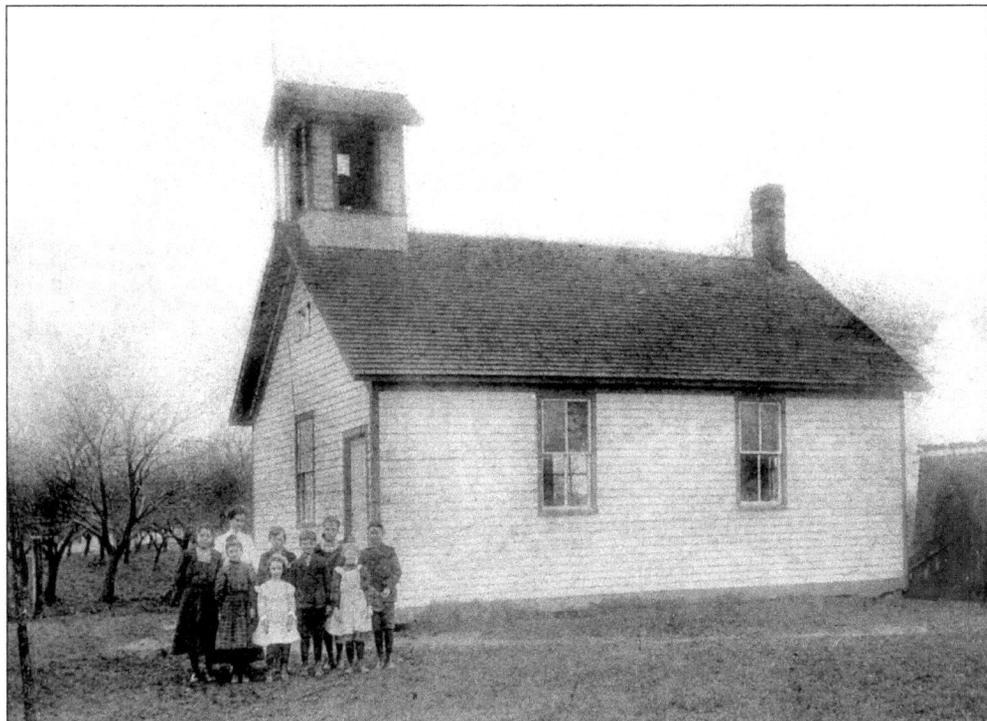

SMITH SCHOOL, 1907. The Smith School stood at Livernois Road and Wattles Road, next to an orchard and was named after Josephus Smith, an early pioneer and supporter of education. The outhouse is visible behind the school. The students are identified as, "(front row) Zola Truesdell, Howard Wright, Edna Belz; (back row) Hazel Wright, Clara Belz, Wiley Groves, Jennie Lakie, Morris Wattles, and Rena Dennison—Teacher." (Image donated by Morris Wattles.)

DISTRICT NO. 7 SCHOOL. Built in 1827, this school stood on the northwest corner of Maple Road and Coolidge Road, on what was then John Stanley's property. In the earliest years, fathers of school-aged children would assess their own property in order to build and support these rural schools, and they would also elect school officials to manage them. (Image donated by David Tinder.)

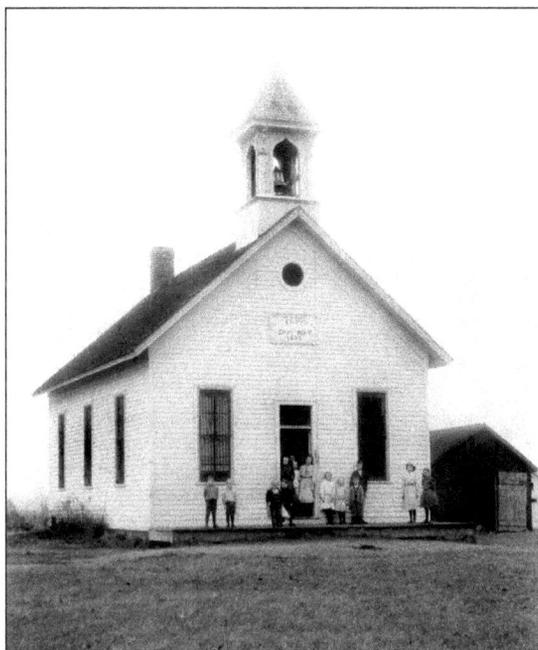

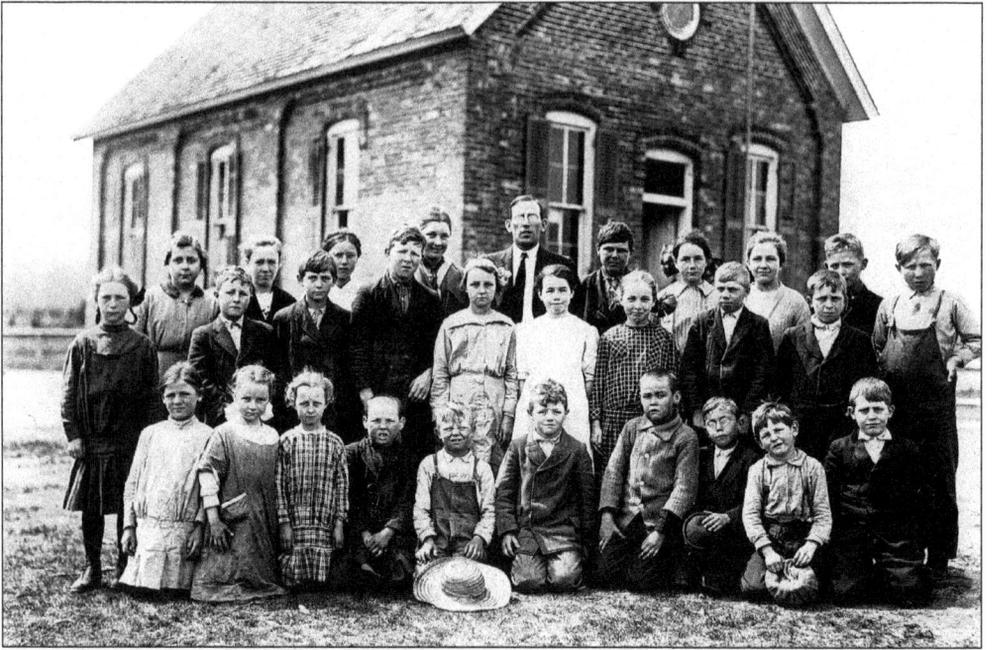

COLERAIN SCHOOL, c. 1909. Colerain School stood on property owned by the Harty family on the southeast corner of John R Road and Long Lake Road. In 1924 this building was replaced with a four-room schoolhouse on land sold by the family to the school district for $1. The school was named for Colerain County, Ireland. (Image donated by James Thompson.)

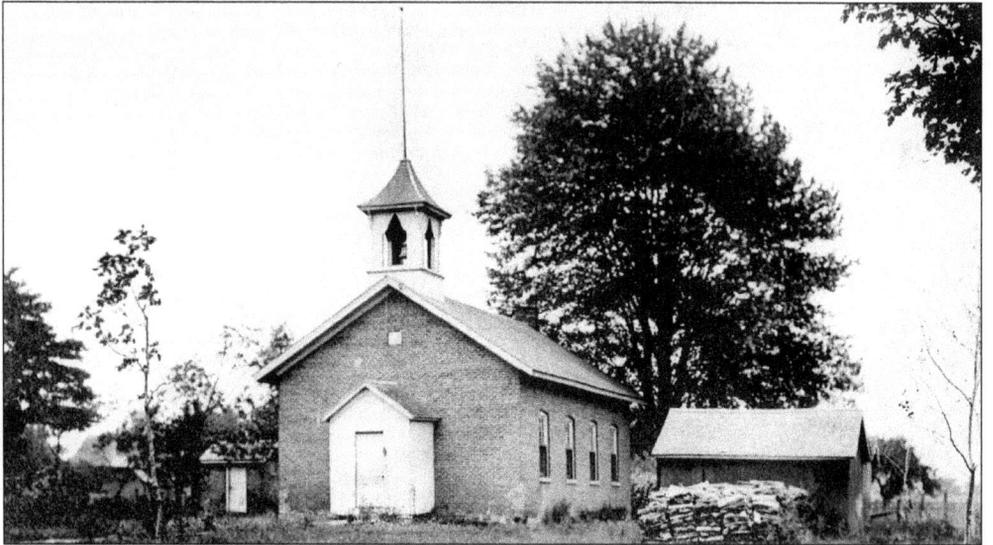

BIG BEAVER SCHOOL. As was typical, Big Beaver School evolved from an 1830s log structure, to a frame building erected around 1845, to this larger, brick one-room schoolhouse, probably built in the 1870s. In 1880 the teacher had 91 enrolled students warmed by a potbelly stove. A curtain drawn across the room divided the younger children from the older. It was pulled aside every morning and the children sang patriotic songs together. In 1919 this building was deemed too small and a new four-room schoolhouse was built on land donated by Jacob Levy, president of the school board. (Image donated by David Tinder.)

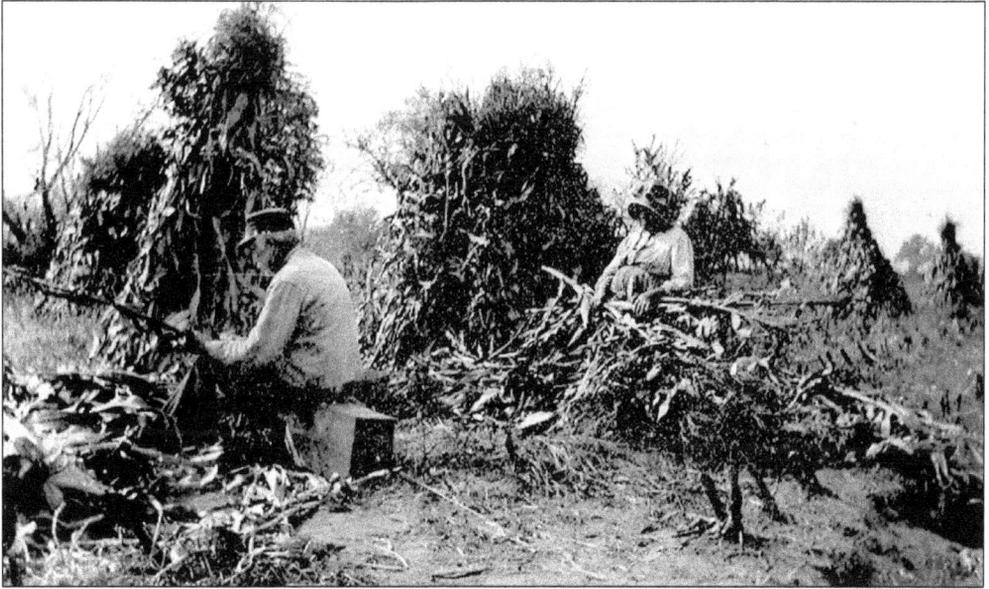

SHUCKING CORN. This photo from the collection of a Troy family shows a typical early farming scene, when backbreaking work was done by hand, the women working right alongside their husbands, even when, as this woman appears to be, they were pregnant. The harvest weather already being chilly, they are dressed warmly but their faces are still shaded from the bright sun by bonnet and hat. The ditch in the right foreground may be for either drainage or irrigation. (Image donated by the Stevens family.)

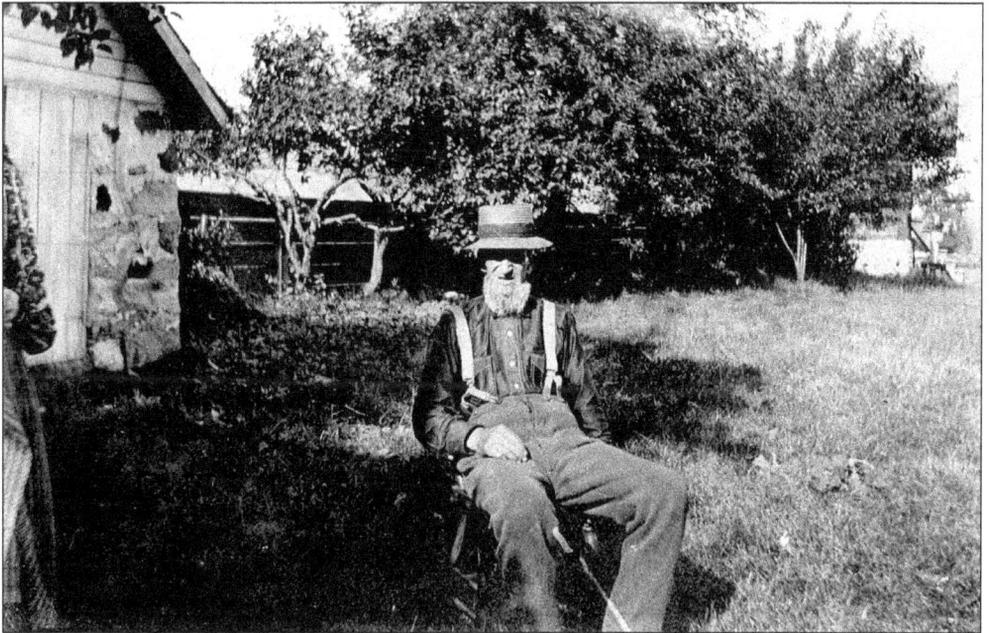

AT REST IN THE ORCHARD, c. 1910. A lifetime of hard farm work was often rewarded with a well-deserved restful old age. Here Silas Wattles, at the grand old age of 80 or more, is at rest in his orchard. Many Michigan farms had at least a few apple trees to provide cider and dried fruit for the fall and winter. (Image donated by Morris Wattles.)

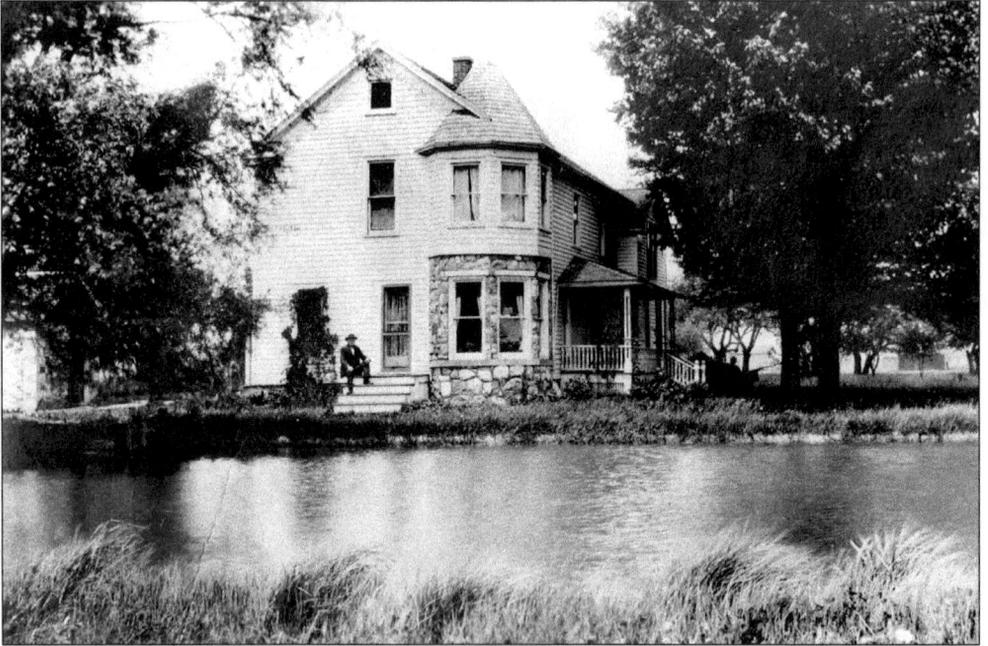

SCOTT LANDS, 1910. This impressive home stood on property at Livernois Road and 17 1/2 Mile Road. The owner, Jason S. Scott, is on the steps. An 1896 plat map shows him owning land on Rochester Road; perhaps he moved because he wanted to be on the D.U.R. line so that his milk could be collected directly. The name of the home and the size of the house seem to imply he was something of a gentleman farmer. (Image donated by his grandson, Jason Scott.)

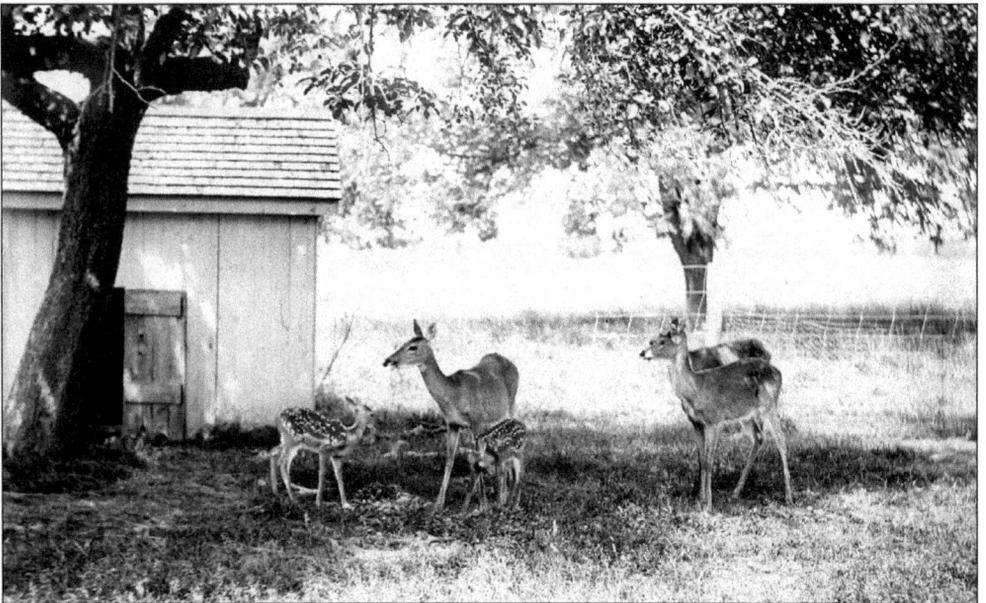

WHITE-TAILED DEER, c. 1910. These deer, enjoying the shade of a tree, were photographed on the Jason Scott estate, Scott Lands. Since most farmers could hunt at will on their land, there would be no reason to raise deer for profit. Mr. Scott may have kept them as pets as the presence of the hut in the background implies. (Image donated by Jason Scott.)

48

TRUESDELL FARM, 1915. The Truesdell family's farm was on Wattles Road between Livernois Road and Crooks Road. William Truesdell purchased the land in the 1860s. A big chunk of it was swallowed up by the construction of I-75, and the rest of it by subdivision construction in the 1970s. (Image donated by John C. Truesdell.)

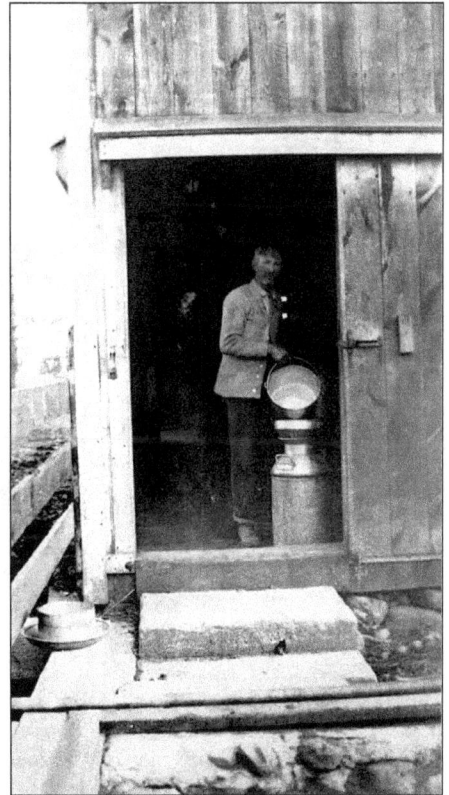

JOHN TRUESDELL IN THE MILK HOUSE, c. 1915. John was William Truesdell's son. In addition to farming, he gave 55 years of service to Troy as township clerk, constable, treasurer, and supervisor. (Image donated by John C. Truesdell.)

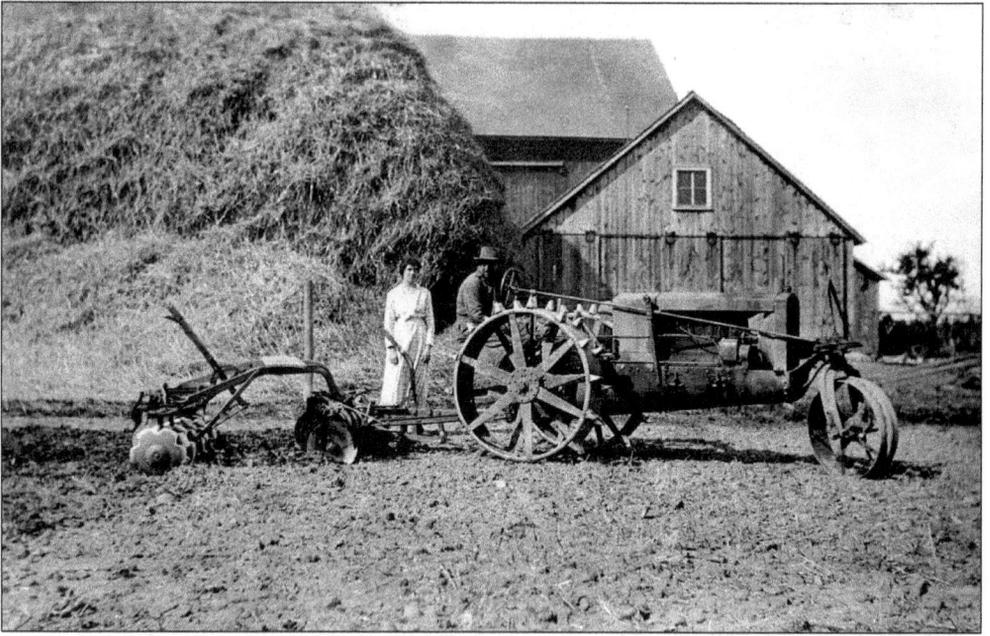

GATHERED HAY, c. 1918. Beginning in the late 19th century George Jackson farmed land at Coolidge Road and Big Beaver Road that had once belonged to the early pioneer William Poppleton. Somerset North now stands in that area. Sister and brother Floy and Berton Jackson are shown here with the family's tractor with disc harrow attached. A mountain of winter fodder is in the background waiting to be moved into the barn. Though unusual for this time, Floy Jackson was divorced in 1913 and returned to the family home. (Image donated by Linda Thielfoldt.)

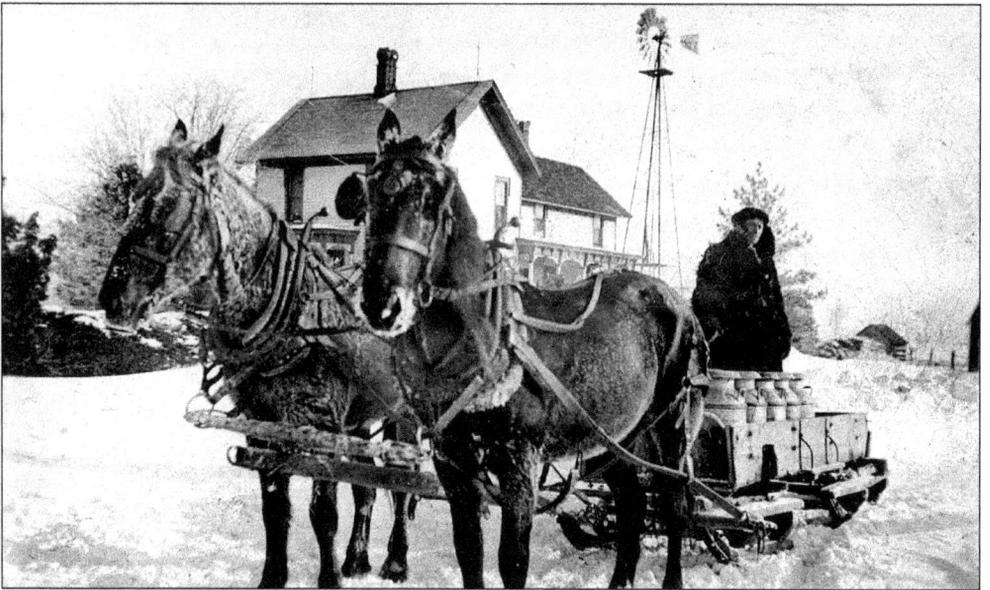

WINTER MILK COLLECTION, c. 1918. Though fields might lie fallow, there was still work to be done on the farm in winter. Here Berton Jackson is transporting milk cans using a sled pulled by horses Pearl and Ruby. Berton, who was born in 1880, was nicknamed Mutt by the family. (Image donated by Linda Thielfoldt.)

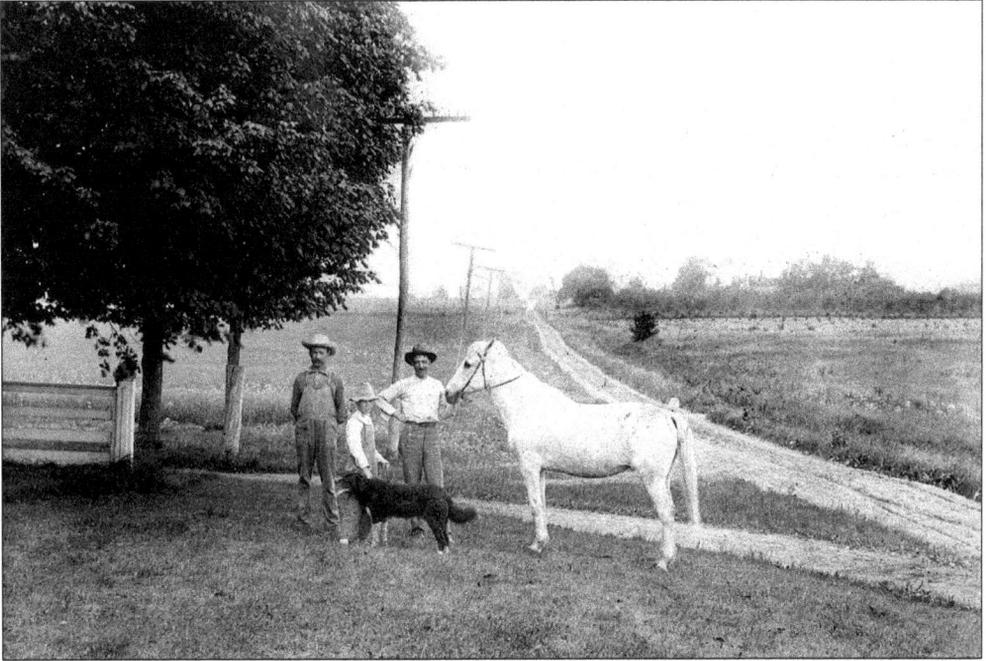

THE ASPINWALL MEN, c. 1910. Shown from left to right are Charles, his son Perry, and brother Harry Aspinwall, along with Kit the horse who lived, according to family lore, to be 32 years old. The dirt road that runs through the center of the photo is present day Square Lake Road, leading to its intersection with Crooks Road, seen in the background. (Image donated by Viola Aspinwall Smith.)

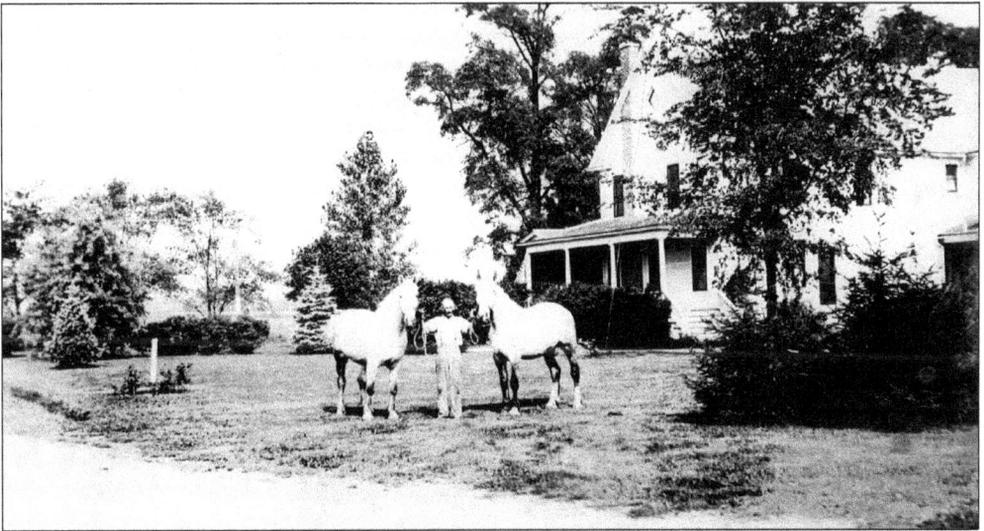

PROUD OWNER, 1918. Harry Wattles, who owned this house and the land around it on the southeast corner of Livernois Road and Wattles Road, was also the proud possessor of these huge draft horses; their names were Dick and Dennis. In 1915, American farmers owned 20 million horses to pull farm machinery, but as a farm boy Henry Ford had disliked them. From about 1916 onwards, he had his engineers at work designing an affordable tractor that could replace horses. (Image donated by Morris Wattles.)

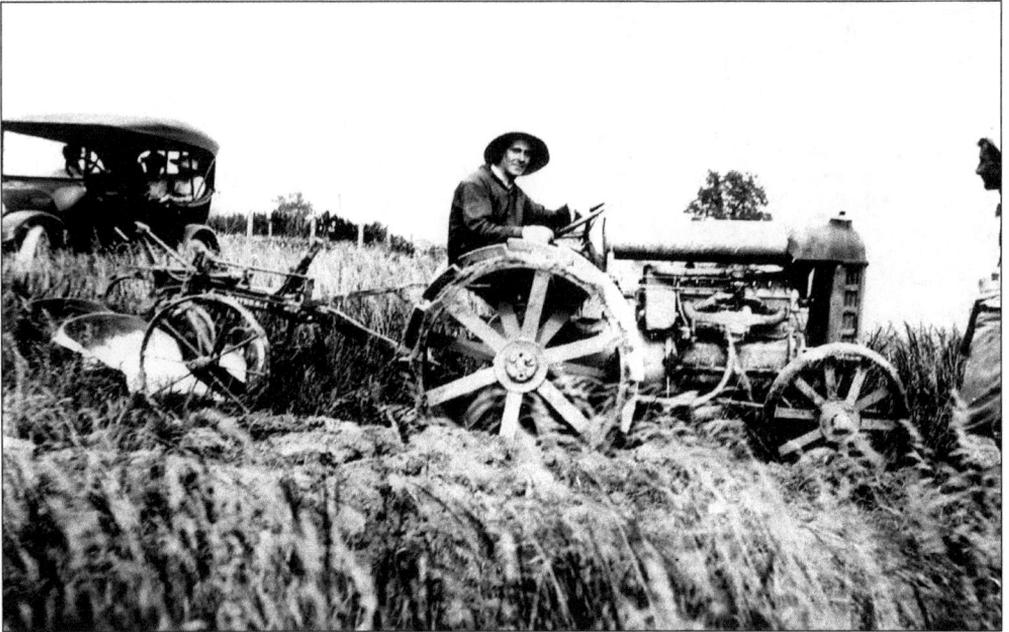

WILLIAM LAKIE, c. 1920. Mr. Lakie moved to Troy in 1866 and bought his property east of present day Livernois Road and north of Wattles Road in 1912. He and his wife Esther (Niles) raised five children there. In this photo he sits on the earliest Fordson tractor (Model F), dating from 1918. The side panels of the radiator make it easy to identify. Henry Ford set up a separate company, Henry Ford and Son Corporation, to make tractors in 1917; production was at Dearborn. (Image donated by Emerson Unitarian Universalist Church.)

MEAT DELIVERY, c. 1920. Not everything was mechanized. Hardy Korff from Rochester is seen here at the Lakie farm making a meat delivery in his horse-drawn wagon. The barn that William Lakie built is in the background. (Image donated by Emerson Unitarian Universalist Church.)

STEAM ENGINE, c. 1920. Workers on the Lakie property stand in front of a steam engine. Wood was burned in the firebox to heat water in the tank. The resulting steam powered the belt that ran between the top wheel and a threshing machine. Such machines were often rented at harvest time. They were too expensive for most farmers to own. The D.U.R. tracks are visible in the foreground of the photo. (Image donated by Emerson Unitarian Universalist Church.)

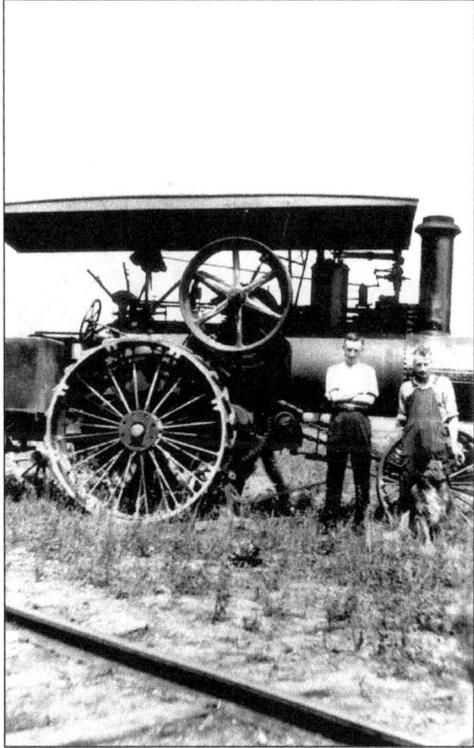

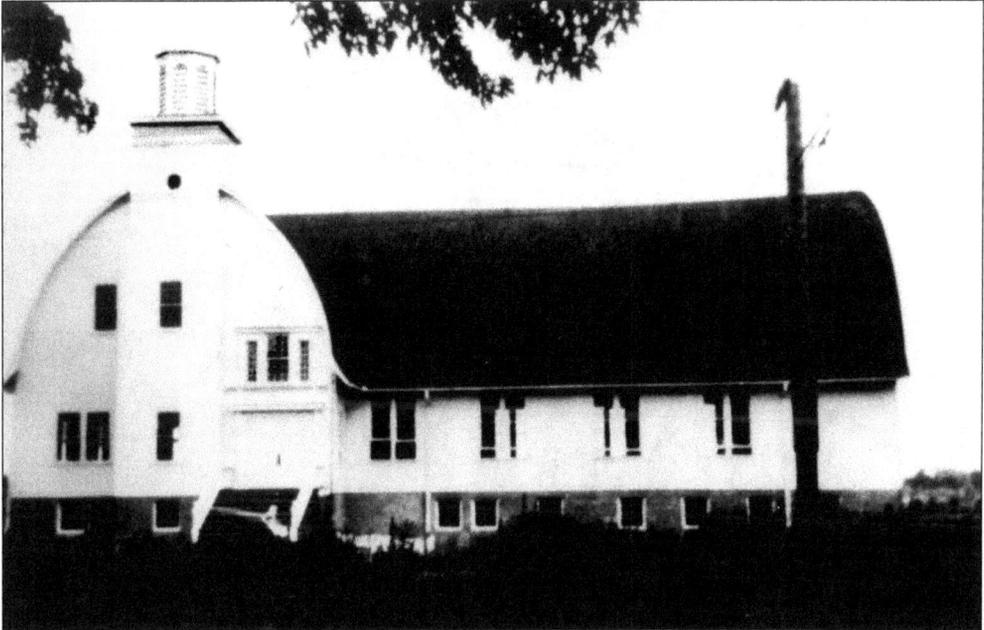

ADAPTIVE REUSE, c. 1928. The Presbyterian Church purchased the Lakie barn in 1928 and converted it for worship. They removed the silo and added a steeple and an appropriate entrance. The hayloft became the chancel. The structure still stands as a familiar and much loved Troy landmark and is today an Emerson Unitarian Universalist Church. (Image donated by Emerson Unitarian Universalist Church.)

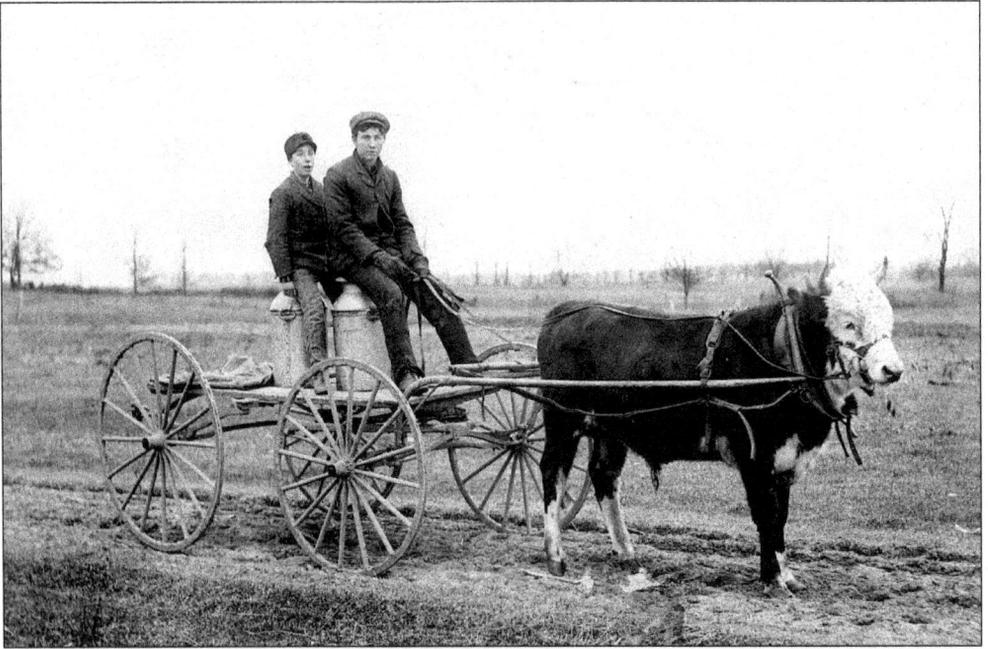

OX CART. Two boys, Samuel and Earl Halsey, carry milk cans either to the road or back to the dairy barn for refilling. The Halsey family farmed land at Livernois Road and Maple Road. In later life Earl worked for the D.U.R. and had many vivid memories of those days. He remembered one occasion when a Halloween "trick" caused great inconvenience to people both on and off the track. Many of the township's outhouses had been dragged onto the line and set ablaze.

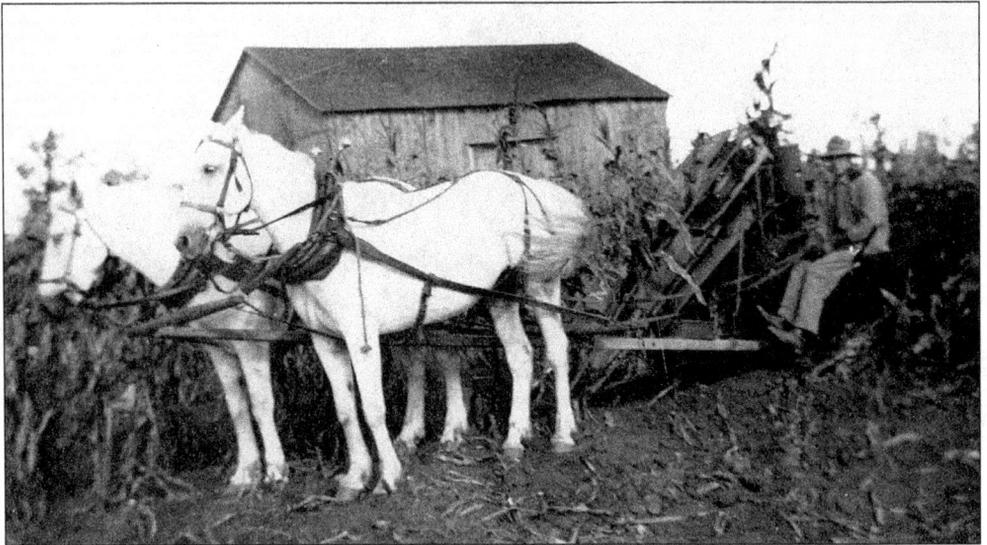

FARMER WITH CORN BINDER, 1920s. This unknown farmer works the land with his matched team of horses and corn binder. The 1877 *History of Oakland County* reported Troy as "one of the foremost farming towns," where "people are noted for their thrifty and industrious habits, which have made them one of the wealthiest communities in the country." Such people would have embraced early mechanization as soon as they could afford it. (Image donated by the Stevens family.)

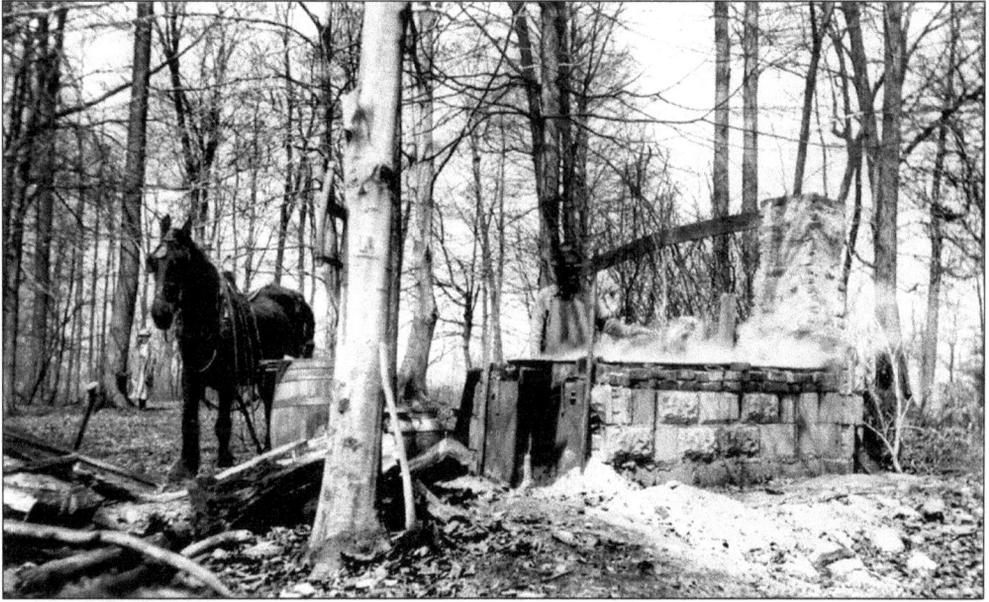

MAPLE SYRUPING IN ELLIOTT WOODS, c. 1920. Jesse Niles, grandson of pioneer Johnson Niles, can be seen in the center behind the evaporator. Jennie Lakie Morrow is in the far left background, to the left of the horse. George Elliott's property was on the west side of Livernois Road, between Wattles Road and Long Lake Road. Tapping the trees each spring to produce syrup was a sure sign that winter was ending. Today, scouts and schoolchildren in Troy still experience the syruping process through special programs at the Troy Nature Center. (Image donated by Emerson Unitarian Universalist Church.)

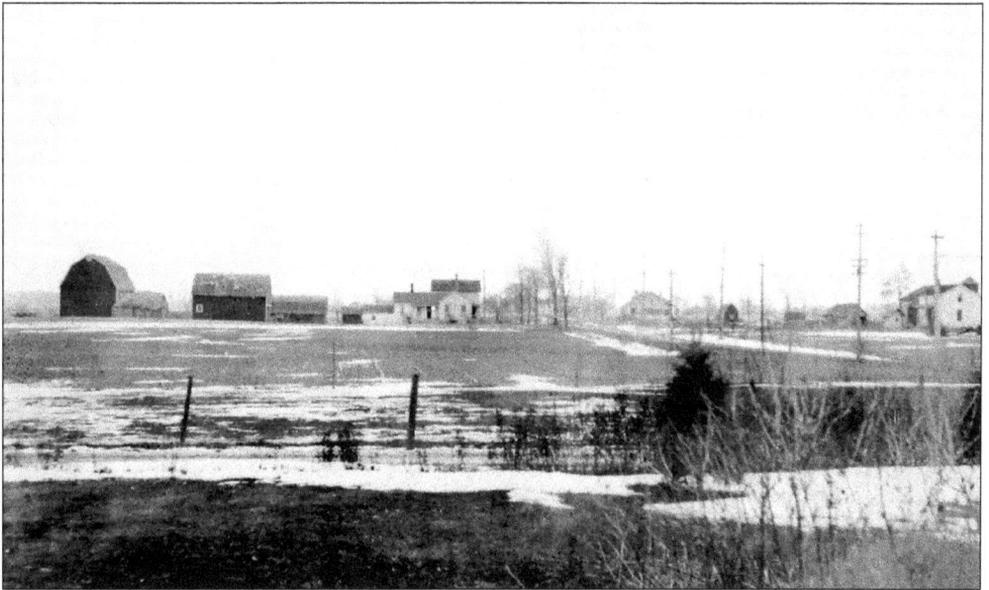

FARMLAND SOUTHEAST OF LIVERNOIS ROAD, c. 1915. This late winter scene shows the view from the Wattles family's Sunnycrest Dairy to the farm that was south of it, probably owned by the Wegners at this time. Today Walsh College and the Zion Christian Church occupy this land. (Image donated by Morris Wattles.)

55

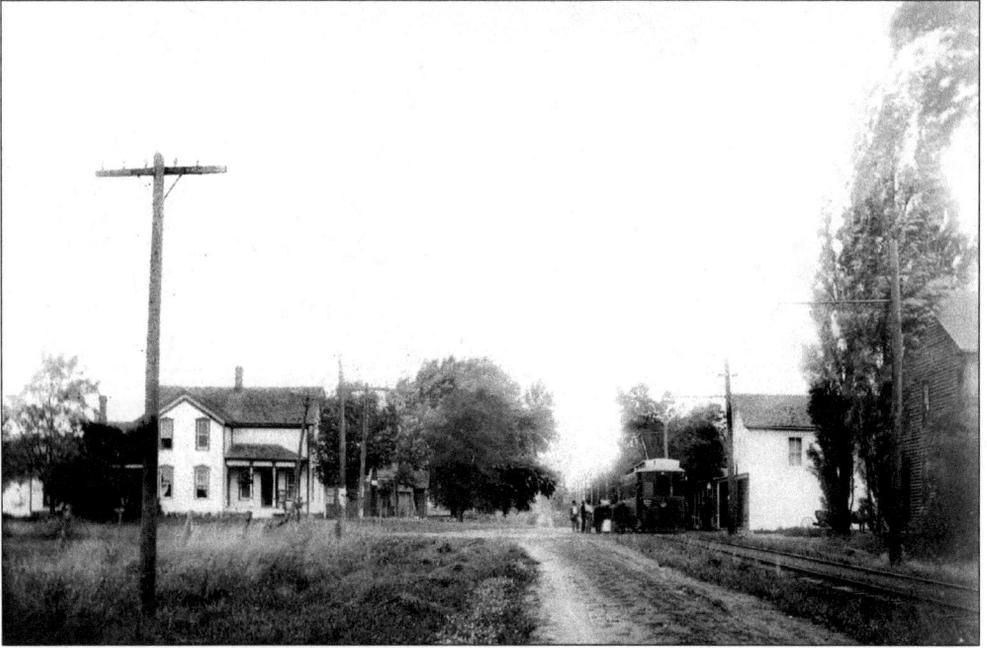

THE D.U.R. STOP AT TROY CORNERS. The D.U.R., or interurban as it was known, changed the nature of Troy after it opened in September of 1899. Farmers were happy to have the cars stop to pick up goods, especially the day's milking, and deliver them to the big city for sale. Socially a D.U.R. trip was often a special treat, whether it meant a picnic in Royal Oak or a long ride to Detroit for a hot fudge sundae at Sanders. (Image donated by David Tinder.)

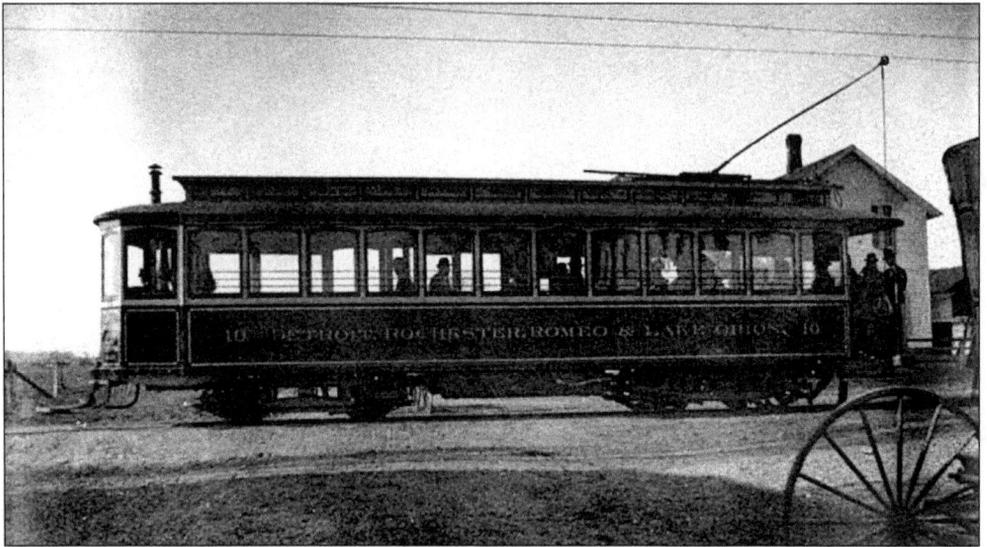

KUHLMAN CAR AT TROY CORNERS. The car shown here may be one of the Kuhlman Car Company cars that ran along the line that went through Troy. Each car, painted maroon and tan, was approximately 45 feet long and seated 54. Note the trolley pole at the back of the car; it attached to electrical wires to provide the power used to run the car. Occasionally these poles broke, and conductors had to balance on the moving car's roof and hold the pole in place. (Image donated by Joyce Harrison.)

THE SUNNYCREST D.U.R. STOP. The Wattles family farmed just south of the intersection of today's Livernois Road and Wattles Road. Harry Wattles sold part of his land (and persuaded his neighbors to do the same) so that the line could go through this part of Troy; the stop was named after his dairy farm. The milk from the Wattles' prize Jersey herd was collected daily and taken to Detroit for use at the Herman Kiefer Hospital. Shown left to right are, Harry Wattles, Helen Mary Wattles, Fanny Bittner, Dorothy Giddings, Charles Bittner, and Mattie Wattles. (Image donated by Morris Wattles.)

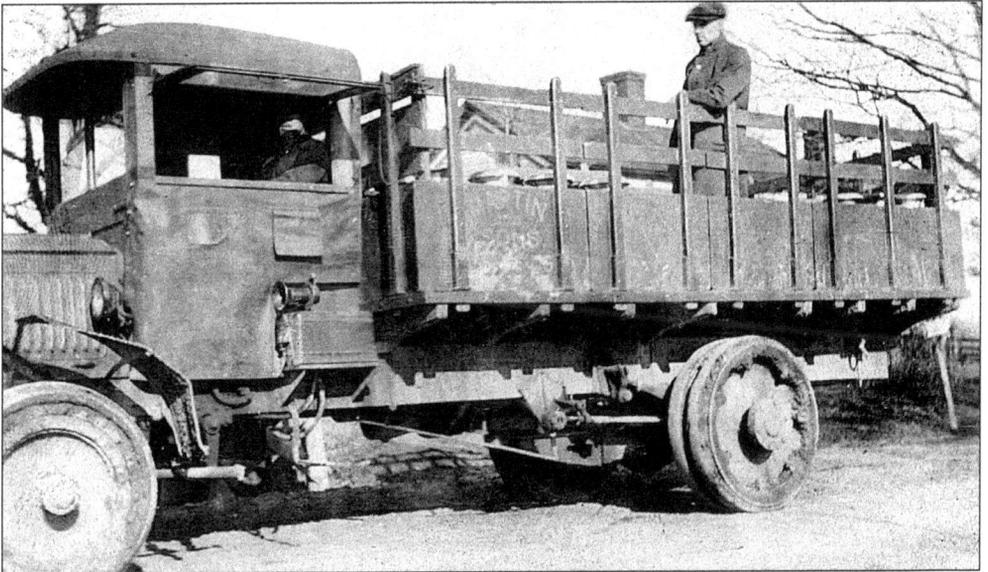

MARTIN & SONS MILK TRUCK, c. 1920. Farmers who were not lucky enough to be positioned right on the D.U.R. line could contract with the Martin trucking business to pick up their ten-gallon milk cans from a platform beside the road. The Martins would then transport the milk to the railway line. (Image donated by Mrs. Llewellyn Clark.)

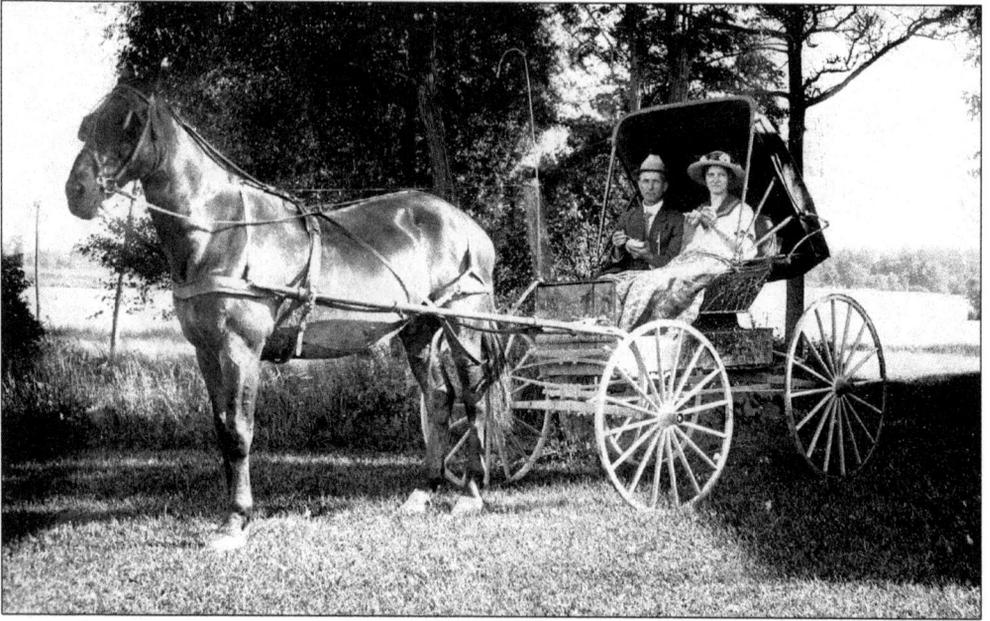

SUNDAY BEST, c. 1910. Every farm still relied on the horse for many things and this Troy family photo shows both beast and owners ready to enjoy their weekly day of rest. The horse has been brushed until he gleams in the lazy sun of a summer afternoon, and the couple appears to be eating ice cream, a delicacy in an era without refrigeration. (Image donated by the Stevens family.)

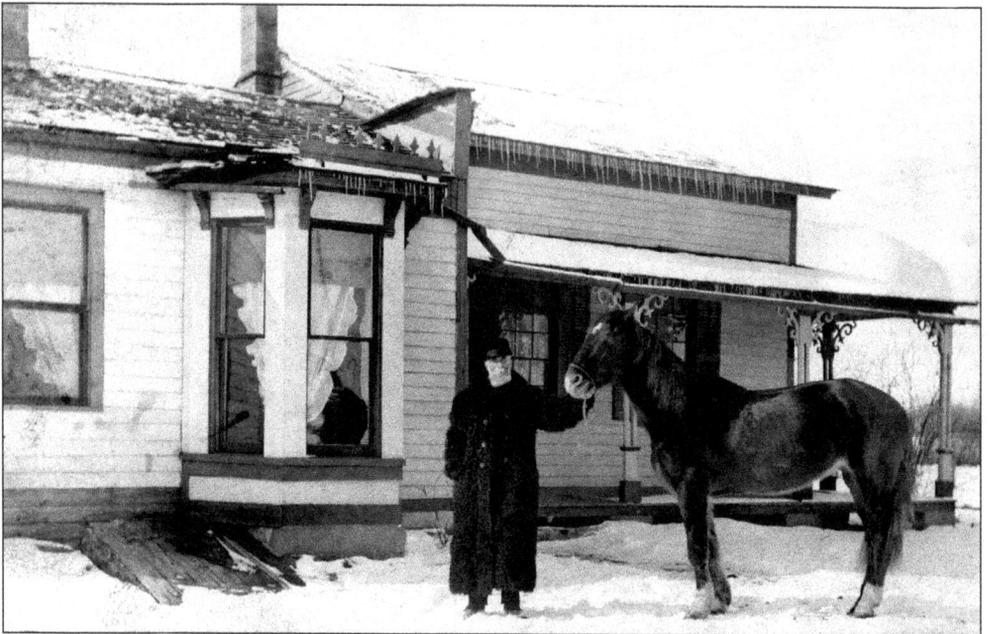

CHAIN LIGHTNING, 1920. The back of this photo postcard taken in Troy and sent to a Mrs. Jennings in Florida reads: "Dear friend, I am glad you are where it is nice and warm for it has been quite cold here and there is lots of sickness, flue [sic] and pneumonia. . . . This is a side view of our little house in which we lived before we moved to the city, and the horse we had at Troy 'Chain Lightning.' Sincerely yours, Mrs. B. Reeve." (Image donated by David Tinder.)

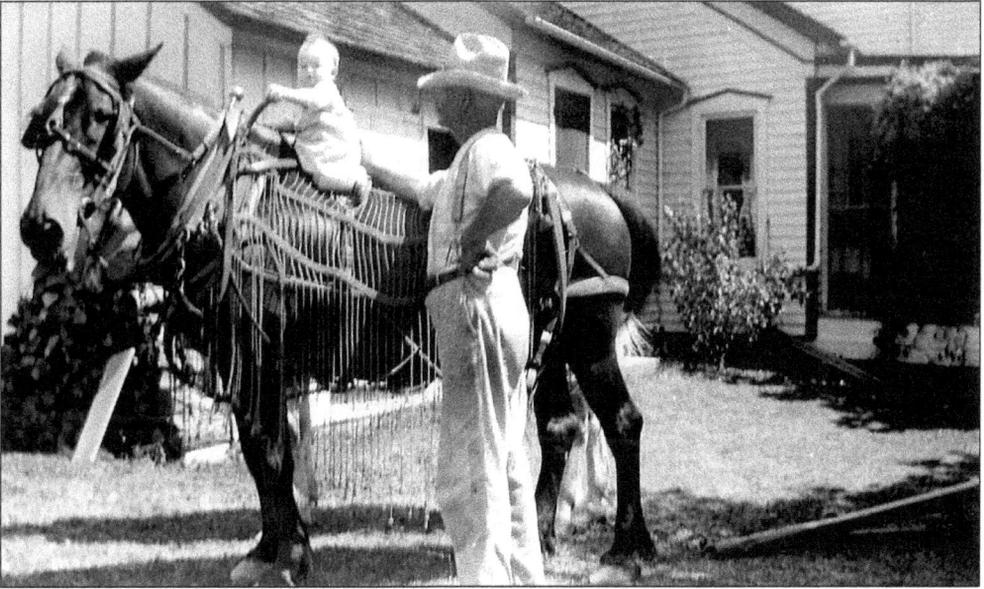

FLY NETTING, 1923. Farm ways were learned at an early age. Here Charles Aspinwall introduces his granddaughter, Desda Terry, to riding. Note the horse's fly netting, a leather fringe draped over its back to protect it from bites in the hot summer sun. (Image donated by Viola Aspinwall Smith.)

MADDOCKS FAMILY, c. 1920. Financially successful families took to the automobile with gusto. Shown here is the Maddocks family on their farm, which stood just west of Rochester Road on Big Beaver Road. Pictured from left to right are: (front row) Uncle Bert, Gypsy the dog, and Walter Miller; (middle row) Minnie Miller, Tom Maddocks at the wheel, and Della Kampe; (back row) Esher Forsythe holding Ruth Miller, Dolly Forsythe, and Lottie Maddocks Miller. Tom owned Big Beaver's first butcher shop and Lottie owned Troy's first beauty shop. Walter ran Miller's Bar. (Image donated by Ruth Wass.)

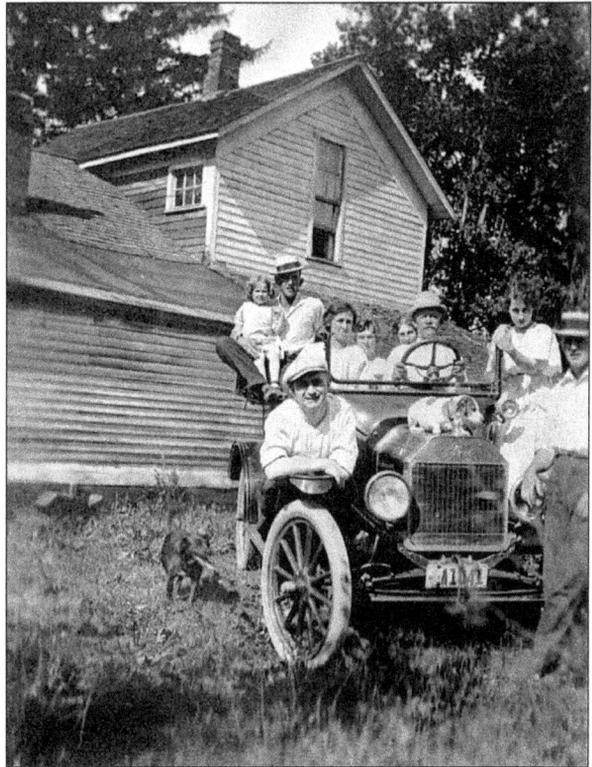

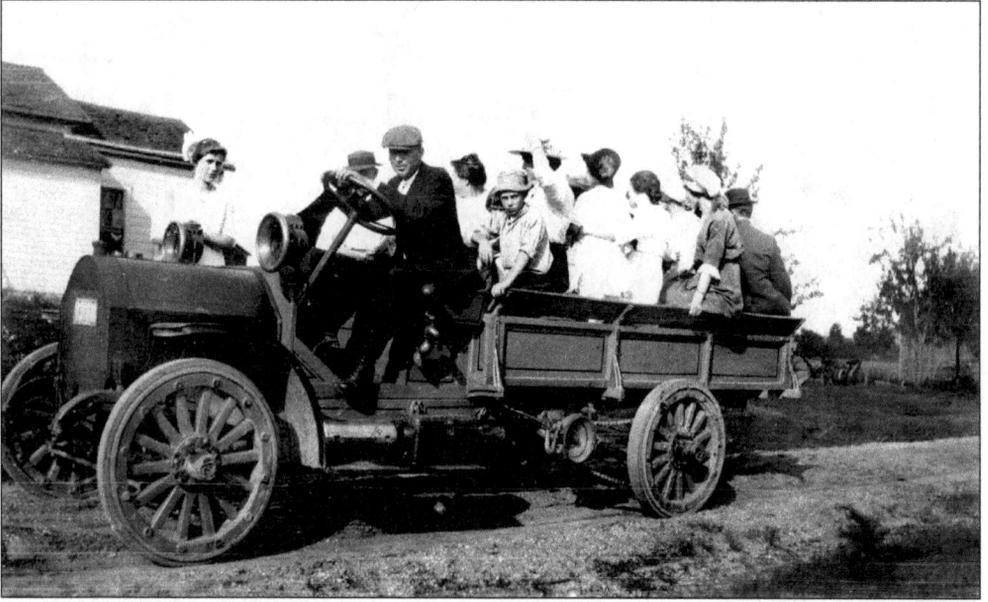

SUMMER OUTING, 1915. Farm and commercial vehicles could also be used for fun. Here a whole party of young people is setting out on an outing of some kind. From the look of the people who have their backs to the viewer, it seems that someone was taking a photo from the other side of the truck. The only identified person in the picture is Gerald Cole, the boy who sits behind the driver. (Image donated by Gerald Cole.)

BIG BEAVER CAR BOYS, c. 1920. Shown left to right are Harry Schultz, Jay Brenner, and Walter Miller posing with Walter's first car, which the back of the photo notes was the second car in Big Beaver. Harry and his wife Margaret owned the first. Harry used it to commute to his job as a real estate agent in Detroit and would give a ride to anyone who showed up at his house in the morning because they needed to shop in the city. The date is uncertain but the car appears to have wheels with wooden spokes. (Image donated by Ruth Wass.)

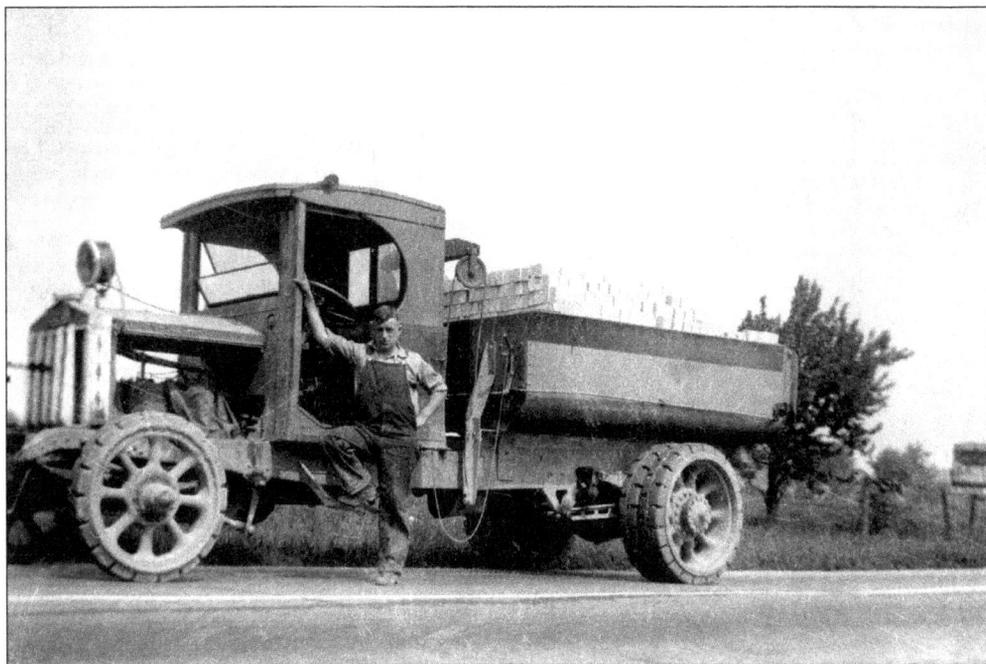

HAULAGE TRUCK, c. 1924. Charlie Lamb, shown here, worked in construction, including road construction, although most of the roads in Troy remained unpaved for many years after this date. He poses by an early truck used to haul cement blocks. (Image donated by the Stevens family.)

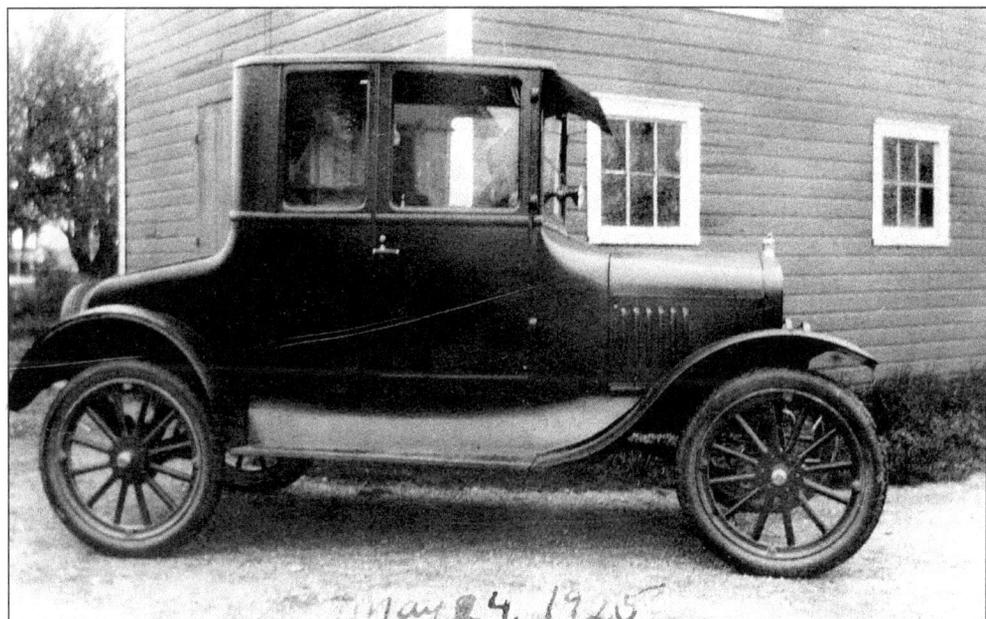

MODEL T COUPE AT TROY CORNERS, 1925. The town's vehicles had to travel along rutted dirt and gravel roads right up until the 1970s. Motorists also had to contend with herds of dairy cows that crossed the roads. Troy still has a few undeveloped streets today. (Image donated by Viola Aspinwall Smith.)

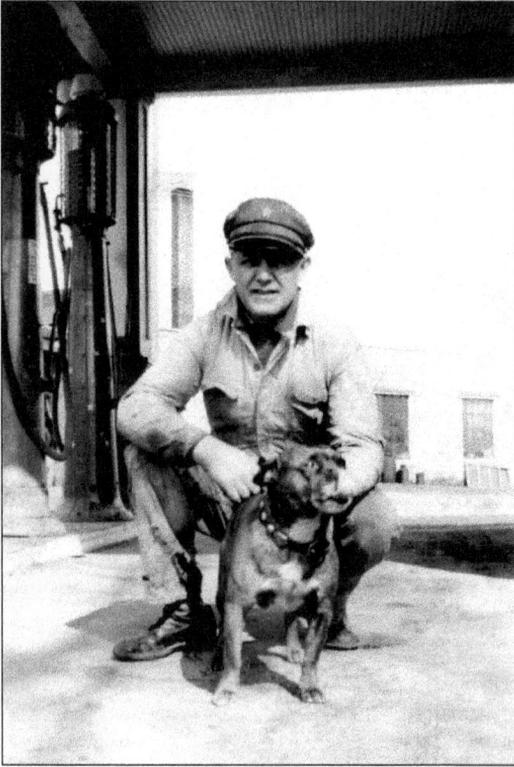

WALTER MILLER AND DUKE. The Miller family lived in Big Beaver Village. Ruth Wass, Walter Miller's daughter, can remember a time when the traffic on Big Beaver Road was mostly horse and buggies and it was safe to play on the roads. Nevertheless, her father owned the first purpose built gas station in the area. He's shown here in front of the pumps. He also owned Miller's Bar and Pool Room, later called Doc-its Club, and today, the Wagon Wheel. Walter became welfare supervisor of Troy and later township supervisor. (Image donated by Ruth Wass.)

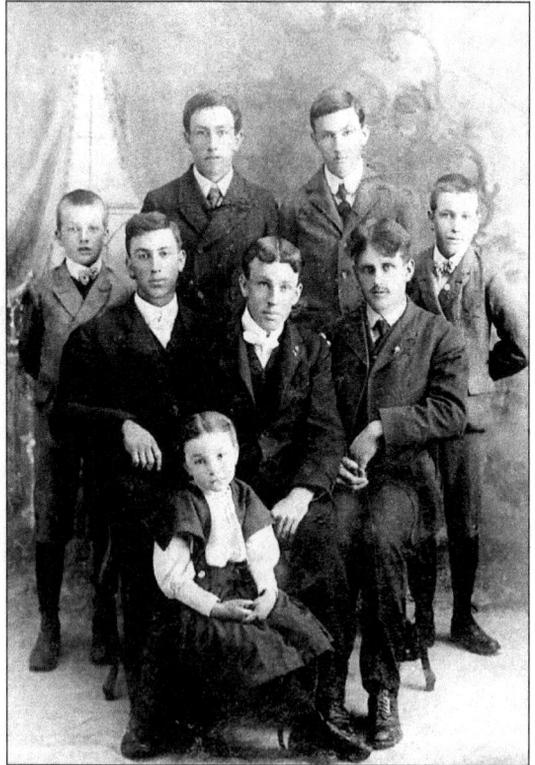

THE HALSEY CHILDREN, c. 1905. The eight children of Payson and Emma (Lamb) Halsey, a Troy farming family, are shown in this studio portrait. Pictured from left to right are the following: (front) Vera Joy; (middle row) Howard, Lee, and Frank; (back row) Arthur, Earl, Sam, and Mark. (Image donated by Morris Wattles.)

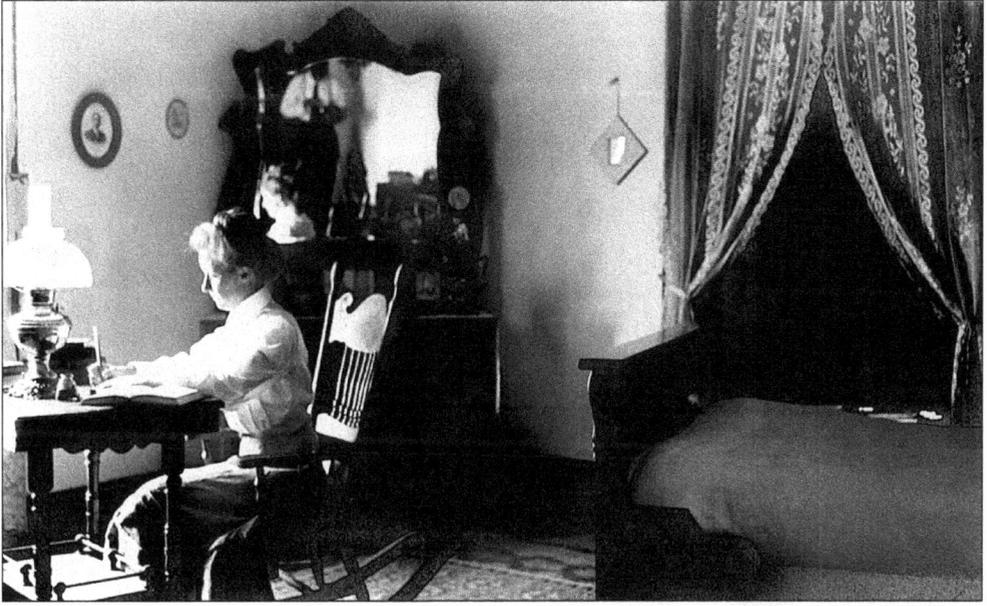

INEZ CASWELL, c. 1905. In this unusual domestic interior, Inez Caswell, granddaughter of Troy pioneer Solomon Caswell, is seen in the bedroom of her home on Adams Road. It offers a tantalizing glimpse into the decor that would have been typical of the time. Visible in the mirror of the dresser is the presumably amateur photographer. He may have been Inez's brother William. Both were unmarried and taught school in Detroit. When William died, the house passed out of the family's ownership.

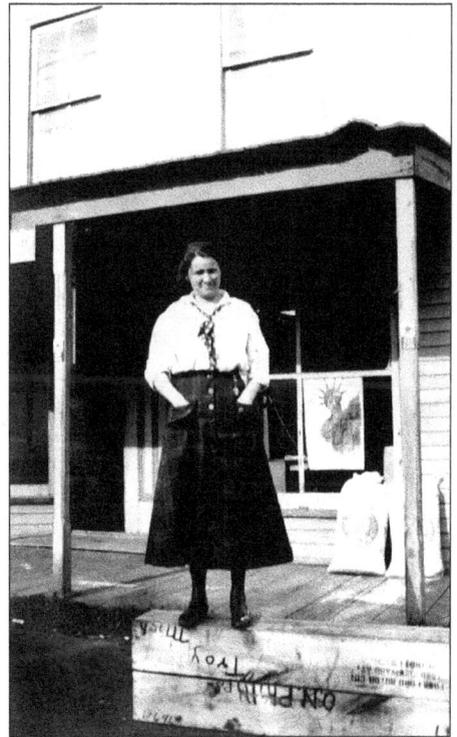

BILL BOISE. A local "character" Bill (actually Wilhelmina) Boise stands in front of the store at Troy Corners. Since this was a D.U.R. stop, the crate was probably to ease the transition from ground level to car height. The sacks on the porch are bread flour; the poster in the window is an entreaty to buy WW I war bonds. (Image donated by Viola Aspinwall Smith.)

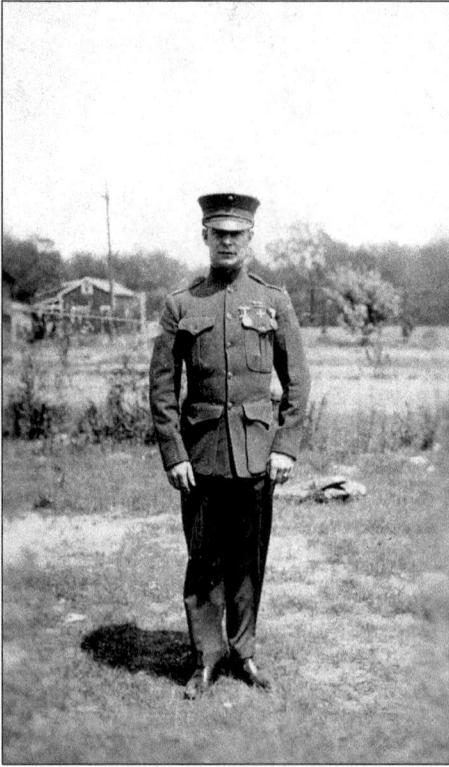

EDWARD ALBERT BUEHLER. Mr. Buehler served as a Marine in WW I and is shown here in his uniform, complete with decorations, including a sharpshooter badge and the Good Conduct Medal. In later years he opened a saltwater swimming hole on the family property, which became a popular recreation spot in Troy. His daughter and her husband later took over its management. (Image donated by Mr. and Mrs. R. Moser.)

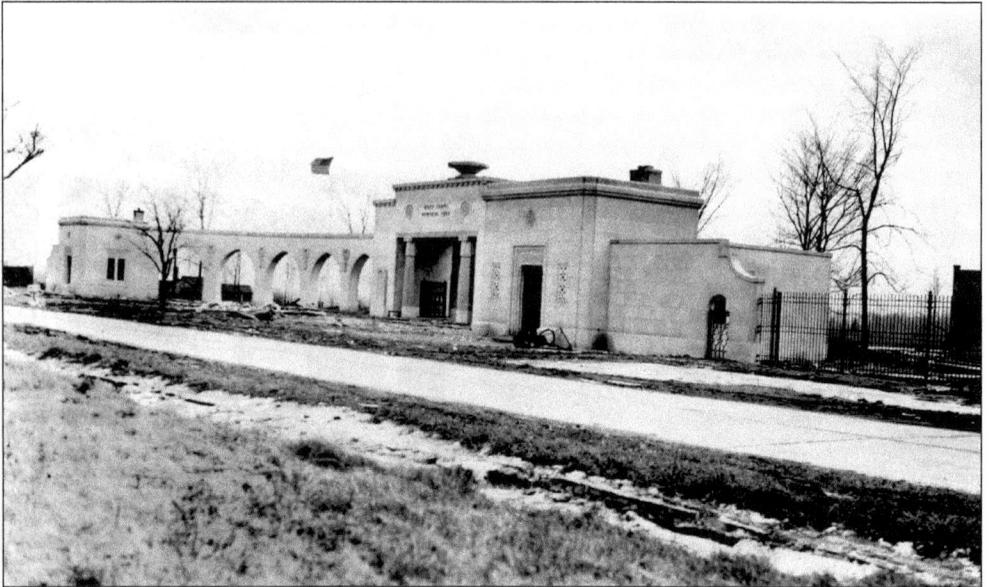

WHITE CHAPEL CEMETERY UNDER CONSTRUCTION, c. 1926. By the middle of the 1920s, Troy was changing. The oncoming depression forced many farmers into bankruptcy. The first subdivisions appeared on plat maps. Construction of White Chapel Cemetery began in 1925. It was built on farmland previously held by the Pearce and Daniels families. (Image donated by David Tinder.)

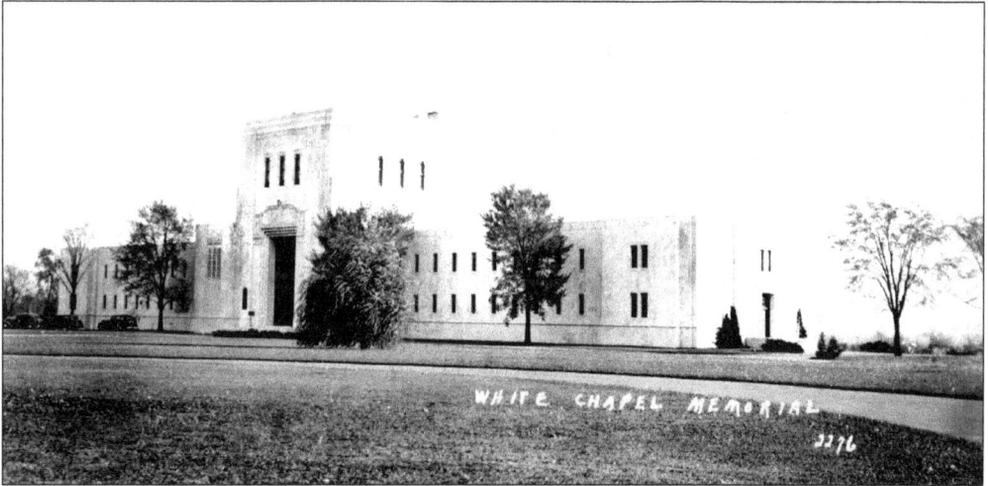

WHITE CHAPEL MAUSOLEUM. In addition to outdoor burial plots White Chapel offered mausoleum space from 1929 onwards. Some members of the Daniels family, including the grandson and great-grandsons of Benjamin Daniels—who in 1837 purchased the land the cemetery stands on—are entombed there. The most famous family in the mausoleum is the Booth family, Detroit newspaper owners. It costs more for space in the mausoleum, but the cemetery does offer niche space for those who favor cremation. (Image donated by David Tinder.)

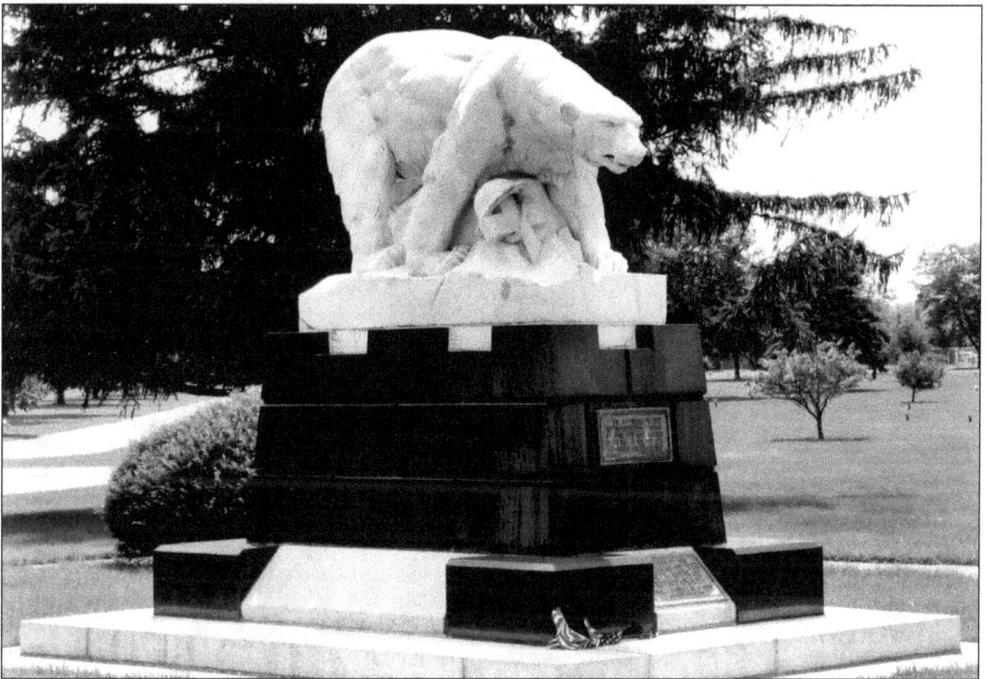

POLAR BEAR MONUMENT. The Polar Bears were members of the 339th Infantry Regiment who fought in northern Russia in 1918 and 1919 along with British forces and Russians opposed to the Bolshevik government. Veterans of the regiment held their first reunion in Detroit in 1922. In 1929 an expedition was organized to recover the bodies of American soldiers buried in Russia. Of the 86 bodies recovered, 56 were buried in a circle around this monument in White Chapel Cemetery on May 30, 1930. (Photo by Laura Freeman.)

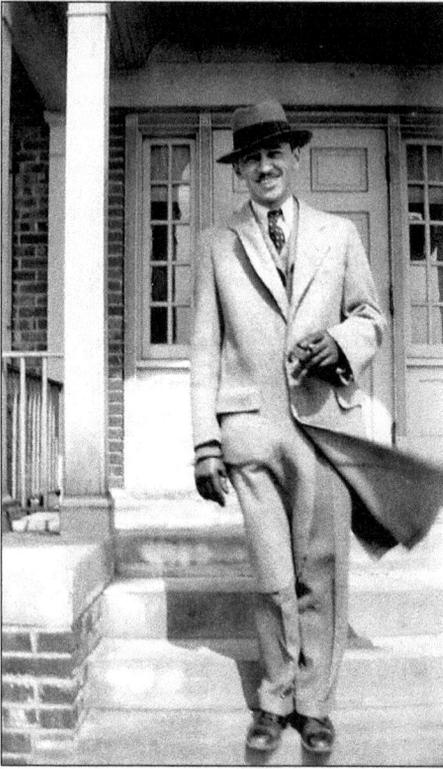

MORRIS WATTLES, 1928. A very dapper township supervisor, Wattles is photographed here on the steps of the then new Township Hall. Troy was expanding at this time and most people considered the old hall inadequate. It consisted of one room and a bathroom. There was a group that opposed the new construction, and *The Times Retailer* of March 18, 1927 reported a very lively Republican caucus meeting with John Truesdell leading the "Big Beaver faction." Mr. Truesdell lost the nomination to incumbent supervisor Morris Wattles, 357 to 186. The project went ahead. (Image donated by Morris Wattles.)

HARVEST TIME, c. 1928. In the fields of Harry B. Wattles on the southwest side of Livernois Road and Wattles Road, unidentified young people are shown gathering grain. In the background stands the recently constructed township hall. (Image donated by Morris Wattles.)

Three

TROY IN TRANSITION
1930–1954

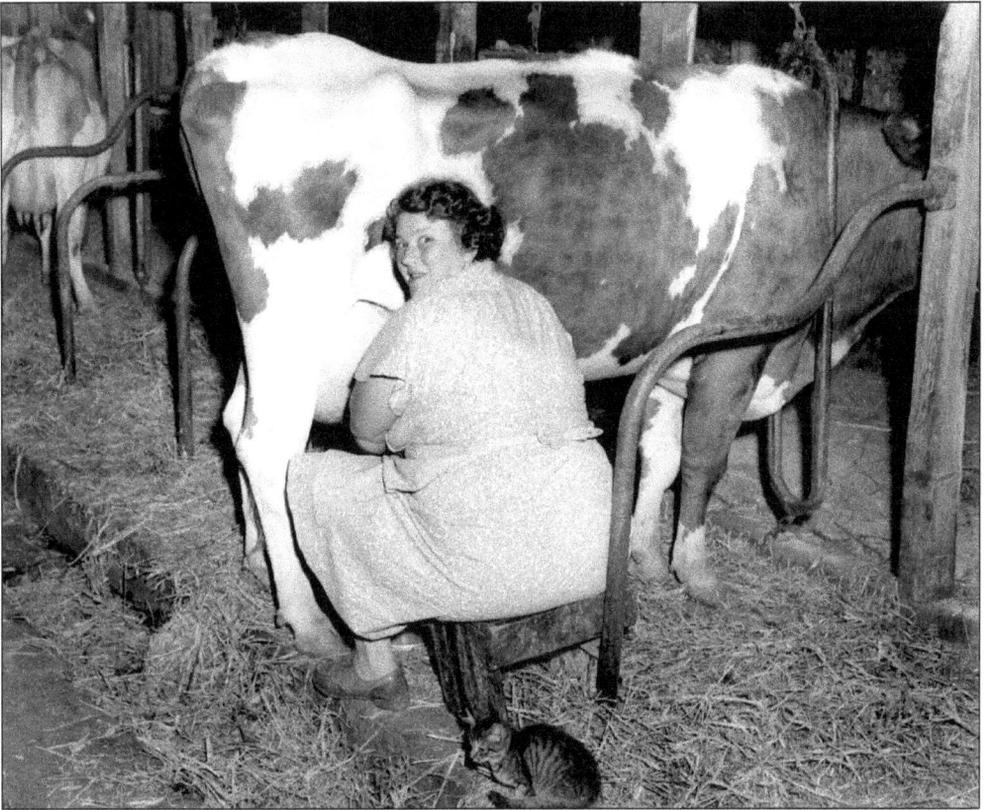

MILDRED HILDEBRANDT MILKS A COW. In this typical farm scene, Mrs. Hildebrandt is milking a cow while the tabby kitten in the foreground awaits a shot of milk directly from the source. Dairy and mixed farming would continue in Troy into the 1960s, but increasingly, the families who managed to hold onto their land during the Depression sold out to developers providing housing for the workers of the booming auto industry. Mrs. Hildebrandt was a member of the Order of the Eastern Star, and her husband was a member of the Masonic Temple. (Image donated by Lois Ballard.)

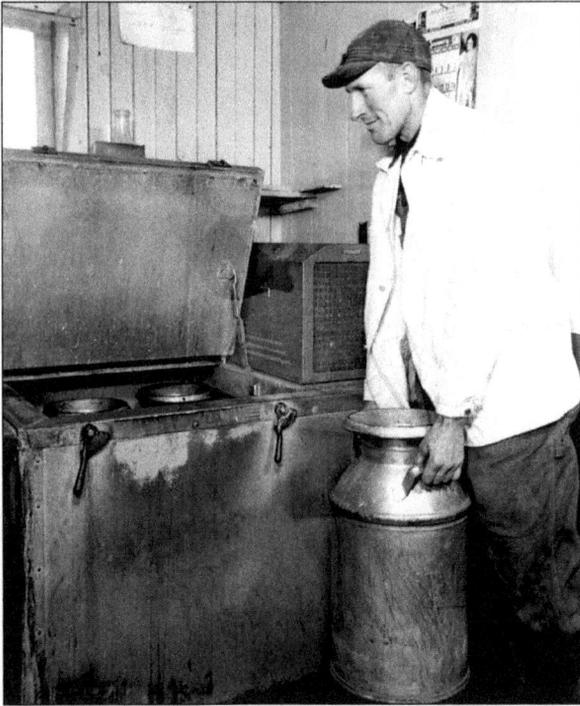

FRED HILDEBRANDT. Vera's husband Fred is shown here with his milk can and cooler. By this time, most milking was done mechanically. The Hildebrandts kept up to 30 Guernsey cows and the cooler could take care of 40 gallons of milk for their over-the-counter retail trade. Fred was very active in the Republican Party, and he became the first city treasurer of Troy as well as an Oakland County commissioner. The Hildebrandts were lifelong members of the Big Beaver United Methodist Church. (Image donated by Lois Ballard.)

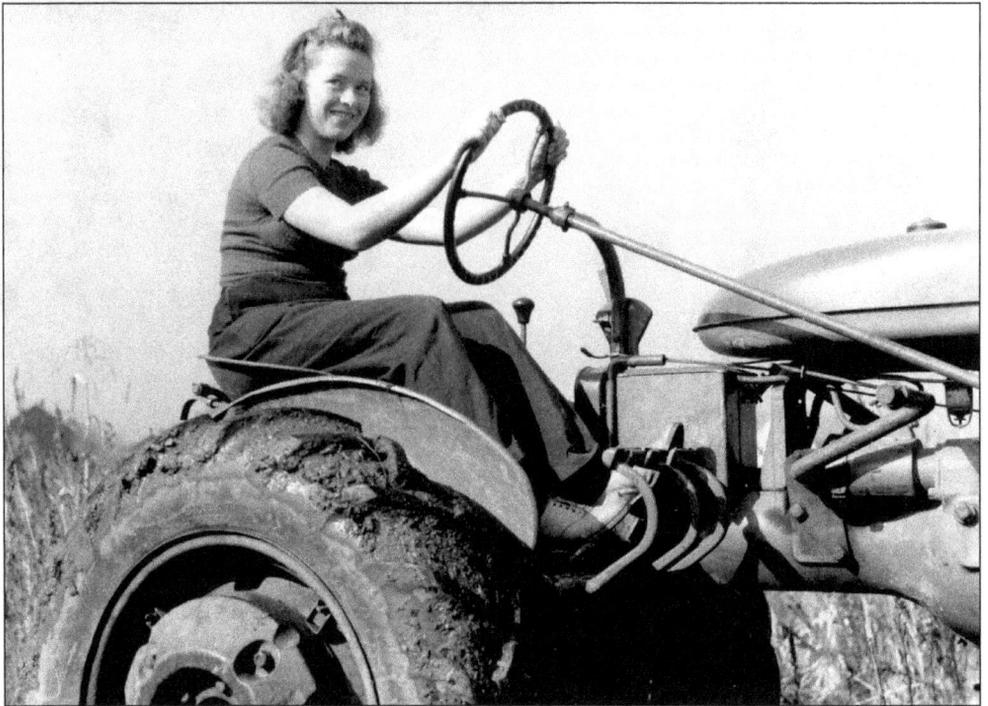

LOIS HILDEBRANDT. Showing off her tractor driving skills on her folks' farm, Lois (later Mrs. Ballard) was photographed by a magazine. The Hildebrandts saw their farmland at today's Maple Road and Stephenson Highway evolve into an industrial/office complex and a hotel. (Image donated by Lois Ballard.)

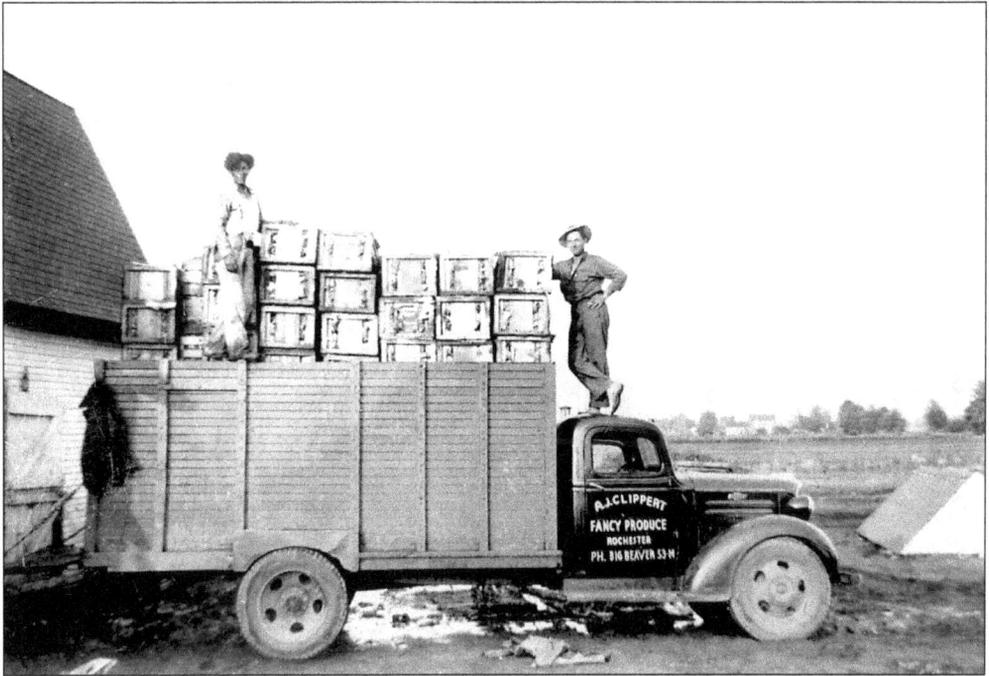

TRUCK FARM, 1940. The advent of the auto made possible the development of truck farming for many Troy landholders. Shown here are left to right, Forrest Clippert and father Alvin Clippert. They supplied the local A&P and Kroger stores with vegetables. The Clippert farm stood next to what is today Wass Elementary School. (Image donated by Ruth Wass.)

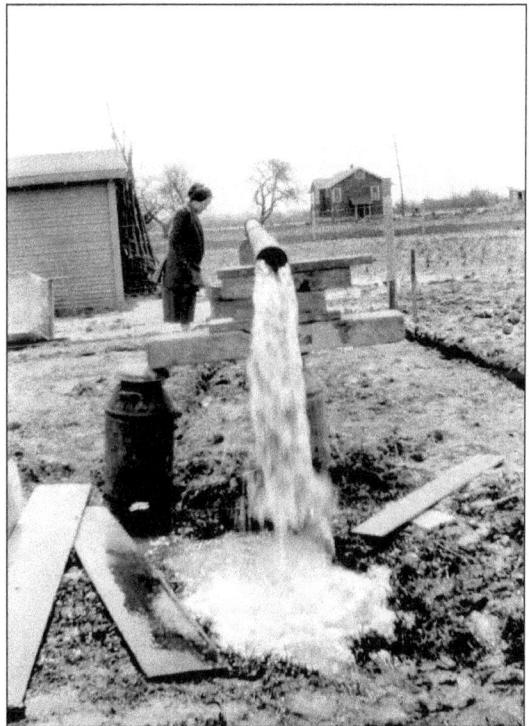

ARTESIAN WELL. Although Troy had few streams, farming was possible because of the availability of underground water. In the area northwest of Troy Corners where this photo was taken it was particularly abundant. Water sat so close to the surface that wells were often struck accidentally and had to be capped. This problem abated as more housing was built and the water was used up by the residents. (Image donated by Viola Aspinwall Smith.)

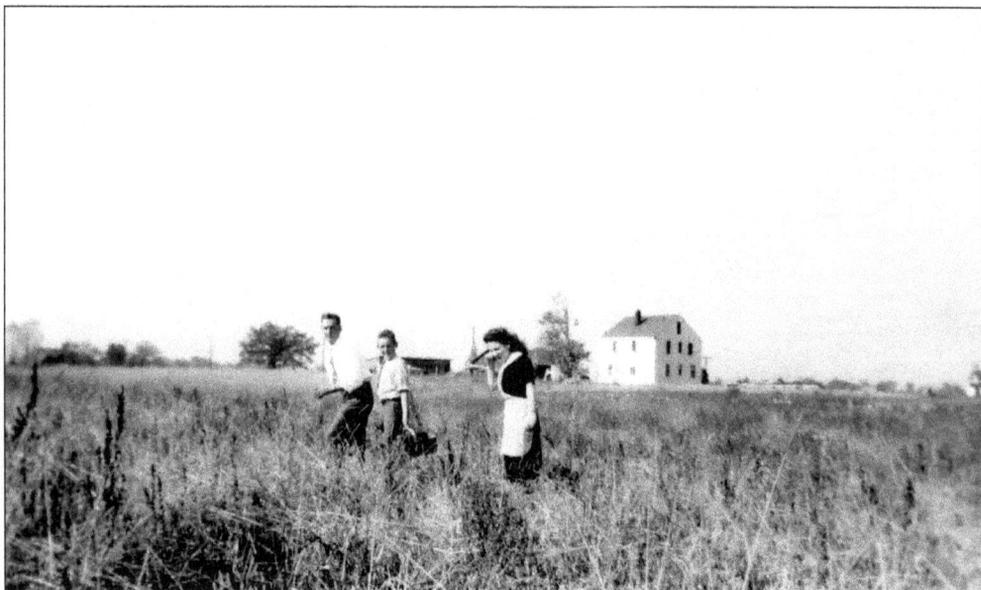

OLIVER FARM, c. 1946. The Oliver family farmed land southeast of Rochester Road and Wattles Road. Ronald Oliver, shown here with his younger brother Edward, married Rose after his service in WW II. (Image donated by Mr. and Mrs. R. Oliver.)

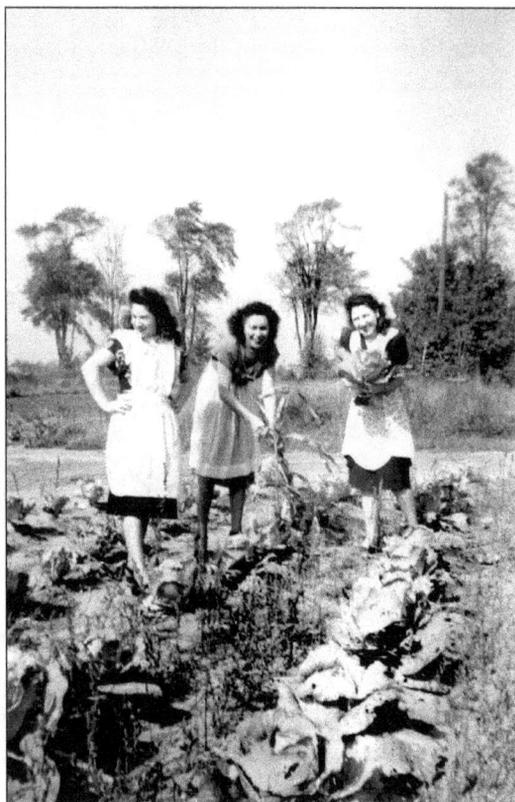

IN THE CABBAGE PATCH, c. 1946. On a visit to the Oliver farm, (left to right) sisters Francis, Ann, and Rose harvest in the cabbage patch. They were Detroit girls, and a journey out to Troy was still at this time very much a trip to the country for city folk. (Image donated by Mr. and Mrs. R. Oliver.)

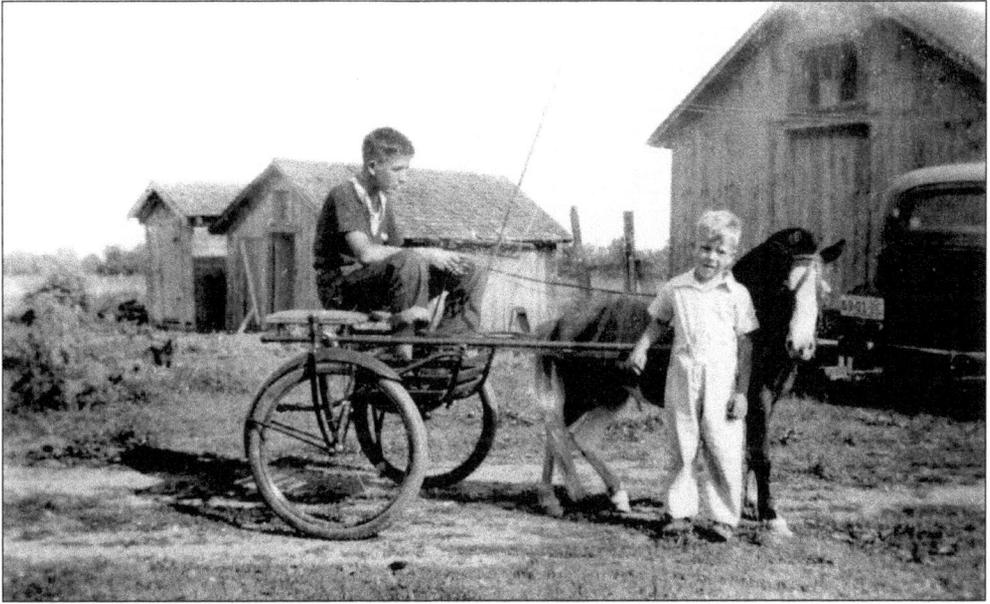

FARM CHILDREN. The children of farm families worked hard at chores before and after school, but kids will always find time to play. In this photo from the 1940s, John C. Truesdell (right) and an unidentified boy enjoy a pony cart ride. (Image donated by John C. Truesdell.)

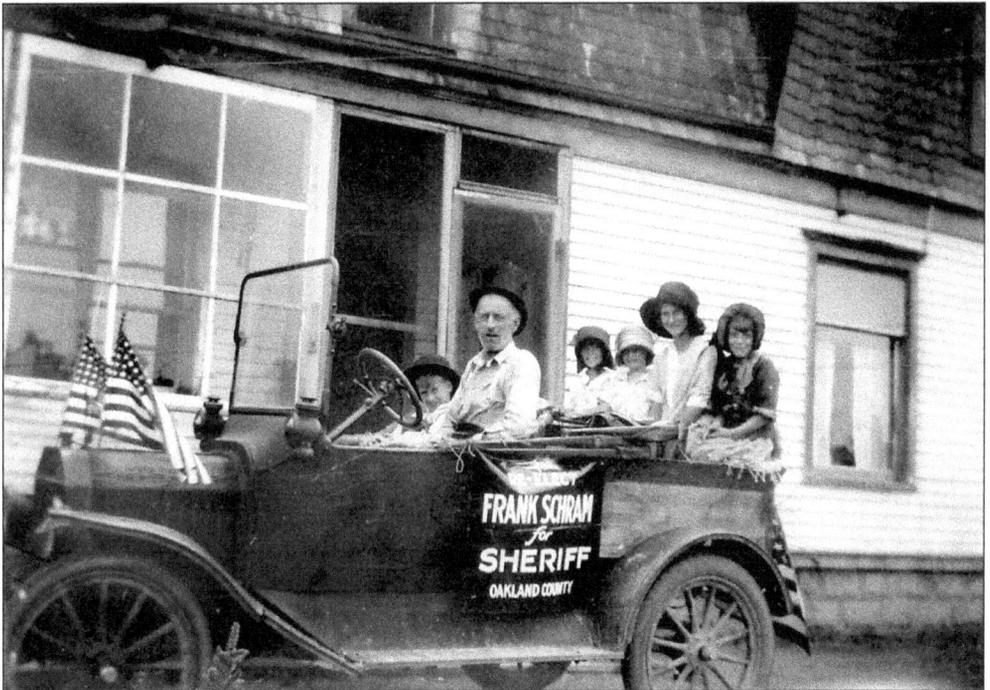

GET OUT THE VOTE, 1928. Frank Schram served as Oakland County Sheriff from 1924 to 1932. Shown here outside the Lamb farmhouse are, from left to right, Harold Stevens, Cyrus Lamb, Beatrice Lockwood, Hazel Lockwood, Mildred Stevens, and Helen Lockwood. All seem ready to set out for a parade. (Image donated by the Stevens family.)

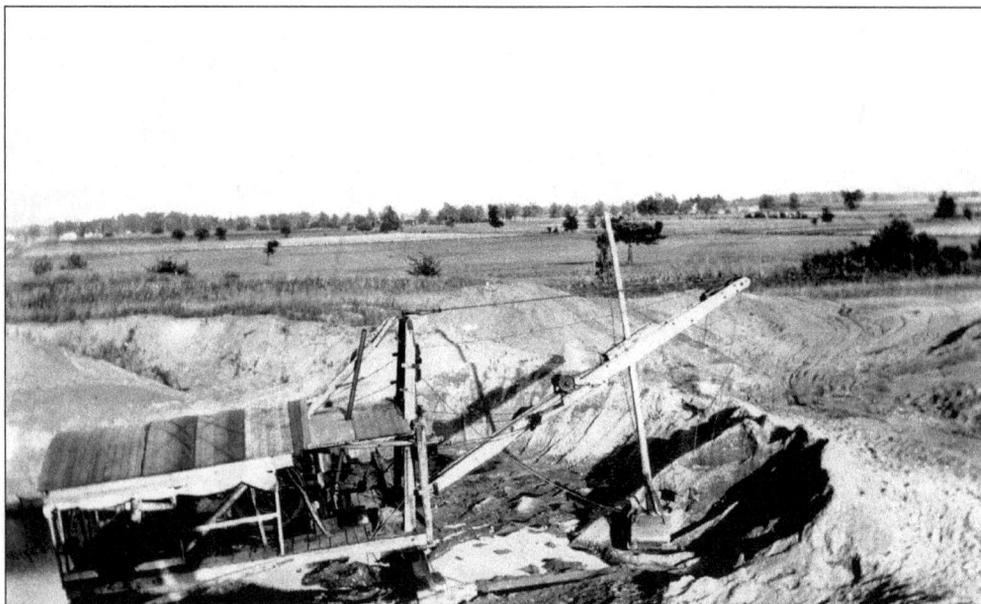

LAND DREDGE. In the 1920s, the Ray Walker Company began mining sand and gravel in an area bounded by Big Beaver and Maple Roads, and Coolidge and Crooks Roads. This large machine is a steam-powered land dredge "with the air conditioning on" as the original caption says. The operation continued throughout the winter with the canvas sides rolled down. (Image donated by Donald Walker.)

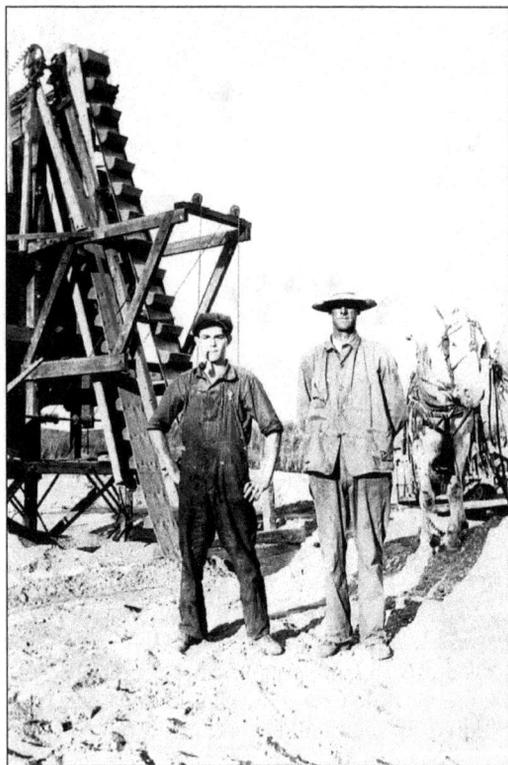

DRY SCREENING PLANT. The mined material was hauled to this machine by horse-drawn wagon to be sorted. Shown at left is Herbert Collins, who started working at the gravel pit at age 13 and stayed there for 42 years. Horses and men could be housed on site with both a barn and a bunkhouse available. (Image donated by Donald Walker.)

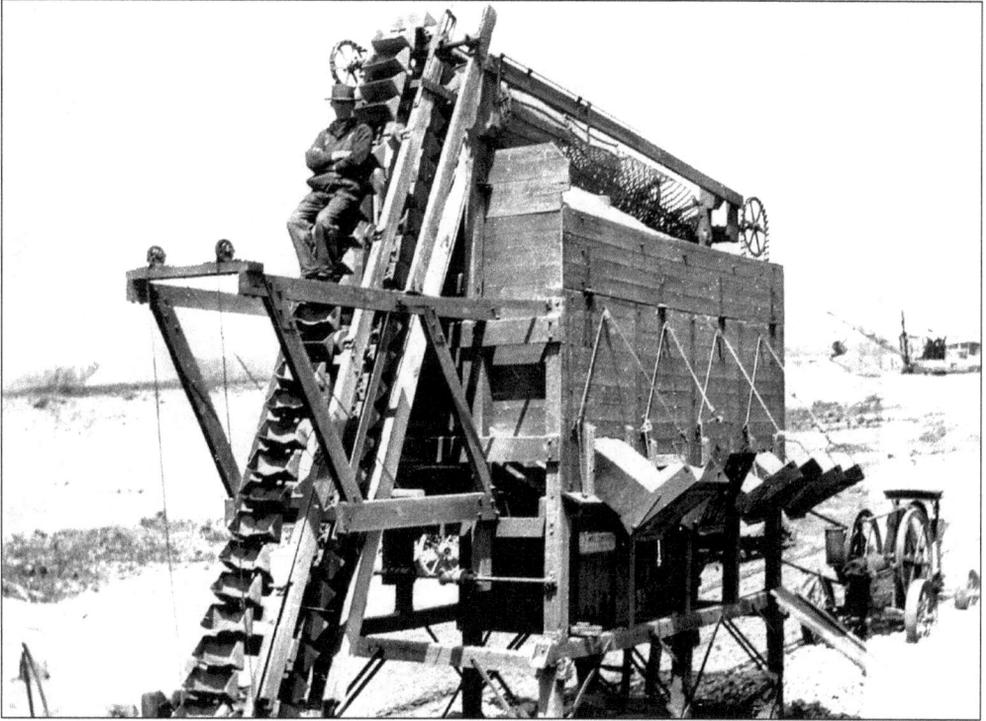

SORTED AND SIZED. This dry screening plant sorted and sized the mix that came out of the ground into the final three or four products that were sold. The buckets on which the man in this photo stands raised the mix to the angled rotating drum screen on top. As the mix traveled the length of the drum, it fell through progressively larger holes and into the appropriate chutes on the side. (Image donated by Donald Walker.)

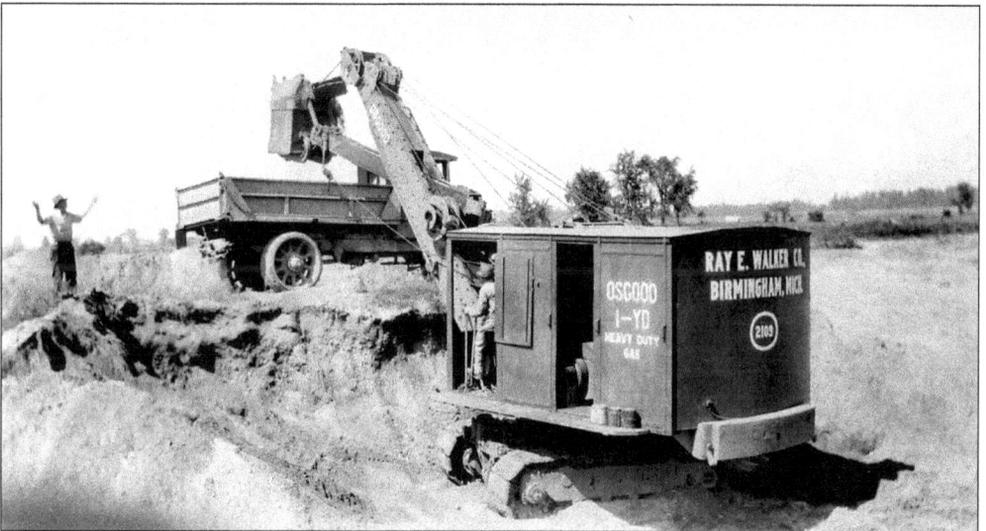

LOAD UP. Although the company's mailing address was in Birmingham, as shown on the back of the truck, the gravel pits were in Troy and remained operational until 1960. This photo shows updated equipment from the 1940s. Prices went up during WW II because of the demand for masonry sand for war factory construction. (Image donated by Donald Walker.)

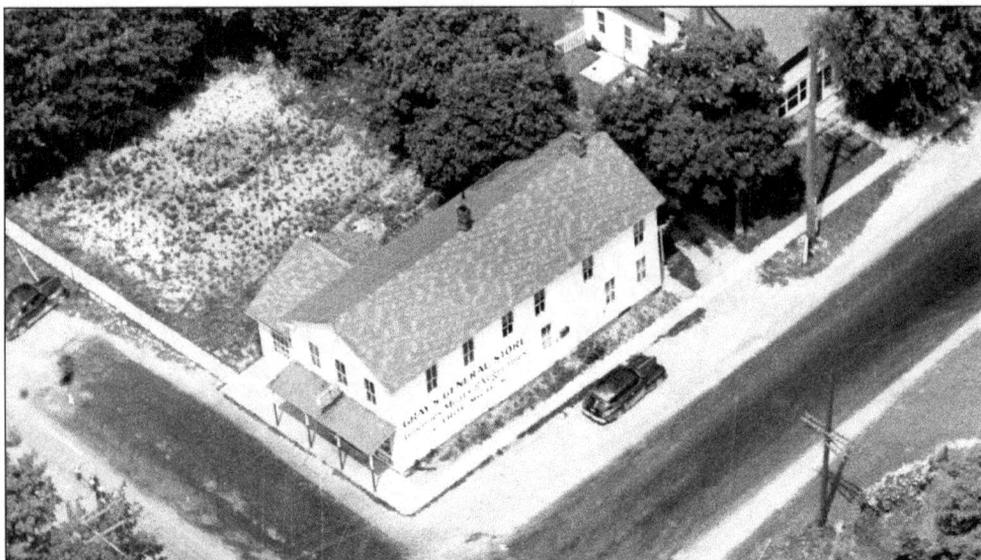

GRAY'S GENERAL STORE, c. 1947. The general store at Troy Corners appears little changed since the time Civil War veteran Franklin Cutting owned it. It still housed the post office (in the small addition to the left of the main building) and was an informal headquarters where folks could catch up on the latest news and gossip. By this date, the D.U.R. lines were gone and the Corners was a much quieter place. Most through traffic now traveled up Rochester Road. (Image donated by Glen Brackenbury.)

TROY CORNERS, 1949. Square Lake Road running west is shown in the top right-hand corner of the photo intersecting at Livernois Road. Nearly all the buildings can be identified; the most important among them, in the top center of the photo, is the home of pioneer Johnson Niles, owned at this time by the Barnard family. Also visible, on the northeast corner of the intersection, is Gray's General Store in a 120-year-old building. In the bottom left of the photo the cupola of the Troy Methodist Church, the oldest church in Troy, is visible.

TEACHERS ON PARADE. Poppleton School originally stood at Big Beaver Road and Crooks Road. Built in 1877, the brick building served Troy's District 8. This photo shows the teachers of Poppleton School in the 1920s. It may have been taken to commemorate the opening of the new school building in 1925. Shirley Giles Brown, who started school in that year, remembers three classes: first, second, and third grades together; fourth and fifth together; and sixth, seventh, and eighth together. (Image donated by Illa Walker Oaks.)

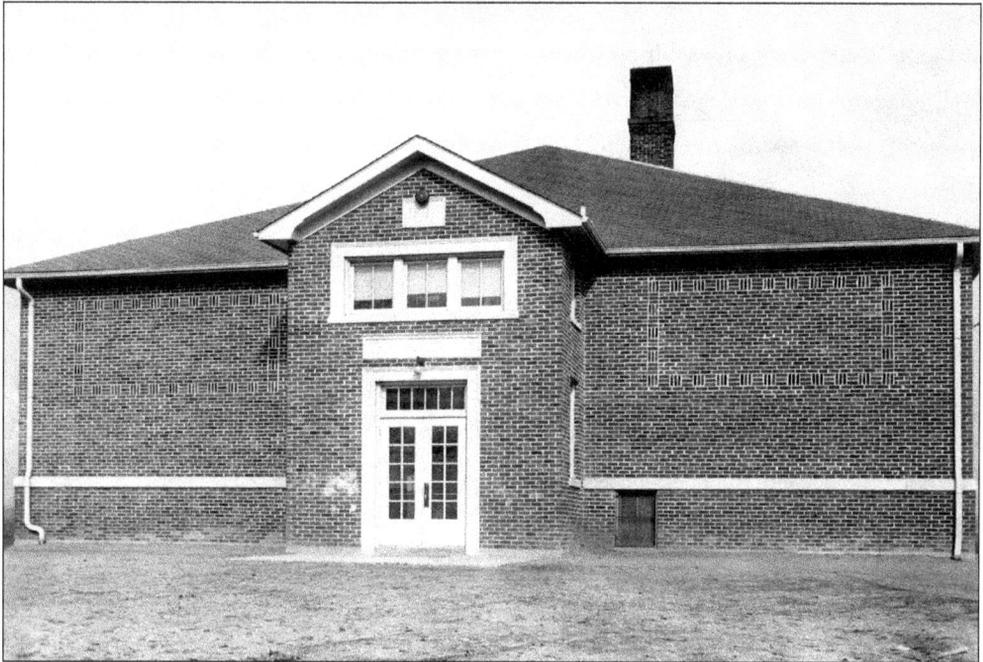

POPPLETON SCHOOL. This is how Poppleton looked between 1925 and 1952. The original one-room building stood off to the east (left). Shirley Giles Brown recalls the school allowed her to take her four-year-old brother to school with her every Thursday, the day her mother worked. She was ten or eleven at the time. (Image donated by Illa Walker Oaks.)

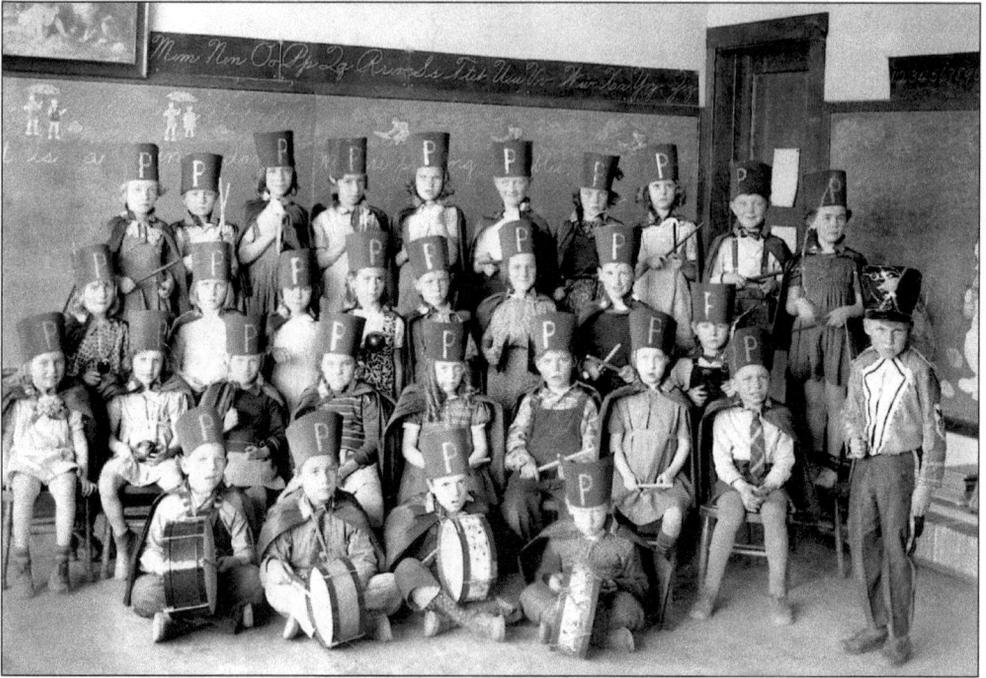

POPPLETON SCHOOL RHYTHM BAND, 1939. Poppleton was Troy's last functioning one-room schoolhouse. Though new buildings and additions were added in 1925, 1952, and 1956, classes were held in the original building—and the old school bell rung—through 1978. It was transported to Troy's Historic Village in 1980. Children still come to the museum to experience the very different style of teaching and learning of the 19th century. (Image donated by Bonnie Jean Hensleish.)

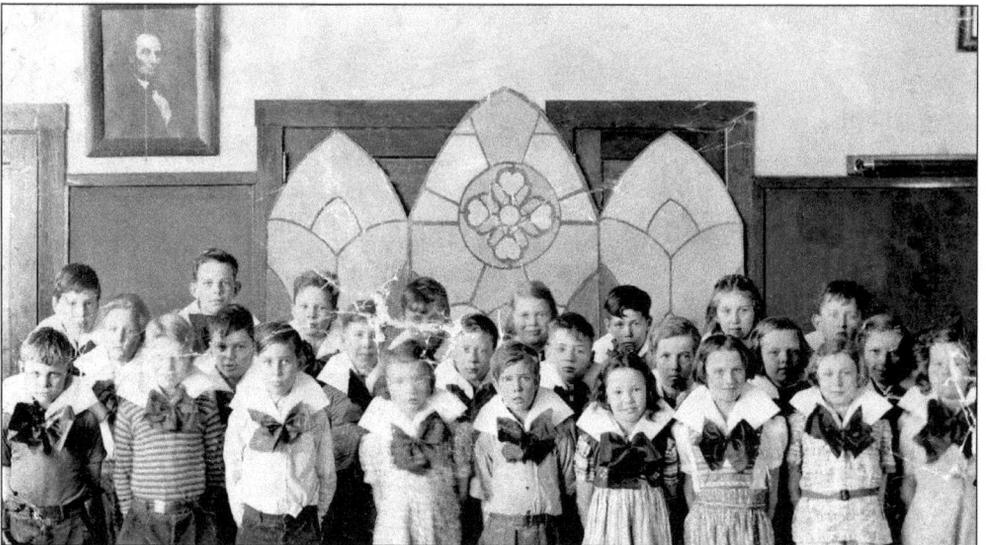

VERSE SPEAKING CHOIR, POPPLETON SCHOOL, 1939. Josephine Serafina, the original owner of this photo, is shown fourth from the left in the front row. The children wore their own clothes but made a "uniform" by adding large decorative collars and floppy bows. (Image donated by Josephine Serafina.)

LOG CABIN SCHOOL, c. 1942. Located in Clawson but part of the Troy School District, Log Cabin stood at 15 Mile Road and Livernois Road. It housed students in kindergarten through twelfth grades, but many Troy students preferred to attend Clawson, Rochester, or Royal Oak high schools. The first one-room schoolhouse was built on the site in the 1830s. Another, the Red School, replaced it in 1851, and then a larger White School in 1870. The school shown here was built in 1917 and demolished in 1978. In 1955, Log Cabin became part of Clawson schools.

BIG BEAVER SCHOOL CLASSROOM. This photo, taken some time in the 1940s, shows a classroom in the 1919 building. A high school was built alongside in 1925. Here, the fresh-faced students, along with their teacher, have the large windows open and the shades down. Once modern construction replaced these classrooms, Big Beaver was used by the school district for administration. It was finally razed in 2003. (Image donated by Adda Mae Akin.)

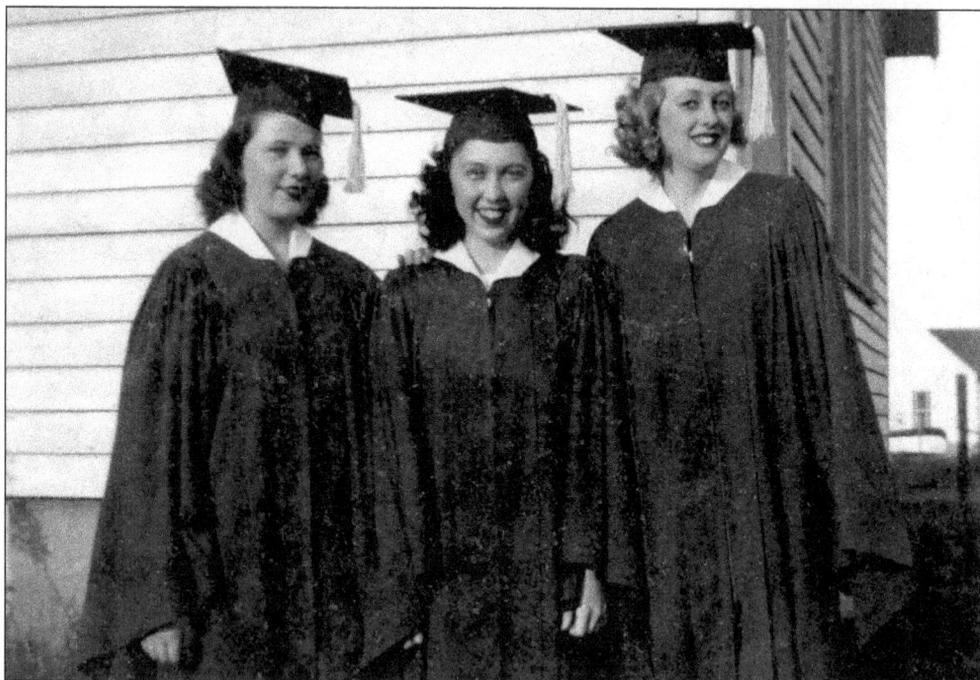

FRIENDS FOREVER, 1945. Big Beaver High School graduated 21 seniors in 1945; here are three of them. Shown from left are Eva Gilbert (Menedez), Gloria Bonino (Anderlie), and Mildred Swee (Wall). According to the Year Book, Eva was voted "the girl with the cutest smile," Gloria "the A-1 senior cheer leader," and Mildred "the class flirt." (Image donated by Calvin Gilbert.)

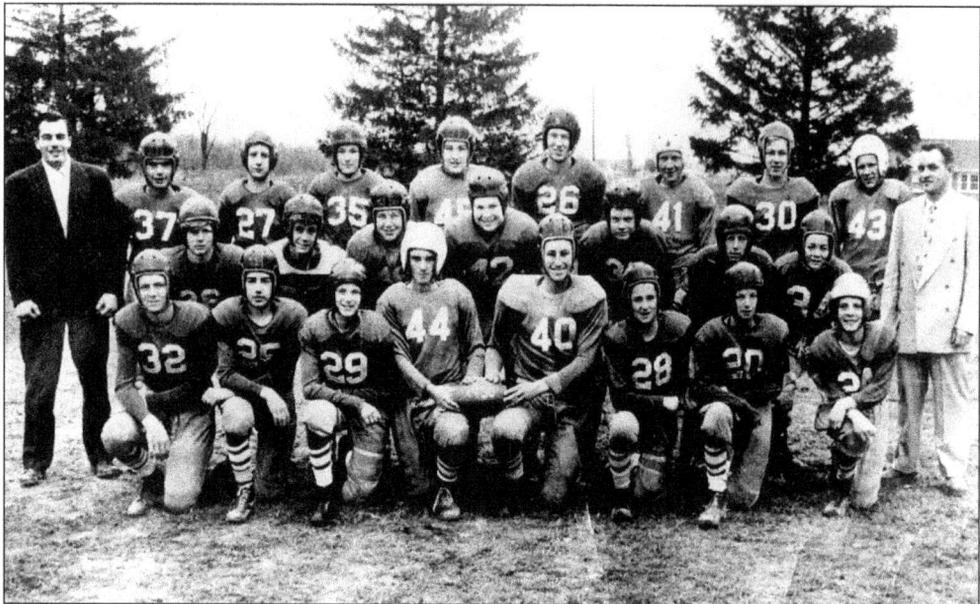

BIG BEAVER FOOTBALL TEAM, 1950. In 1950 Big Beaver School fielded a championship winning Varsity team. This photo shows the Junior Varsity players. On the extreme left is Coach Benjamin and on the right is Coach Goodwin. The player in the exact center, number 42, is Lawrence Smith. (Image donated by Viola Aspinwall Smith.)

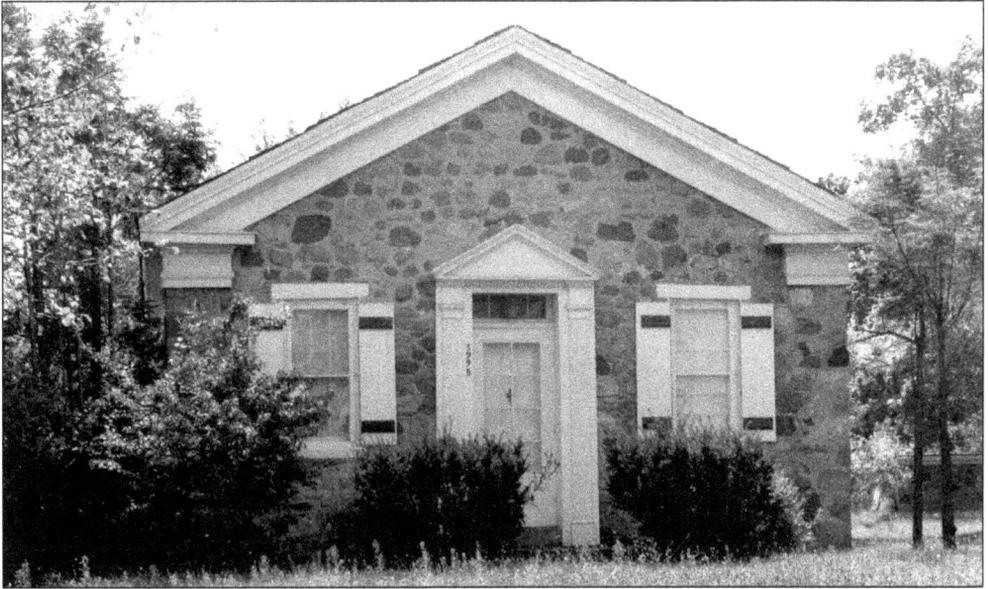

STONE SCHOOL. This school was built in 1852 with stone found on site at Adams Road and South Boulevard. It remained in use as a one-room schoolhouse in the district of Avondale until 1927. The building, complete with 20-inch-thick stone walls and a stone outhouse covered in school children's initials and carvings, was converted to a private residence in 1947.

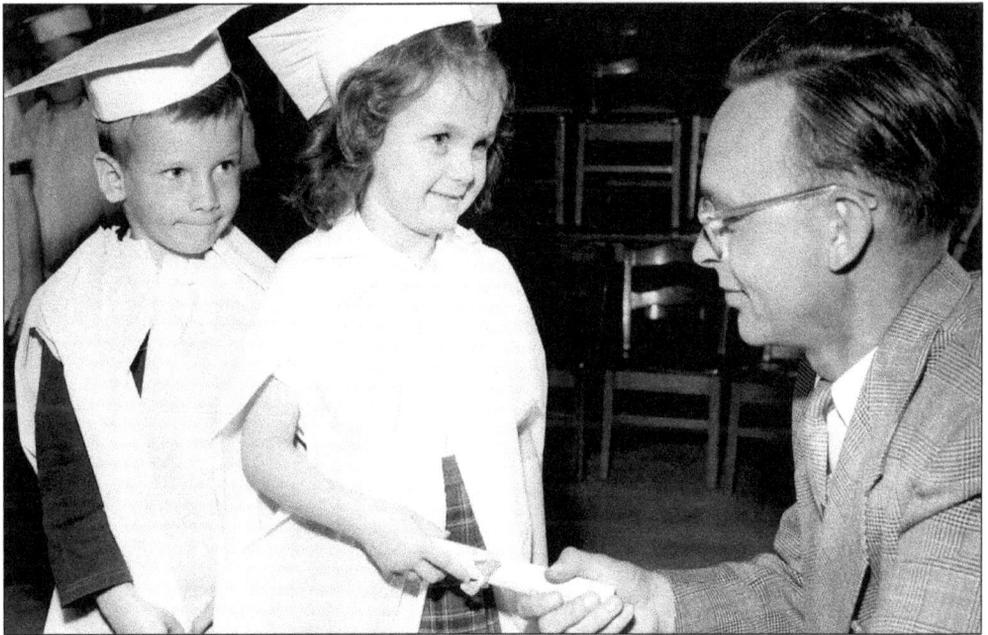

BOYD LARSON, 1958. Mr. Larson began working in the Troy School District in 1946 as the eighth grade teacher and principal at Poppleton School. Here he's shown handing out a kindergarten graduation diploma at the school. After a few years as athletic director at Troy High, he was made principal of Baker Junior High (as it was then.) He ended his 31 years of service as assistant superintendent. Larson Middle School is named in his honor. (Image donated by Joan Larson.)

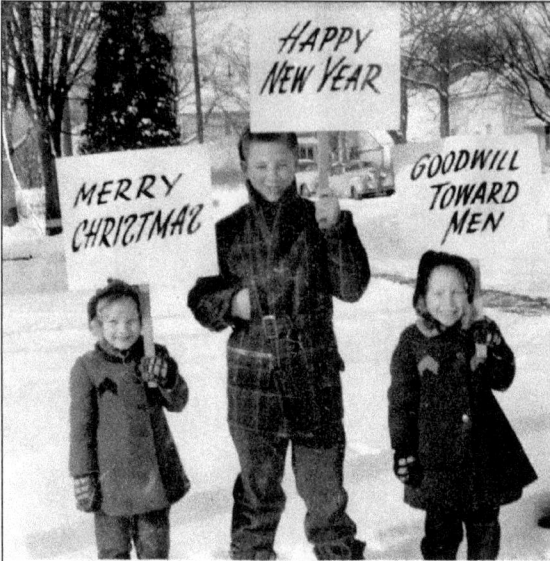

GREETINGS FROM THE SNELL CHILDREN. The Troy Methodists were probably served by circuit riders until 1862, but from that date to the present they can list their ministers, including Reverend Snell from 1944 to 1949. His family lived in the parsonage at Troy Corners, though he also officiated at Big Beaver Methodist and the congregations shared the cost of his living expenses. In what is presumably the family Christmas card, the Snell children, Roger, Silvia, and Marjorie, send their greetings to the congregation. (Image donated by Roger Snell.)

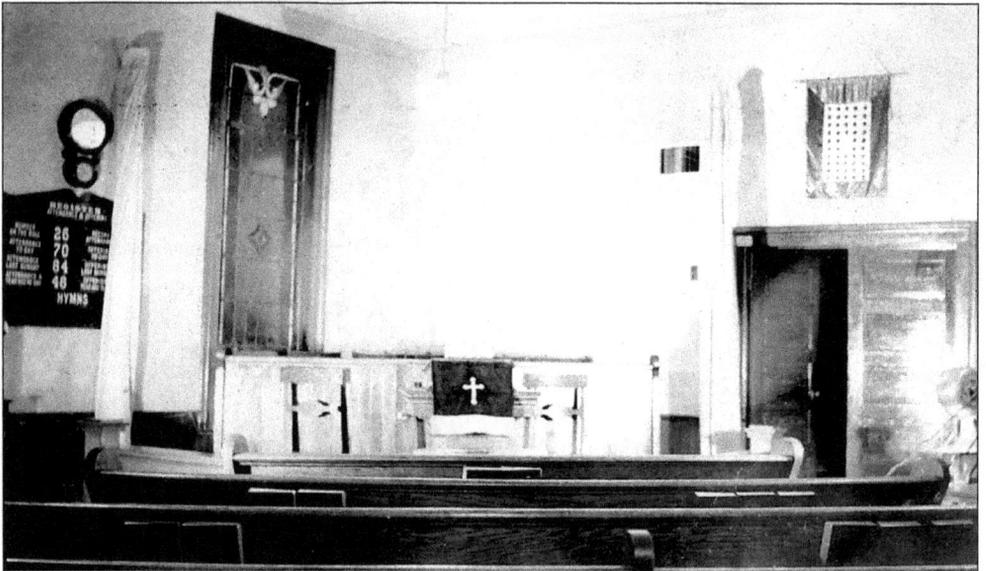

CHURCH INTERIOR. This rare photo shows the interior of the Troy Methodist Church; the Blue Star Banner over the double-door clearly dates the shot to the years of WW II. This arrangement with the altar in the corner and two side aisles, rather than a central one, was reproduced when the church was restored after its 2003 removal to the Troy Historic Village. (Image donated by First United Methodist Church of Troy.)

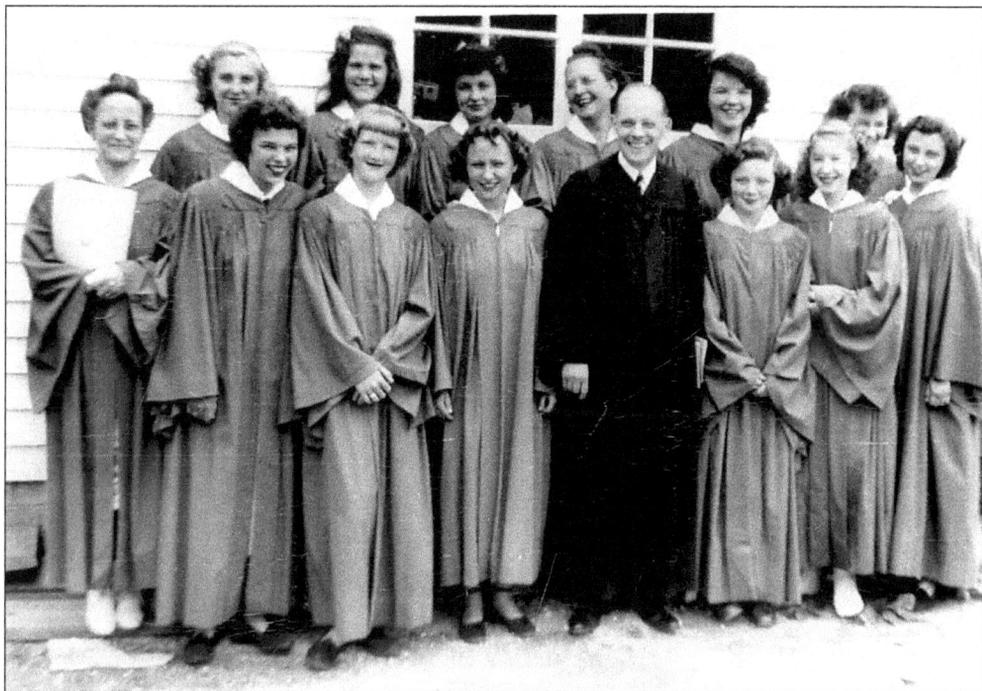

TROY METHODIST CHURCH CHOIR, c. 1950. Shown from left to right are the following: (front row) Illa Mae Renshaw, JoeAnne Hughes, unidentified, Reverend Howard Snell, Leah Rae Fornwall, Pat Mortensen, and unidentified; (back row) Vera Sherman, Joan Vincent, Thera Cooper, Aloyce Mitchell, Olive McLellan, Dawn Belyea, and Viola Aspinwall. (Image donated by First United Methodist Church of Troy.)

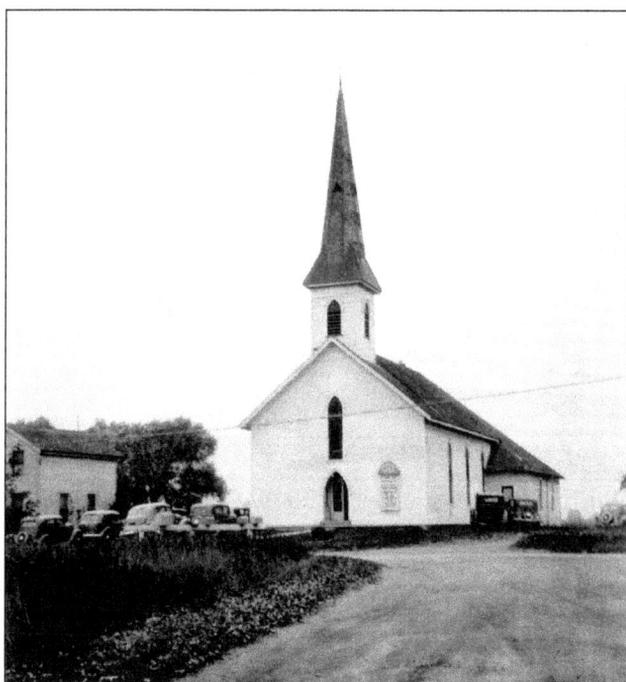

BIG BEAVER METHODIST CHURCH. Judging from the cars of the congregants who have gathered for services, this photo appears to be from the 1930s. At this date many of the old timers would doubtless have remembered riding to church in their horses and buggies. (Image donated by Ron Bernard.)

81

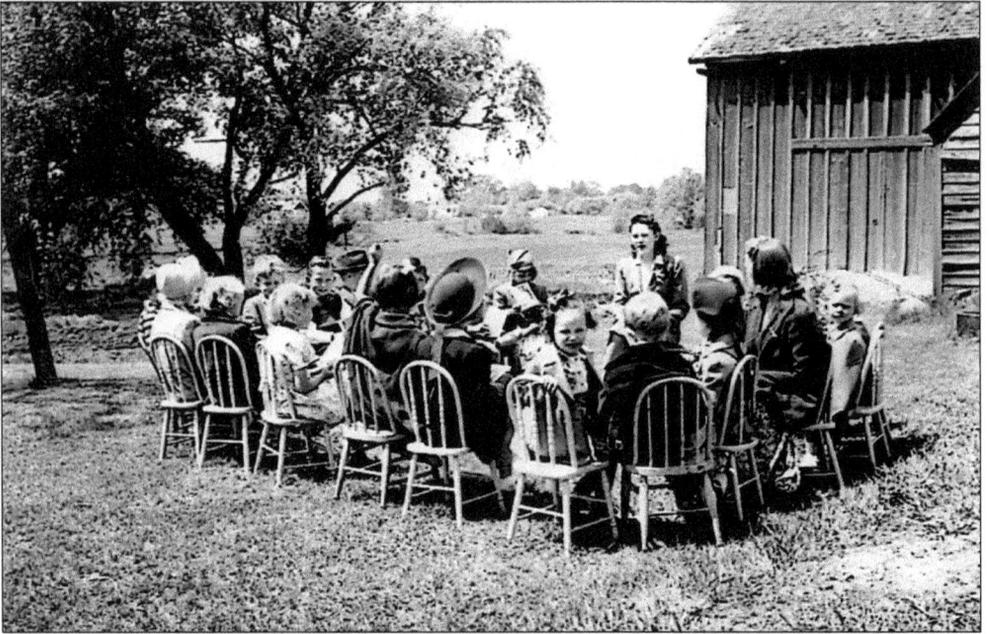

SUNDAY SCHOOL. This photo shows Dorothy Welch Spencer's Sunday school class enjoying the fresh air beside the original Big Beaver Methodist Church (not visible); in the background is Sam Howlett's barn. Ginny (Welch) Killing aids her sister. The construction of Hartland Road altered this landscape completely. (Image donated by Virginia Killing Welch.)

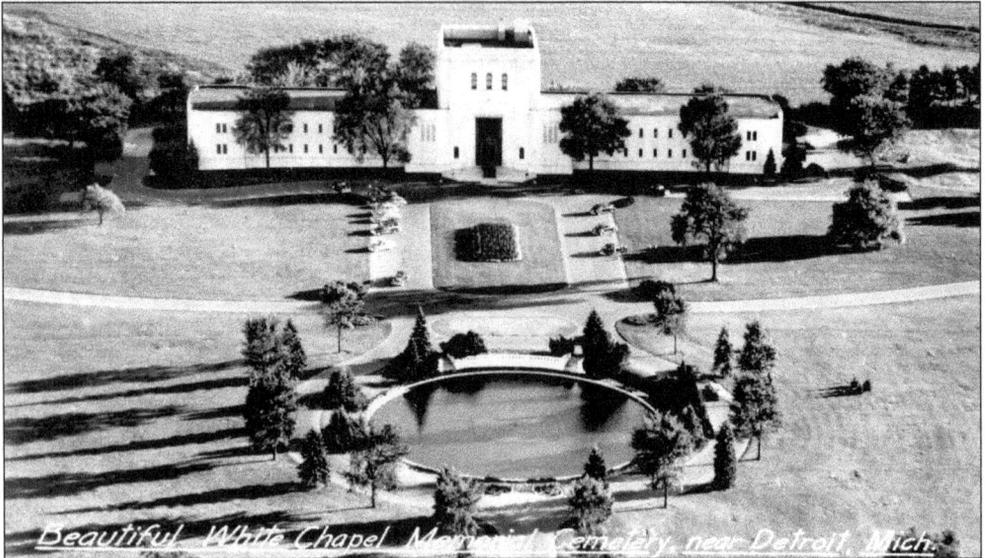

Beautiful White Chapel Memorial Cemetery, near Detroit, Mich.

WHITE CHAPEL CEMETERY, c. 1949. Once finished, White Chapel was so beautiful it became a favorite destination for families who drove to it to picnic and enjoy the grounds. The pond in front was filled by tapping a natural underground spring, which unfortunately drained the pond on Jason Scott's land. Families also visited their interred loved ones. Shirley Giles Brown's family truck-farmed at the corner of Livernois Road and Wattles Road. She remembers selling tulips for 25¢, the baker's dozen. On Memorial Day, 1943, they sold $135 worth. (Image donated by David Tinder.)

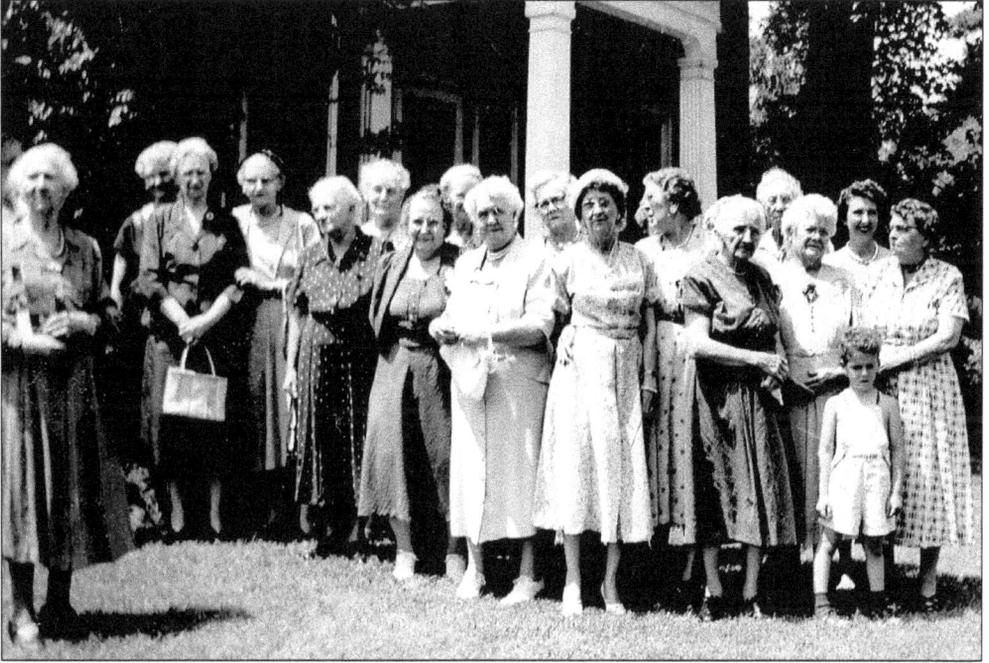

TROY GIRLS, 1954. Women who were descended from Troy's early settlers formed a somewhat exclusive group and met in each other's homes. They called themselves the Troy Girls. This appears to be a summer reunion with someone's curly-headed grandson along to enjoy the fun. (Image donated by First United Methodist Church of Troy.)

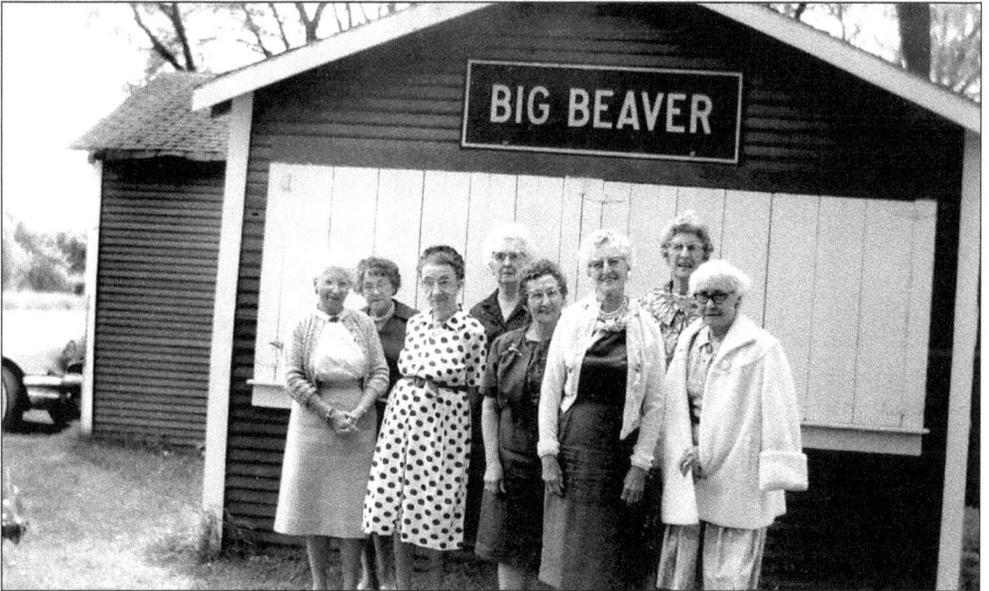

THE BIRTHDAY GATHERING. These women gathered, sometime in the 1950s from the appearance of their outfits, to celebrate the birthday of Margaret Schultz. All of them were Maccabees, part of what the organization called "a hive." From left to right are as follows: (front row) Olga Fuller, Anne Tracey, Lottie Miller, Mrs. Lindbert, and Rena Winters; (back row) Florence Orr, Ella Schlaack, and Margaret Schultz. (Image donated by Ruth Wass.)

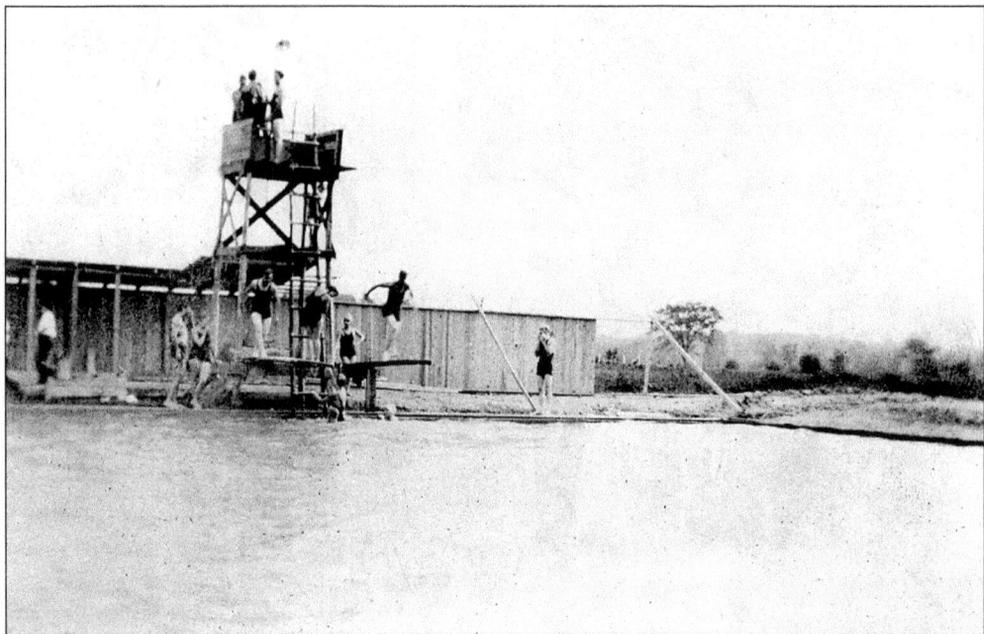

SALT WATER POOL. Although Troy had few streams, there were abundant sources of underground water. In the area of Rochester Road and Creston Road, near Long Lake Road, the water was salty. The Buehler family opened a saltwater swimming hole to the public. This photo was taken in the 1920s when facilities were very limited. (Image donated by Mr. and Mrs. R. Moser.)

POOL ENTRANCE. By the middle of the 1930s, the pool had an entrance on Rochester Road along with a stand that sold gas and snacks. The larger structure in the middle of the photo was the Buehler family home. Rochester Road was designated a state road and paved around 1932. Ruth Wass remembers that the boys were let out of school during the paving so they could carry water to the cement workers. (Image donated by Mr. and Mrs. R. Moser.)

84

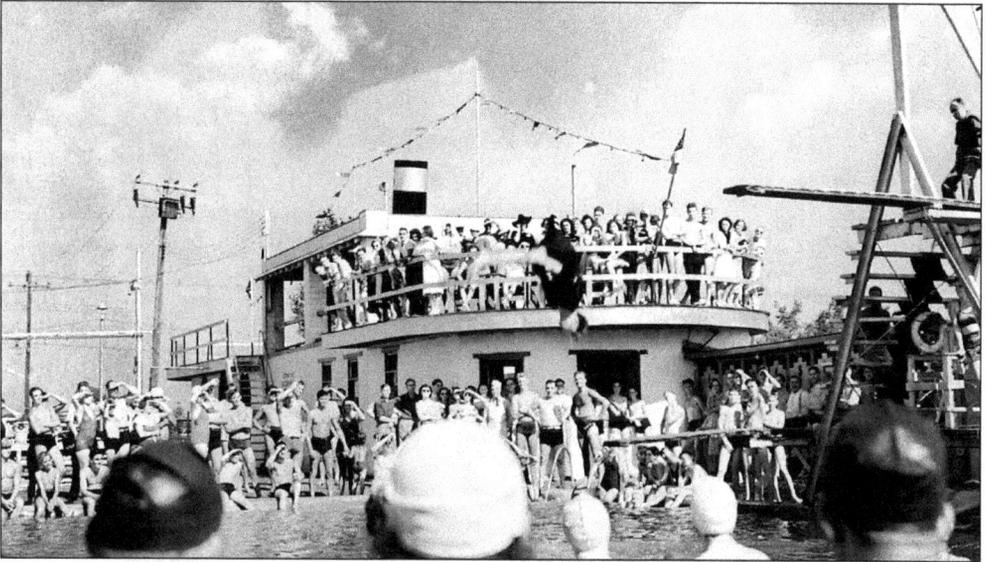

POOL HEYDAY. As trade increased, the family built up the business and what had been a swimming hole became a saltwater pool with the fancy facilities shown here. There were changing rooms around the perimeter, while this boat facade included showers and bathrooms, with summer living accommodations for the lifeguards upstairs. Business was brisk on this hot summer day in the late 1940s. (Image donated by Mr. and Mrs. R. Moser.)

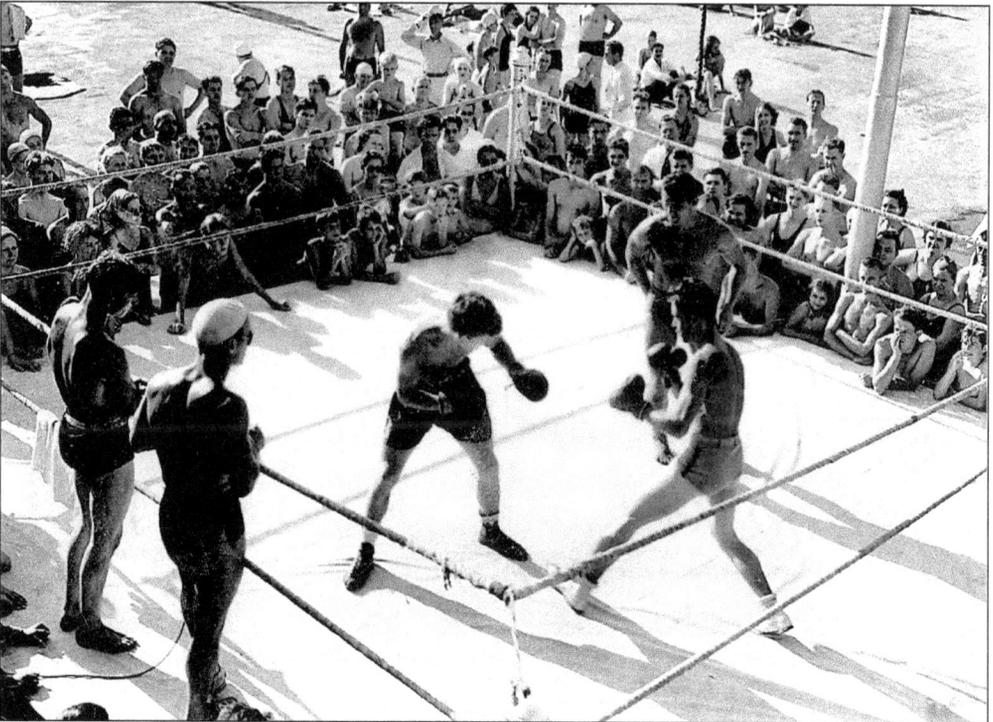

BOXING RING. The owners also set up a ring for boxing matches next to the pool. The sport was doubtless an attraction for local youths, especially since many in the audience appear to be young women. (Image donated by Mr. and Mrs. R. Moser.)

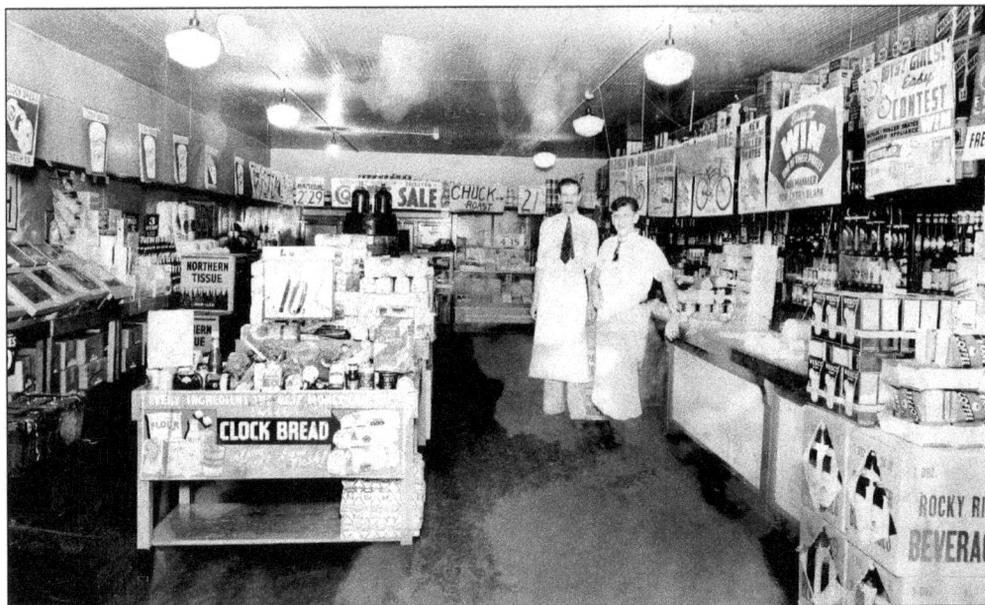

BIG BEAVER KROGER STORE, c. 1934. Shown from left are Norman Ewers and Frank Morton, surrounded by grocery and general items of all kinds. Visible are Clock Bread, made in Detroit, Northern bathroom tissue, and Rocky River beverages, among other things. They also sold local produce. Signs in the upper right of the photo announce a contest giving youngsters the chance to win a bike.

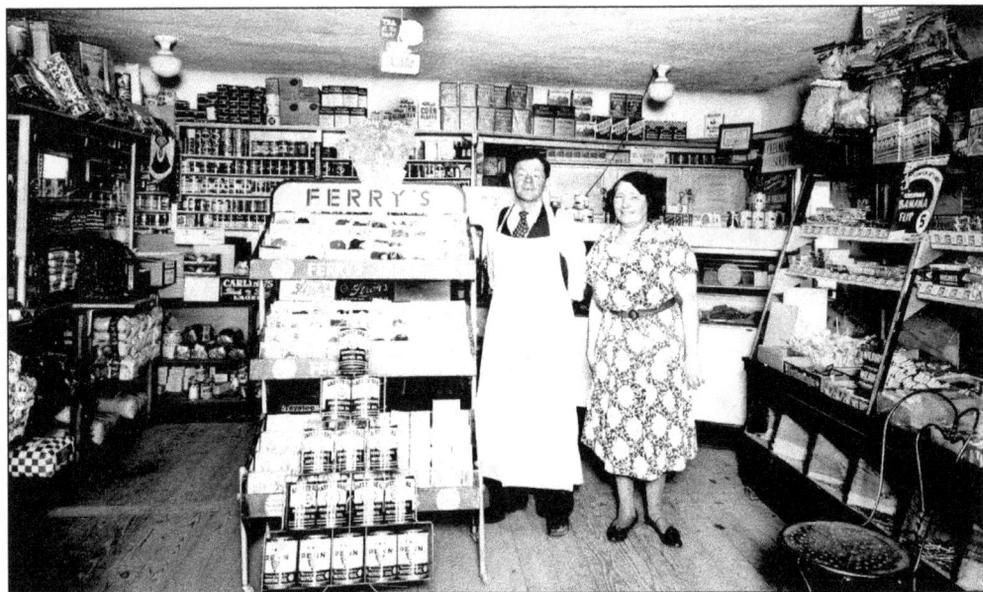

MILLICENT'S GROCERY STORE, 1940. This store, located at Maple Road and Dequindre Road, was owned and operated by George and Mary Barrow. Notice the "scrambled" merchandising—anything a customer might need is placed at an easy-to-reach level, close to hand, and in seemingly random fashion. This picture must have been taken in the spring, as the Penn motor oil for tractors was propped up next to the Ferry Morse Seeds. Familiar names are on view, including Salada Tea, Carling Black Label Lager, and Kellogg's Cornflakes. (Image donated by Fred Brown.)

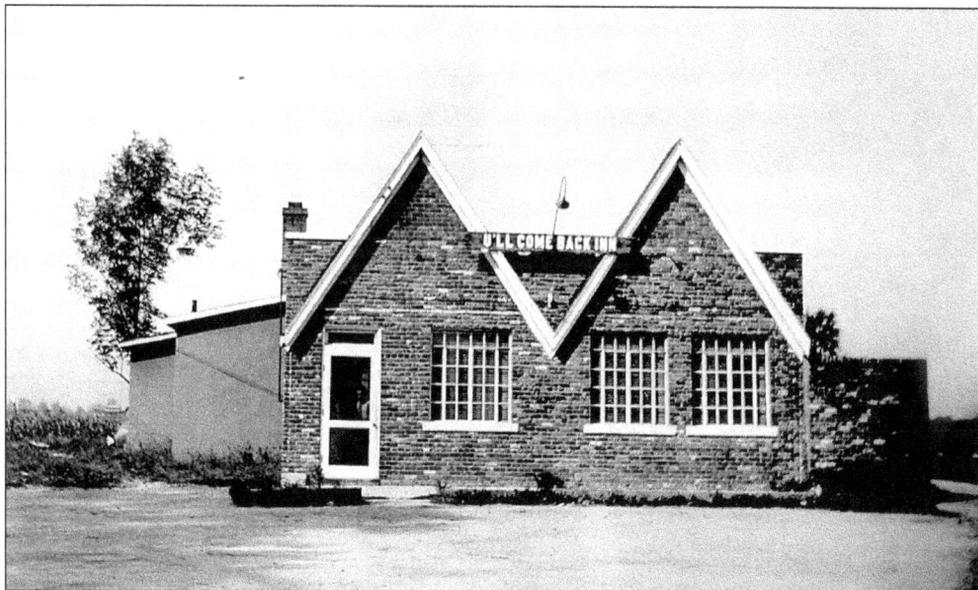

U'LL COME BACK INN. Clarence and Florence DeLoy bought land in 1930 at Wattles Road and John R Road. Clarence built a one-room dwelling with the help of his brother Frank. The family farmed and kept as many as 1,000 chickens. In 1935 the building was transformed into a restaurant serving chicken dinners. When a liquor license was acquired in 1937, the family had to move into the incubator room of the chicken coop, because the law would not allow people to reside on licensed premises. (Image donated by Arline DeLoy Shaver.)

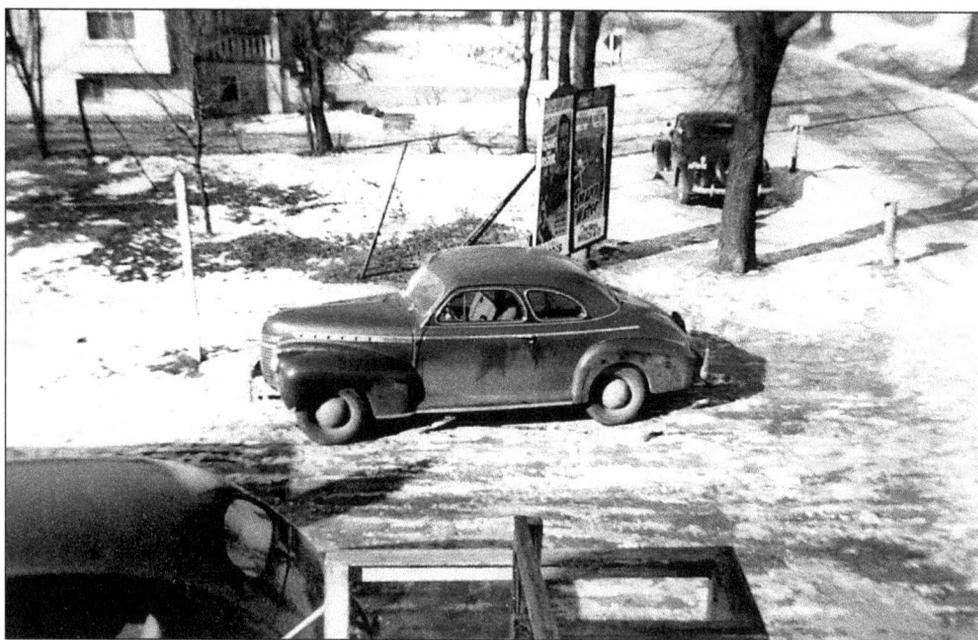

STREET SCENE, 1941. Shown is a March day at the intersection of Livernois Road and Maple Road. Motorists who battle with Troy's traffic today must envy this relatively peaceful sight. The movie billboards advertise *Swamp Water*, starring Walter Brennan, and *The Maltese Falcon*, starring Humphrey Bogart and Mary Astor. (Image donated by Clarence Bonenfant.)

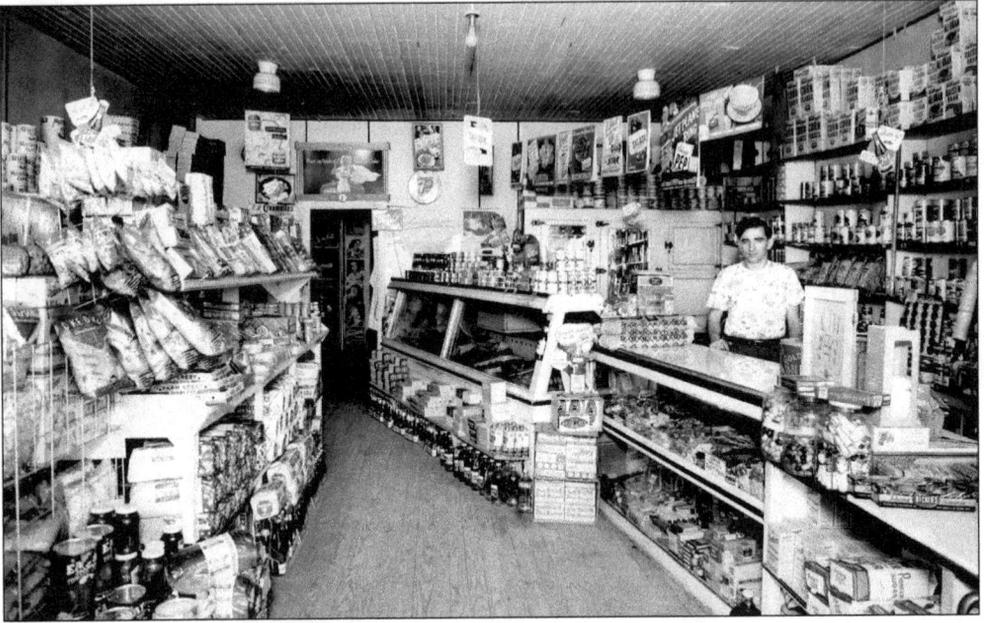

FROM CEILING TO FLOOR, 1946. After his tour in the Navy, Fred Brown, Mary Barrow's son, opened his own store at 15 Mile Road and Livernois Road. It belonged to an age of personal service but less choice, even though every inch is crammed. He was carrying on a family tradition and would do so until he sold his property in the 1970s. (Image donated by Fred Brown.)

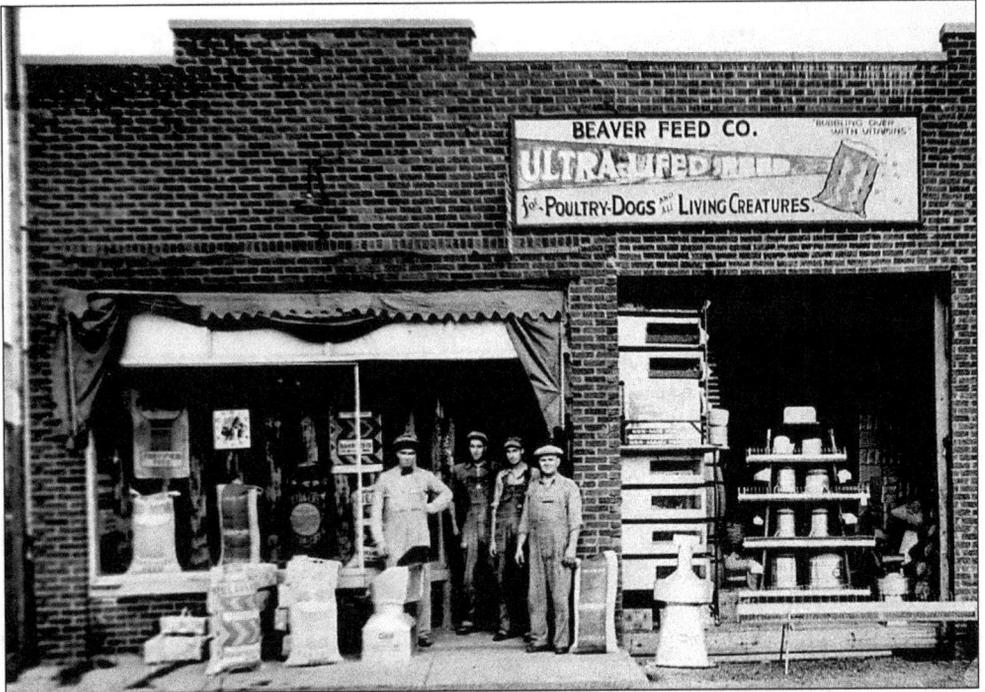

BEAVER FEED COMPANY. J. Wesley Smith bought the feed store from the previous owner in 1938. It served the needs of "poultry, dogs, and all living creatures." Shown left to right are Mr. Smith, John Moulis, Norm Whittey, and Earl Kluendorf. (Image donated by Viola Aspinwall Smith.)

SHERWOOD E. SHAVER, 1943. There were three Shaver brothers who saw action in WW II. Glenn was killed in France in December of 1944. Clark served in the Pacific Theater. Shown here is Sherwood, who enlisted in the Army in December of 1942. After training he participated in campaigns in Normandy, Northern France, and Germany. In December of 1944 he was wounded and lost a hand. He was awarded the Purple Heart and the Good Conduct Medal. In December of 1945 he became Troy's postmaster. (Image donated by Arline Shaver.)

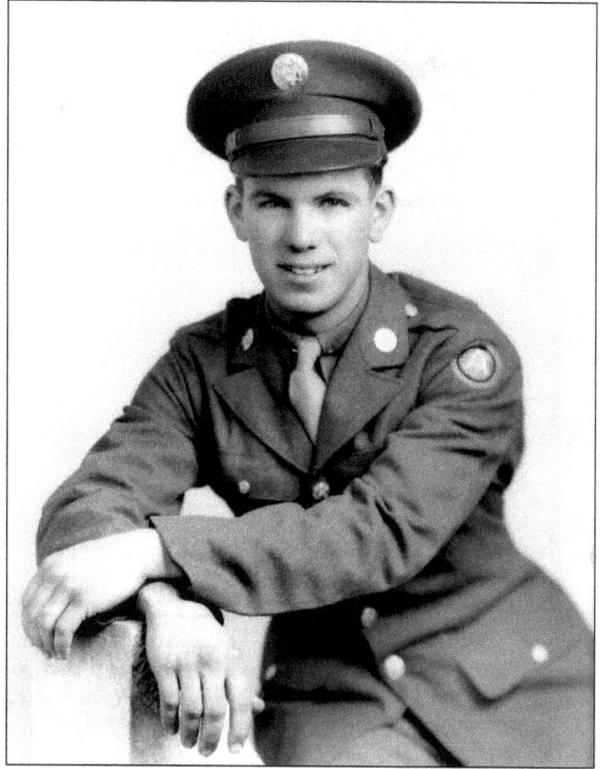

GRANDPA BECKER, c. 1943. Many Troy residents did their duty during WW II. Among those too old to see service overseas was this grandfather of the Snell family, who was a night watchman at a Detroit area war plant. (Image donated by Roger Snell.)

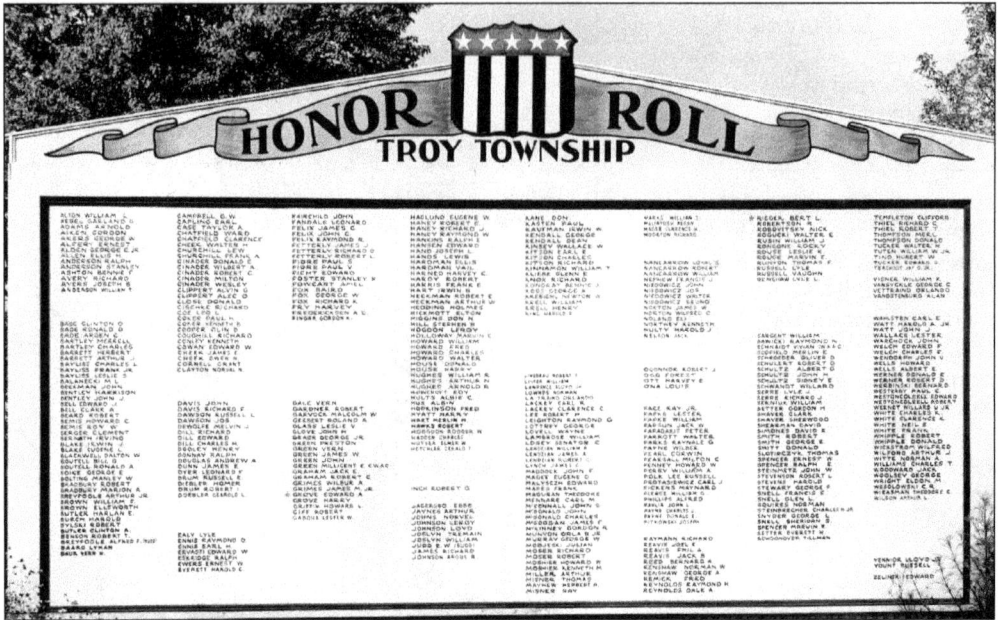

TROY TOWNSHIP HONOR ROLL. This patriotic honor board stood at Big Beaver Village. The Haney family obtained and erected the guardrail that surrounded it and donated the flag. The youngest children of the family mowed the grass around it. Mrs. Madeline Haney was president of the Big Beaver Blue Star Mothers. She had three sons who served overseas during WW II. When one of the Troy boys listed on the board died, a gold star was placed next to his name. (Image donated by Virginia Killing.)

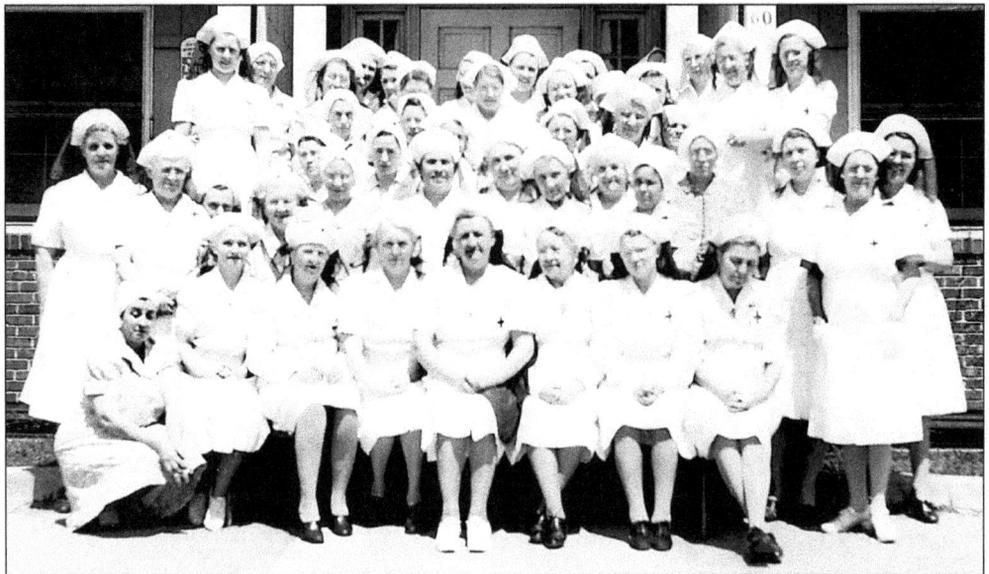

RED CROSS VOLUNTEERS. Clara Barton founded the American Red Cross after the Civil War, and in every war since the organization's volunteers have played their part. During WW II those volunteers were based in the Township Hall on Wattles Road, which is where this photo was taken. There they rolled bandages. (Image donated by Virginia Welch Killing, whose mother Jennie and oldest sister Gladys are in the photo.)

FOUR FREEDOMS MEMORIAL. In August of 1948 the Four Freedoms Memorial was unveiled at White Chapel Cemetery to honor the war dead of WW II, especially those who were unknown or were buried where they fell. Toward that purpose 115 soldiers were brought back from the four corners of the world and reburied. Statues representing the four freedoms immortalized by Franklin Roosevelt stand atop the monument. They are guarded by land and by sea in the form of a soldier and sailor at its base. (Photo by Laura Freeman.)

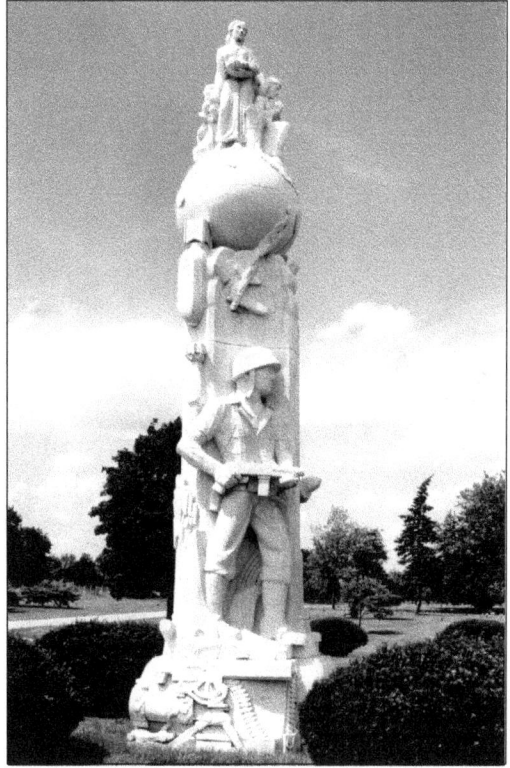

ON THE HOME FRONT, 1942. While the boys were away, the girls (mostly) stayed home and did war work in the factories or in the fields. This photo shows, from left, Alice Mae Harrison and Virginia Welch on the bridge that crossed Big Beaver Creek. Both graduated in 1943, and the boys they knew enlisted. Because of development, the creek is no longer visible. The Big Beaver Methodist Church can be seen in the background. (Image donated by Virginia Welch Killing.)

91

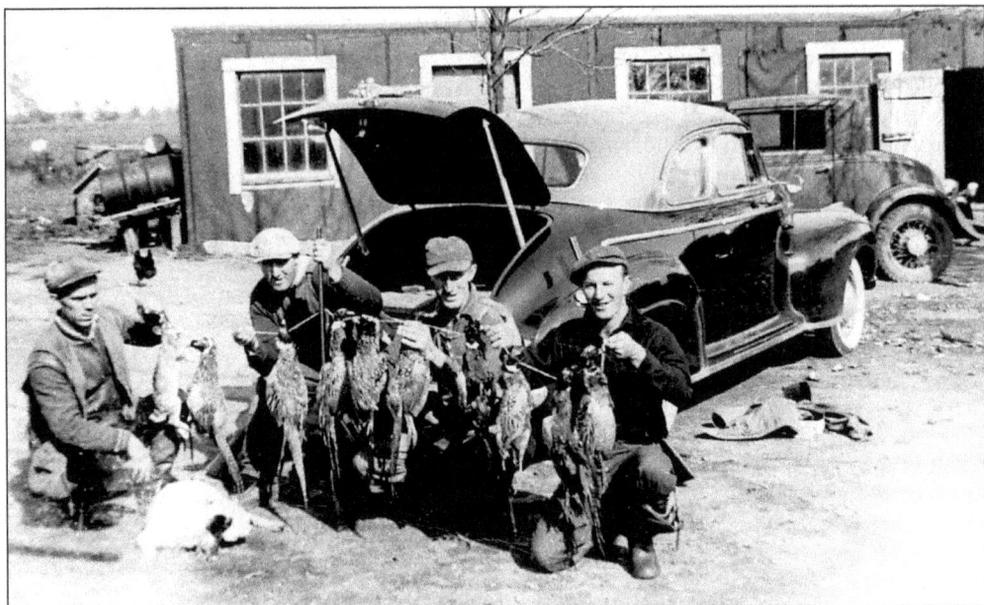

THE PHEASANT HUNT. Pheasants are a rare sight in Troy today, but they once provided food and sport for Troy farmers along with deer and rabbits. Fred Hildebrandt is shown third from the left. (Image donated by Lois Ballard.)

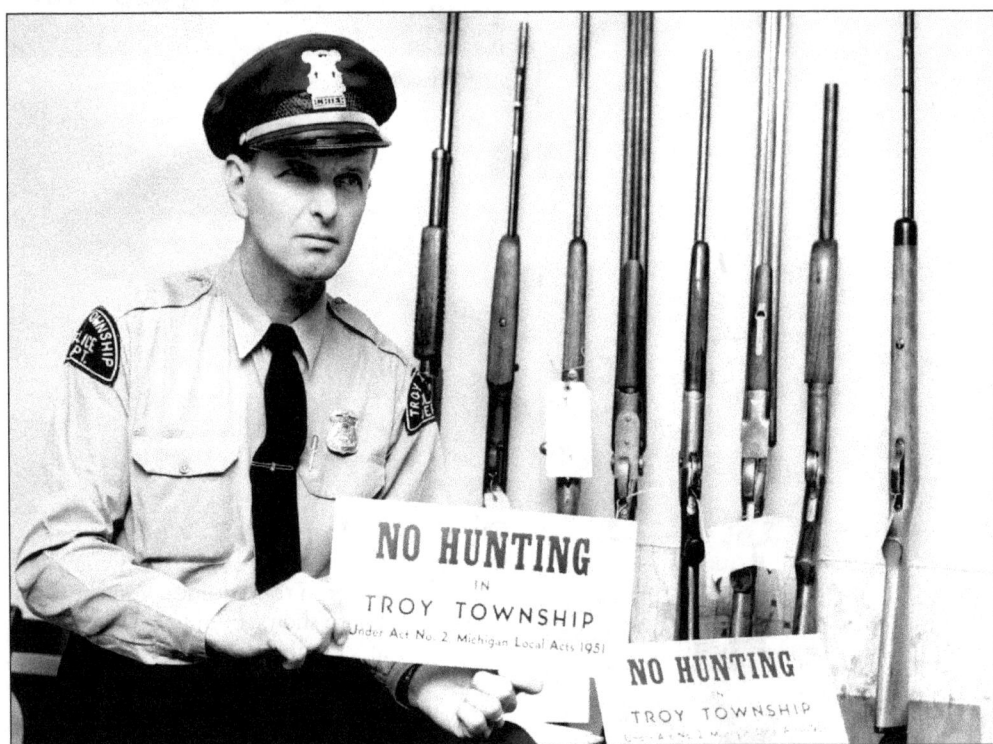

POLICE CHIEF DAVID GRATOPP, c. 1952. Gratopp was Troy's first police chief. Here he poses with a "No Hunting" sign, and confiscated shotguns and rifles. Hunting was outlawed in 1951 because the increase in the city's population made it unsafe. (Image donated by Lynda Ballentine.)

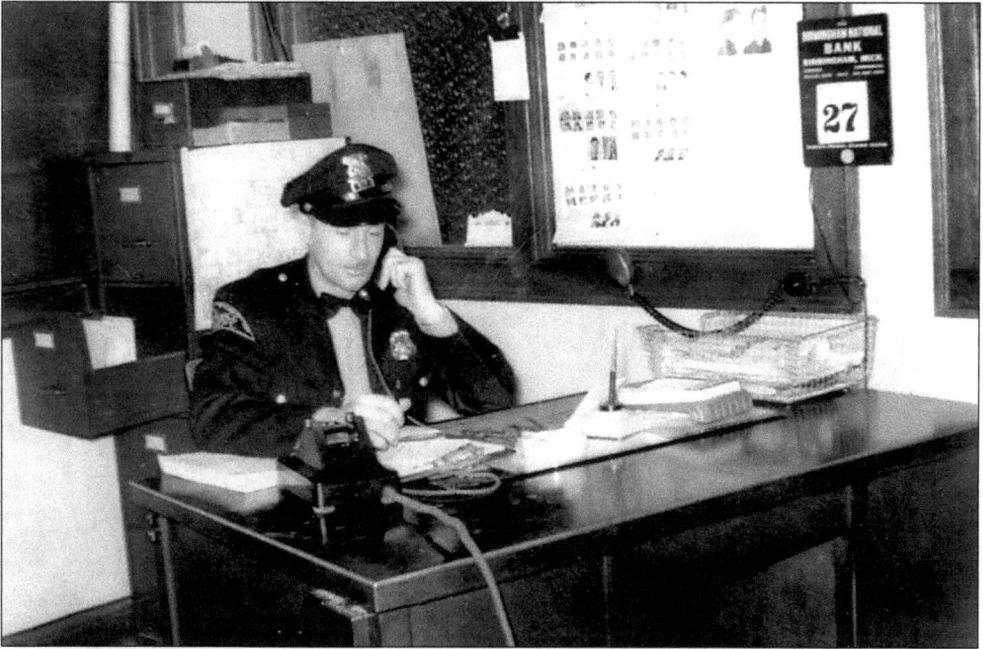

WILLARD SCHWANDT AT HIS DESK. In addition to Chief Gratopp, the township hired a second officer, Willard Schwandt, when the force was constituted in July 1952. He's seen here at his desk in the original police office, which was on Wattles Road at Livernois Road in the Township Hall. The building is now the Troy Museum. A third officer, Patrolman Eugene Sackner, was added in November, allegedly so that Gratopp would not have to miss his annual hunting vacation.

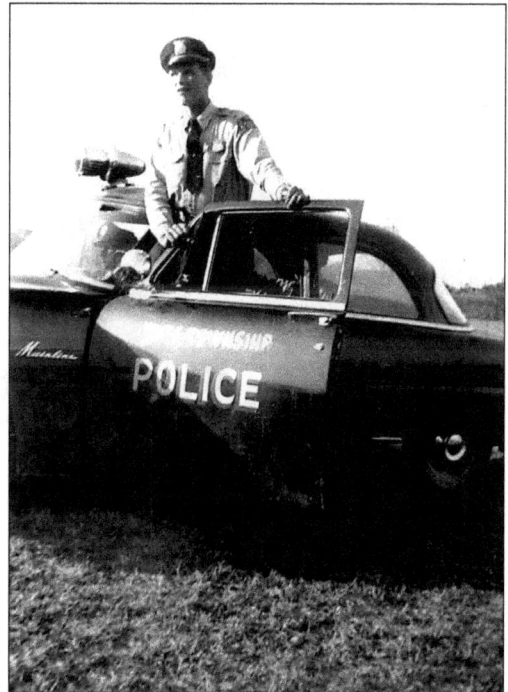

TROY'S FINEST. Chief Gratopp stands outside the only car the Troy police owned, and since both of the other officers are inside the car, this picture shows the entire might of the Troy force in those early days. Ted Halsey, who was hired onto the force in 1957, remembered a time when limited resources meant that the officer going on duty had to be picked up at home by the officer going off duty, who would then be driven home.

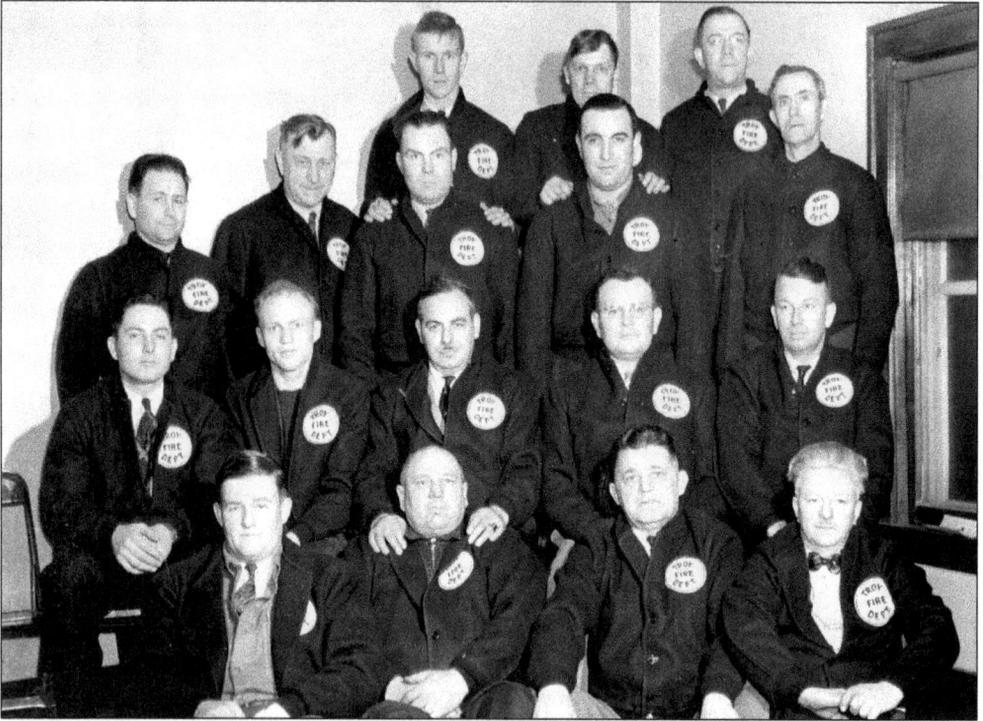

EARLY VOLUNTEER FIREFIGHTERS. Troy's fire department began as a group of volunteers in 1940; before then fire calls were handled by Clawson. They based themselves in the Big Beaver area. Today, Troy has one of the largest volunteer forces in the state. Shown here are early volunteers, from left to right: (front row) Cliff Sutermeister, Elmer Schroeder, Walter Miller, and Cliff Truesdell; (second row) Forrest Clippert, Stanley Heitman, Gene Marenette, Earl Klusedorf, and Sam Halsey; (third row) Glenn Ladd, Henry Eseman, Wesley Smith, Lauren Ford, and Harry Schultz; (back row) William Halsey, William Renshaw, and Clarence DeLoy.

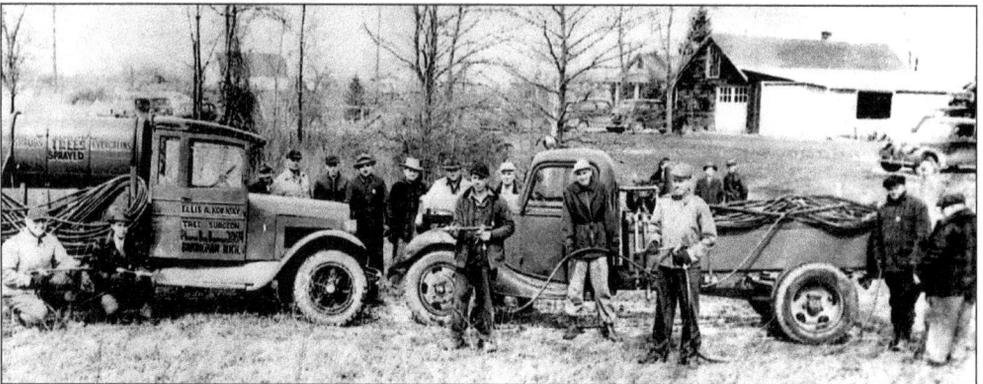

FIRE STATION 2'S FIRST TRUCK, MARCH 1947. Another group of men in the northern area formed a small auxiliary force. Shown here are members of Station 2, from left to right: Ernest Gray, Harry Mortensen, Russell Barnard, Ned Aspinwall, Romeo Marceau, Norman Barnard, George Ford, W. Smith, J. Schell, future mayor Frank Costello, L. Weaver, K. Lawrence, Henry Krell, Jim Haley, Fire Chief Ellis Kowinsky, Elmer Schroeder, and Bill Mumford. The group used Kowinsky's tree surgeon truck. As late as 1966, the group reported fighting more grass fires than building fires, reflecting Troy's continuing rural atmosphere.

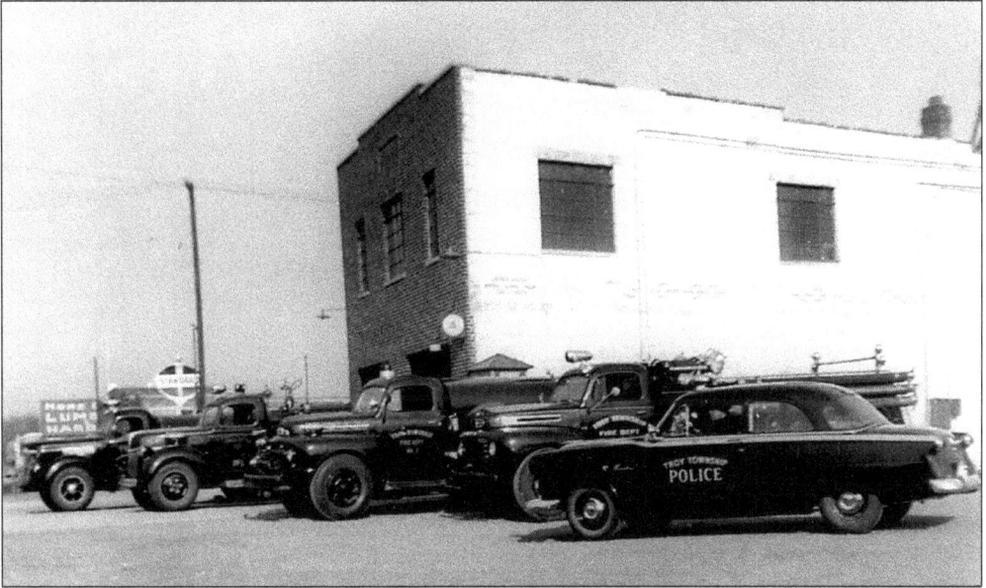

FIRE STATION 1, c. 1952. Vehicles from Fire Stations 1 (Big Beaver) and 2, as well as the Police Department's only vehicle of the time, stand outside Fire Station 1. This building was erected shortly after WW II and was Troy's first purpose built fire station. It was closed when I-75 was constructed. For many years afterwards it was O'Rilley's Real Estate, but was demolished in 2004. (Image donated by John C. Truesdell.)

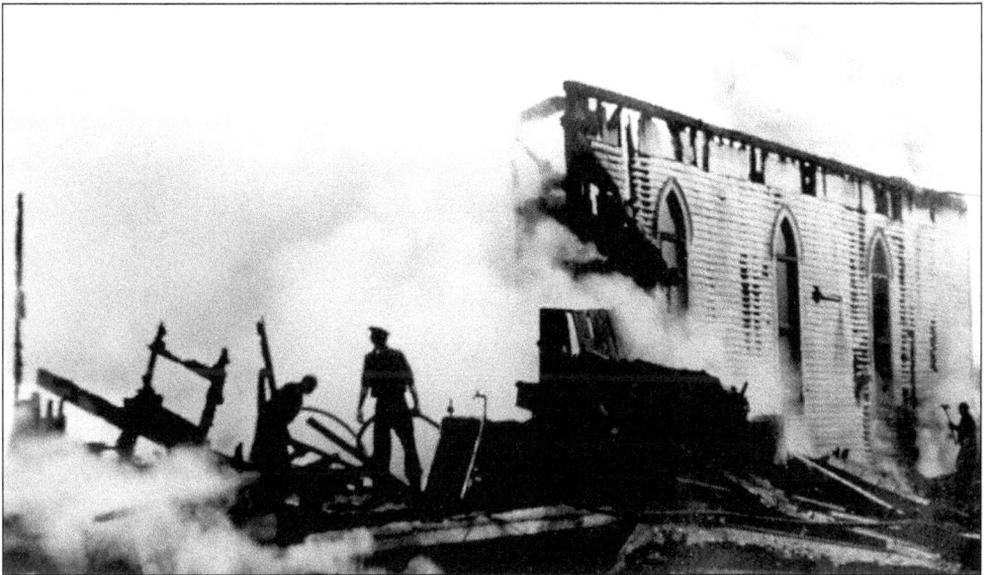

DESTRUCTION AT BIG BEAVER, 1945. The Methodist church on Rochester Road was destroyed by fire in October of 1945, just three days after the congregation's centennial anniversary. Big Beaver School was using it for overflow kindergarten classes and Gail Myers discovered the fire around 12:30 pm when she arrived with her daughter for the afternoon session. She broke down the doors and together with other people saved some chairs, the choir robes, and two pianos. Volunteers from the Troy and Clawson fire services fought the fire. (Image donated by Ron Bernard.)

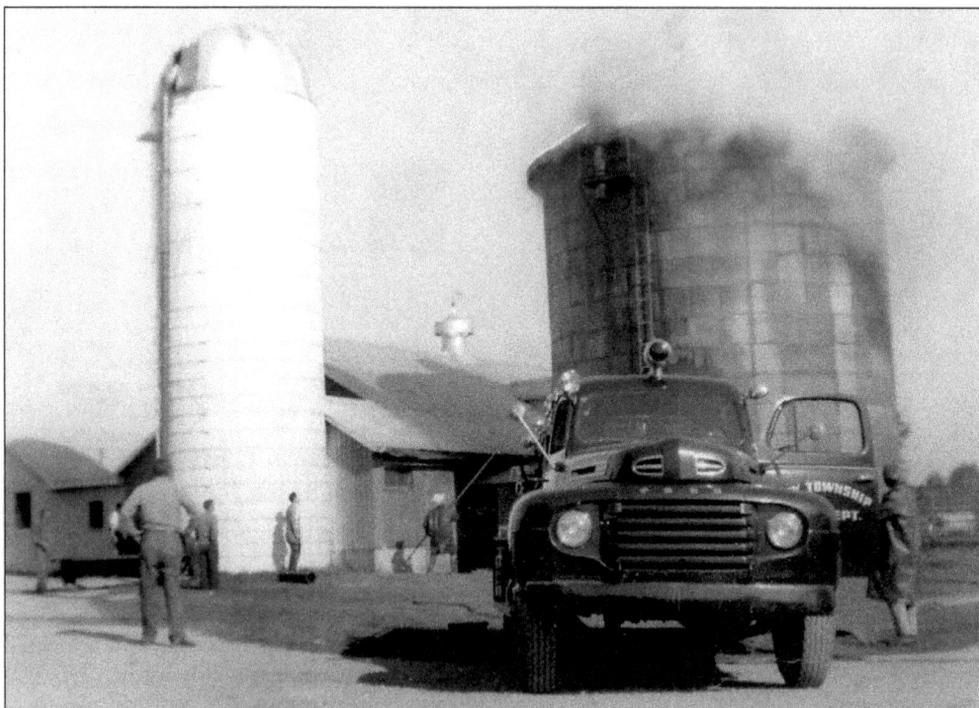

CORNCRIB FIRE, c. 1950. Corncribs and silos are a dangerous part of farm life because of the methane gas that builds up inside them. Here the Troy Fire Department fights a local corncrib fire and endeavors to stop it from spreading to the nearby barn. (Image donated by John C. Truesdell.)

THE END OF THE LINE, 1952. Troy Township's days were coming to an end. In this photo taken on South Boulevard, a lone car heads eastwards from Adams Road and drives past a welcome sign that would soon be replaced with a City of Troy sign.

Four

THE CITY GROWS
1955–2004

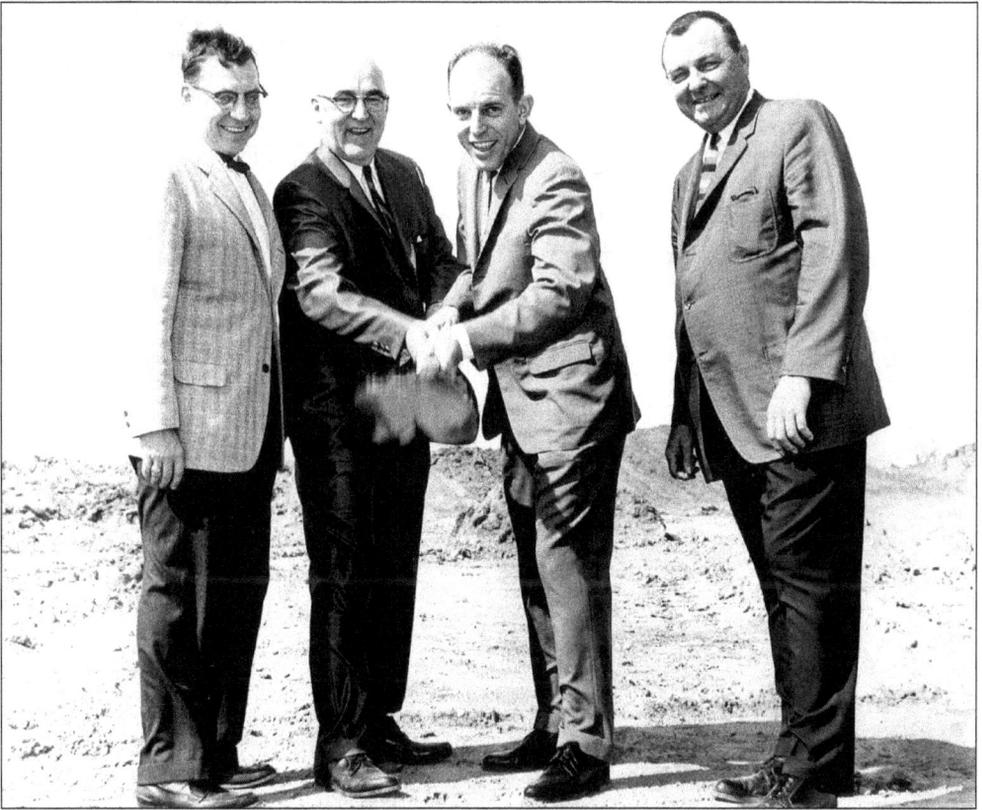

CITY HALL GROUNDBREAKING, 1965. In 1955 Troy Township became a city and entered a period of dramatic growth. Corporate headquarters, shopping malls, and subdivisions replaced the open fields. The new city Master Plan included a Civic Center and modern City Hall. Land for the Civic Center was purchased from former Mayor Robert Huber (far left). He participated in the City Hall groundbreaking with, from left to right, Mayor Vincent McAvoy, City Manager Paul York, and unidentified.

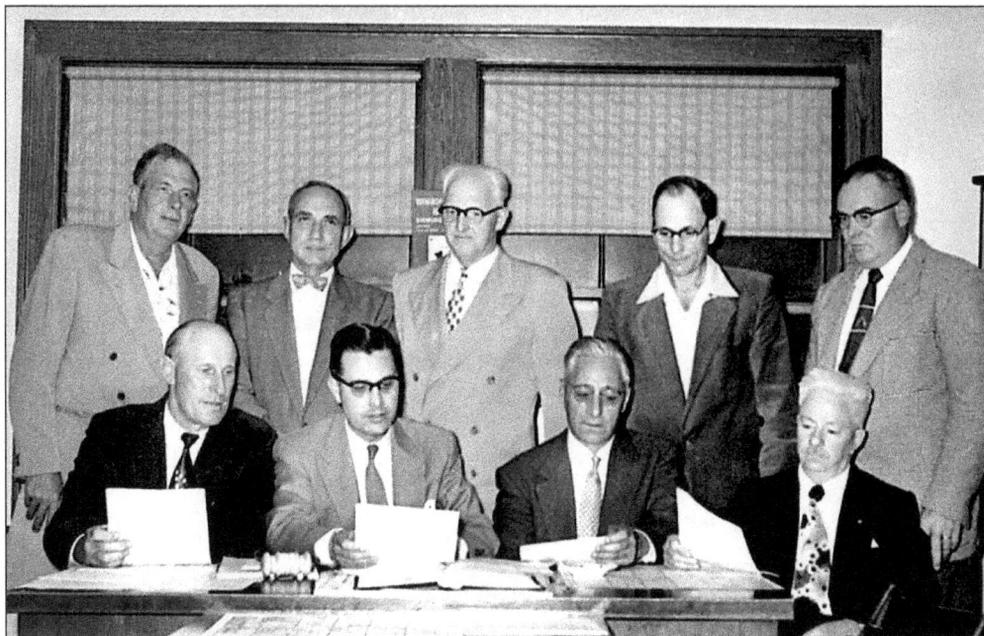

CHARTER COMMISSION, 1955. On June 7, 1955, the township residents overwhelmingly approved the proposal to incorporate and elected a Charter Commission. Pictured left to right are the following: (front row) Fred Hildebrandt, Norman Barnard, Frank Costello, and Clifton Truesdell; (back row) Roy Duncan, George Ford, Ernest Gray, Elmer Lowe, and Wesley Smith. (Image donated by Mrs. George Ford.)

NORMAN BARNARD, 1947. Norman Barnard was the last Township Supervisor. He helped orchestrate the plan for Troy to become a home rule city. Barnard and others were concerned about initiatives by neighboring cities to annex township land to their municipalities. In March of 1955, these men quietly circulated petitions supporting incorporation and filed them with the Oakland County Clerk before Royal Oak could file another annexation request.

THE FIRST TROY CITY COMMISSION, 1955. On December 12, 1955, Troy voters approved the charter by a slim margin of 86 votes. Also elected that day were, from left to right: Mayor Frank Costello, City Commissioners Roy Duncan, George Ford, Ernest Gray, George Yeokum, Elmer Lowe, and Donald Lance, Associate Judge Deville Mason, and Judge Charles Losey. (Image donated by Lois Lance.)

MAYOR FRANK COSTELLO, 1955–1959. Frank Costello was a successful businessman and noted public servant. He served on the Troy Board of Education from 1949 to 1956, was a charter member of Station 2 of the volunteer fire department, and was the first elected mayor. According to his friend Bertha Trost, Costello donated every penny he received as a public servant to the schools and churches. (Image donated by Harriet Barnard.)

99

TROY LOOKING EAST, c. 1955. Troy remained a rural community through the 1950s. In the lower left corner of the photo is the intersection of Long Lake Road and Beach Road. In the top right corner is the mausoleum of White Chapel Cemetery, which was founded in 1925. The farm in the center of the photo is Hilly Acres Dairy.

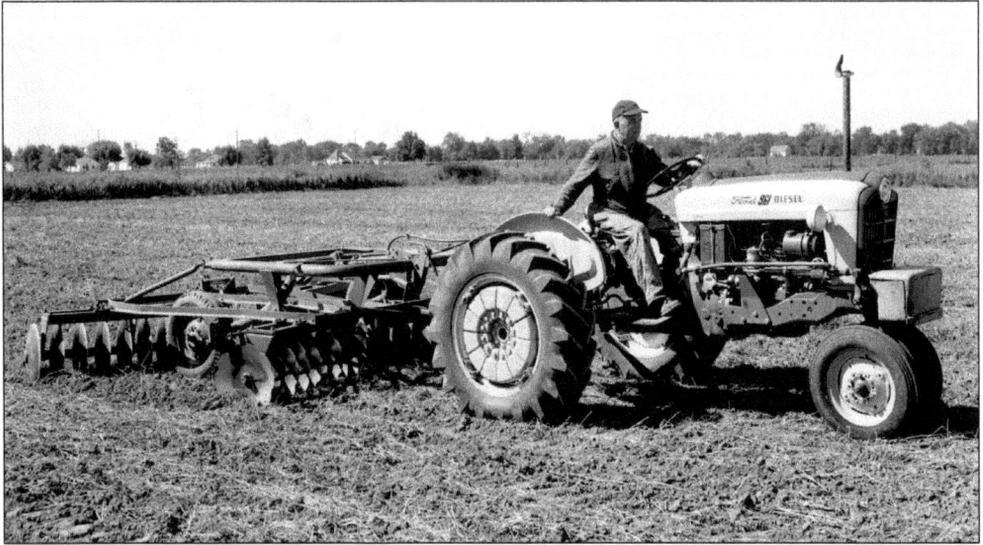

FORD TRACTOR, 1964. Robert Mageehan posed in his Ford 901 tractor on his farm on the northwest corner of 14 Mile Road and John R. The promotional picture was featured in a Ford tractor ad in *Michigan Farmer*. In 1961, the Ford Tractor Division combined the responsibility for tractor manufacturing and worldwide marketing into a single operation headquartered in Troy. Ford Tractor Operations was located on the south side of Maple Road near Coolidge Road. (Image donated by Marilyn Miller.)

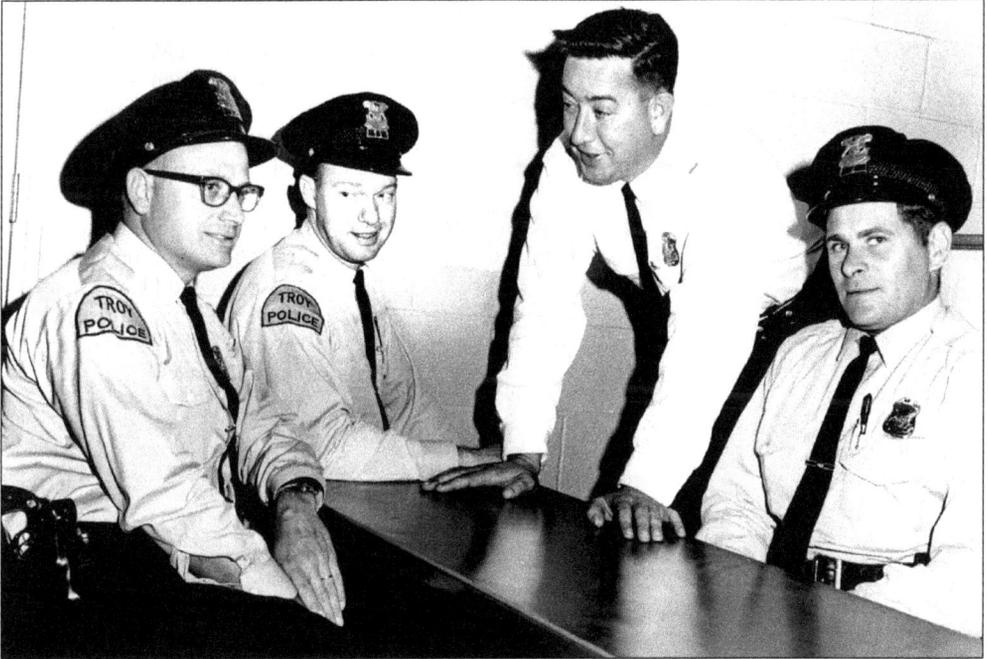

TROY POLICE FORCE, c. 1960. Shown left to right are officers Ted Halsey, George Reed, Robert Mortensen, and Ray Major when the police department was housed in the old Troy Fire Station No. 3 on Big Beaver Road. (Image donated by Robert Mortensen.)

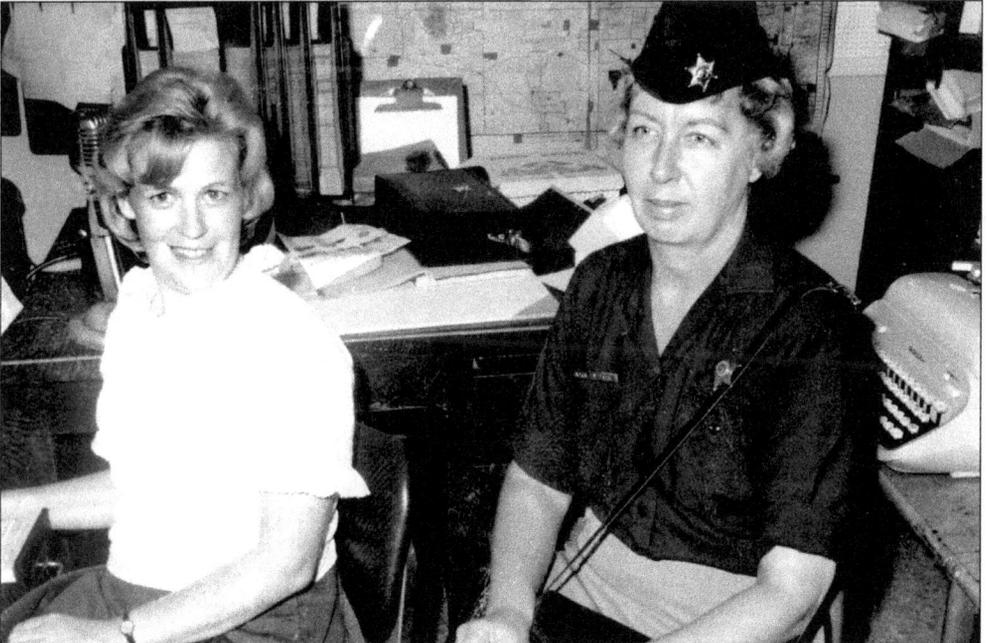

BARB ASHLEY AND NORINE BALLENTINE, 1965. Before the Secretary of State issued driver's licenses, uniformed employees of the Oakland County Sheriff, including Norine Ballentine, performed this job. Norine met Police Chief Dave Gratopp through her weekly visits to distribute licenses in Troy. Later the couple married. (Image donated by Lynda Ballentine.)

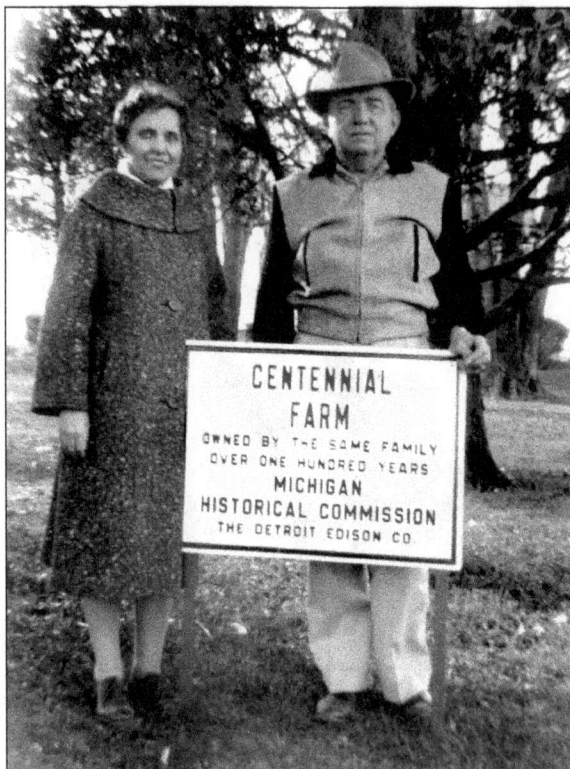

CENTENNIAL FARM, c. 1962. Robert H. and Mary Capelli Mageehan proudly displayed a sign issued by the Michigan Historical Commission that designated their 80 acres as a Centennial Farm. Robert's ancestors, Robert and Esther Mageehan, emigrated from Ireland and purchased the land in 1862 from John Hannay. In 1963, J. Kogan and D. Mossman bought the Mageehan farm as the site of the new Oakland Mall. (Image donated by Marilyn Miller.)

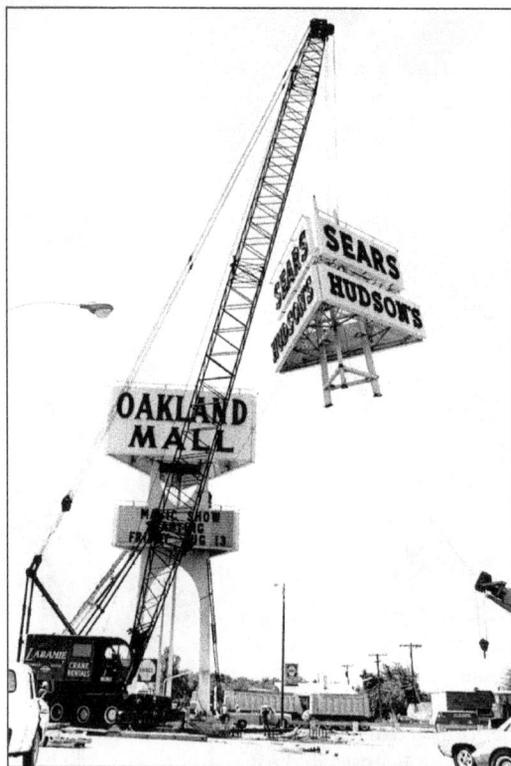

A NEW LANDMARK, 1968. Workers erected a 100-foot sign for the grand opening of the new Oakland Mall on August 13, 1968. It advertised the two anchor stores, J.L. Hudson's and Sears, which first opened in 1965. The enormous pylon, later reduced to its current height of 45 feet, still stands on the northwest corner of John R and 14 Mile Road and remains a symbol of suburbanization that forever changed the rural landscape. (Image donated by Oakland Mall LLC.)

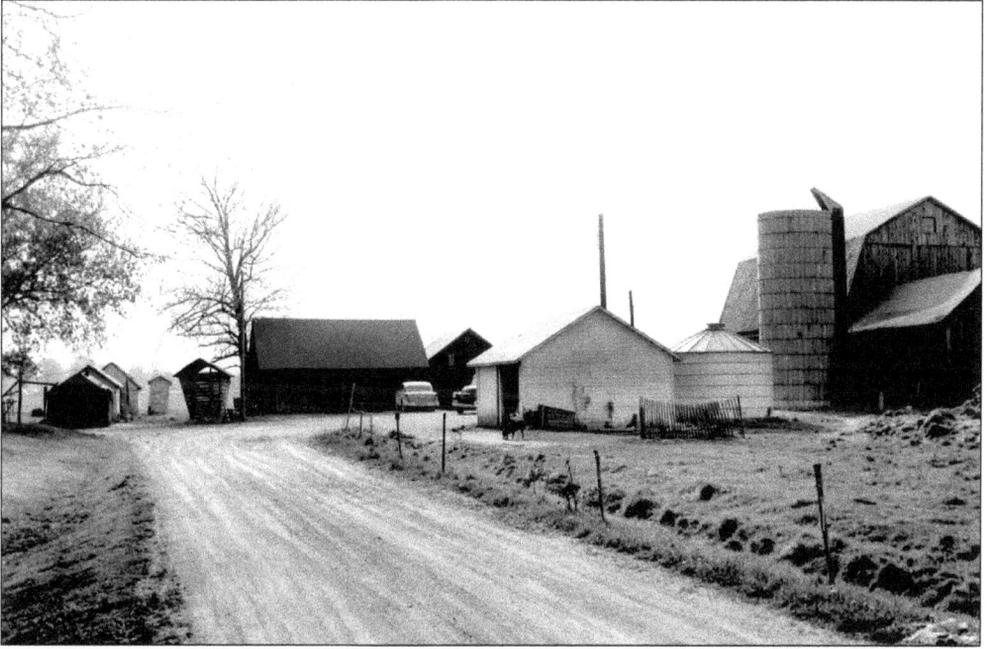

THE MAGEEHAN FARM, c. 1958. Robert Mageehan raised dairy cows, pigs, chickens, ducks, farmed grains, and later sold sod. Included in this family photograph of the outbuildings are duck and chicken coops (far left) and the main barn on the far right. The family dogs, Junior and Butch, stand in front of the icehouse in the center of the photograph. (Image donated by Marilyn Miller.)

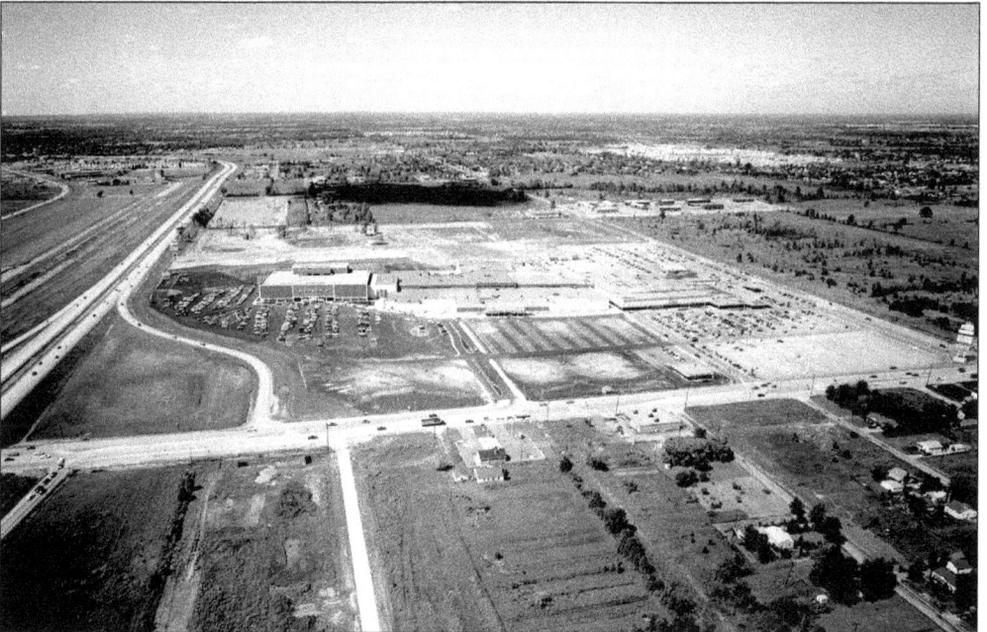

AERIAL OF OAKLAND MALL, 1968. This photograph taken facing north recorded the grand opening of J.L. Hudson's in the summer of 1968. Note Interstate 75 at the far left. The freeway was routed through Troy between 1961 and 1963. Fourteen Mile Road bisects the photo left to right and John R runs nearly parallel to I-75 on the right. (Image donated by Oakland Mall LLC.)

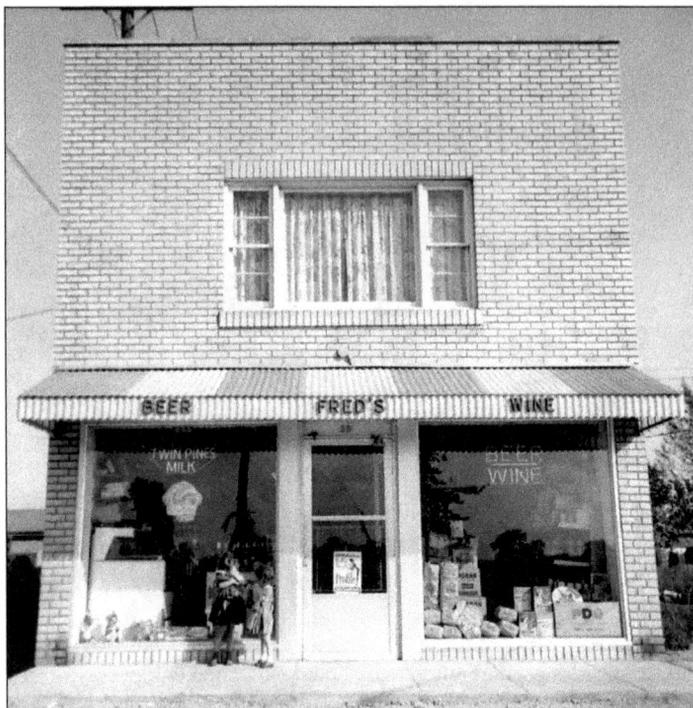

FRED'S MARKET, 1965. Following military service in the Pacific aboard the U.S.S. *Botetourt* during WW II, A. Fred Brown opened a grocery at Halsey Corners. A photo of the interior of that store at the intersection of Maple Road and Livernois Road is seen on page 88. Later, Brown tore down the building and built the corner market shown here. He operated this store until 1978 when he sold it to a rubber stamp company. Today the building is a Nextel Phone Shop. (Image donated by Fred Brown.)

WATTLES ROAD, 1962. Ruts, wicked potholes, and mud defined the miles of unimproved roads in Troy. This view of Wattles Road between Rochester Road and John R was typical. As the city grew, the community agreed that paving roads was a priority.

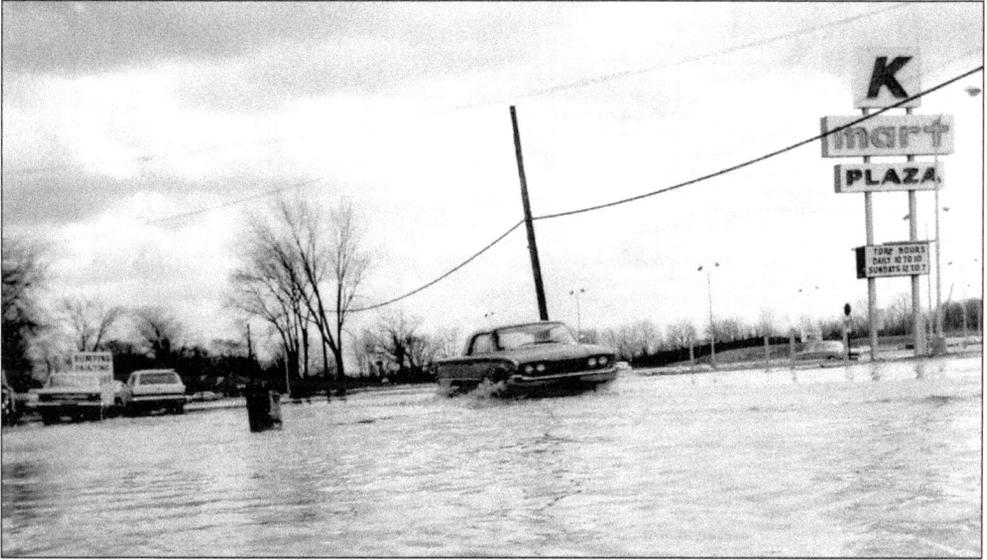

SPRING FLOOD, 1965. The new Kmart was located on the south side of Maple Road, across from Fred's Market. This picture, taken after extremely heavy April rains, shows severe flooding that was common in Troy. Much of the land did not drain well and officials knew one of the biggest challenges facing the young city was the installation of sanitary sewers and storm drains. A number of developments were postponed until this infrastructure was completed. (Image donated by Fred Brown.)

DETROIT WATER REACHES TROY, c. 1964. The growing city required large quantities of good water. However, many Troy wells contained high concentrations of salts and minerals. Troy purchased water from Clawson and Birmingham to supply the growing number of residents until water mains from Detroit were completed. This photo shows Mayor Robert Huber (left) and Gerald Remus, General Manager of Detroit Metropolitan Water Department (right) opening the valve on a Detroit water main to supply Troy with "city water."

OLD TOWNSHIP AND CITY HALL, 1952. In 1927 Township Supervisor Morris Wattles oversaw the construction of the Township Hall on the northwest corner of Wattles Road at Livernois Road. The building, designed by Birmingham architect J. Bissel, was modeled after a Dutch Colonial Tavern in Troy, New York. In 1955 Township Hall became City Hall. By the early 1960s there were nearly 50 people working here. One employee remarked that it was so crowded he had to step into the hall to change his mind!

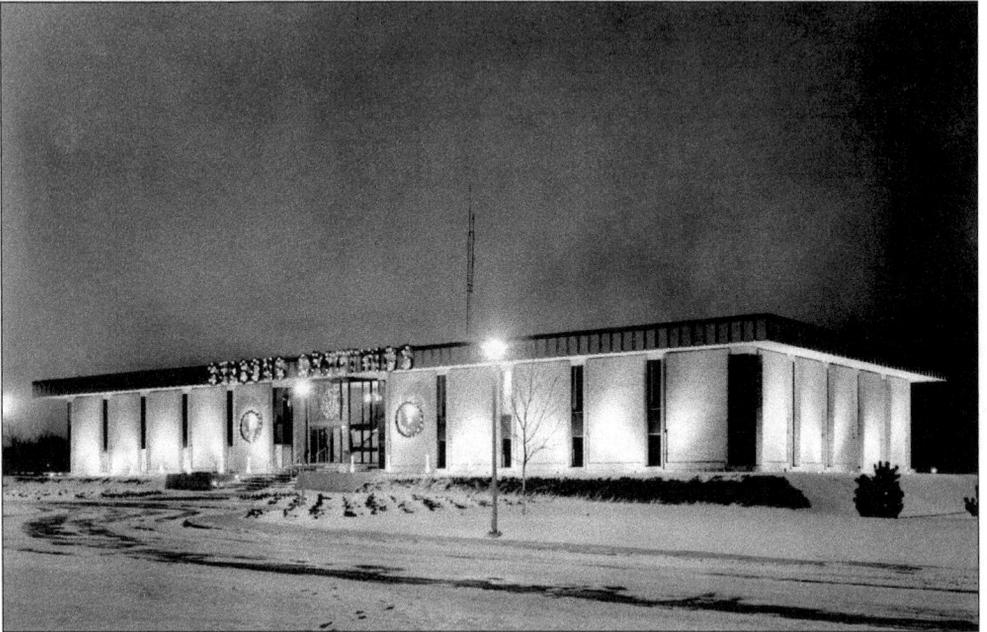

CITY HALL, CHRISTMAS, 1968. The new City Hall on Big Beaver Road, conceived by local architect Frank Straub, was designed to accommodate future expansions. The 30,000-square-foot building faces Big Beaver Road and is located on the 89-acre Civic Center. It was dedicated November 12, 1966.

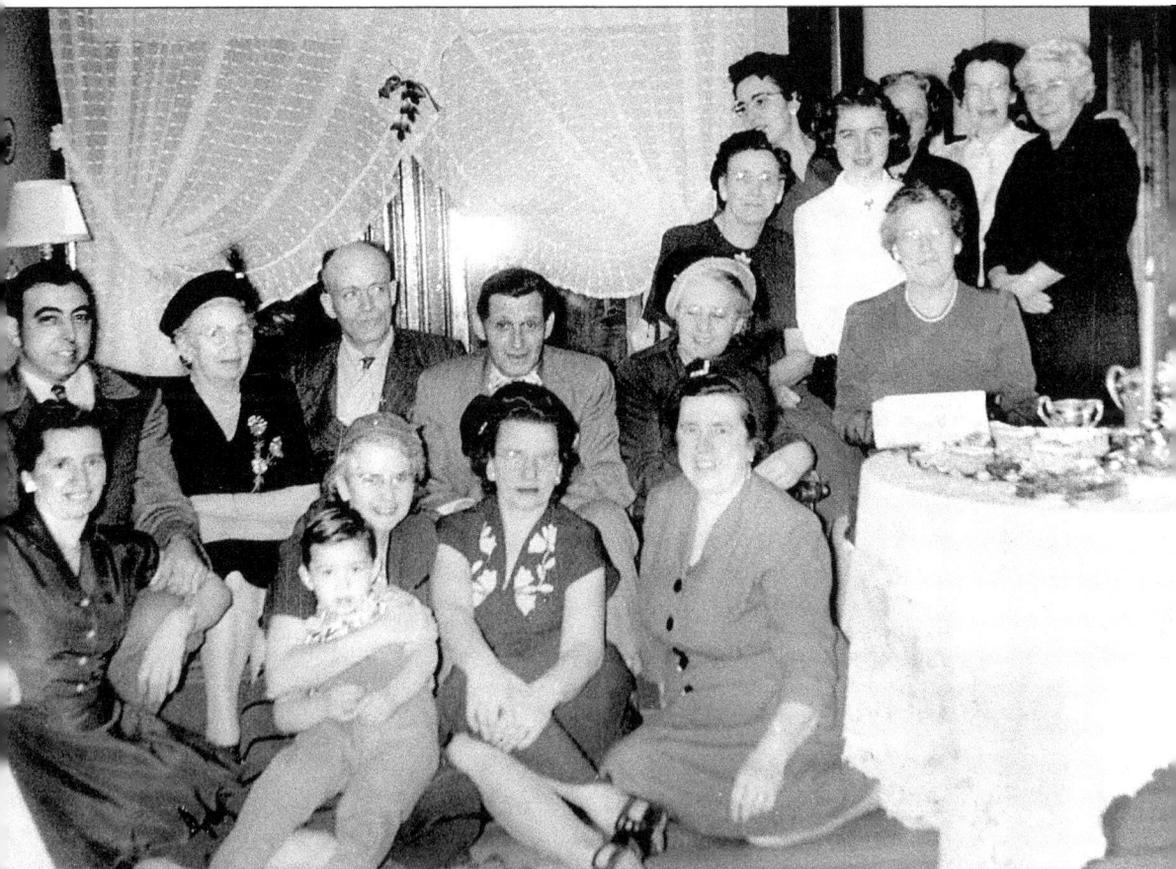

TOWNSHIP FOLKS, 1947. Church and school functions were at the center of social life in Troy Township. As the City of Troy grew, a larger, culturally diverse population replaced the close-knit community. Pictured in the parsonage of the Troy Methodist Church are, from left to right: (front row seated) Esther Northey, John Northey Jr., Pearl Williams, Leota Aspinwall, and Irma Heisenger; (second row) Jack Northey, Viola Ehle, Clarence Williams, Harold Williams, Lucy Williams, and Laura Schultz Kumler (at table); and (standing in the back, from left) Alice Martell, Mrs. Hocking (the pastor's wife), Ann Harold, Margaret Lockhart (obscured), Mrs. Mumford, and Clara Strong Haage. (Image donated by Viola Aspinwall Smith.)

FIRST SERVICE, 1957. Between 1954 and 1964, the congregation of the Troy Methodist Church increased from 168 to 564 members. The small clapboard church, built in 1837, was too small. In 1956 the congregation pledged $51,260 to purchase land and start a building fund. In 1957 they bought almost ten acres of the Eastwood Hills Golf Course and held the Easter Sunrise Service shown here. Their new church was built on the ninth green. (Image donated by First United Methodist Church of Troy.)

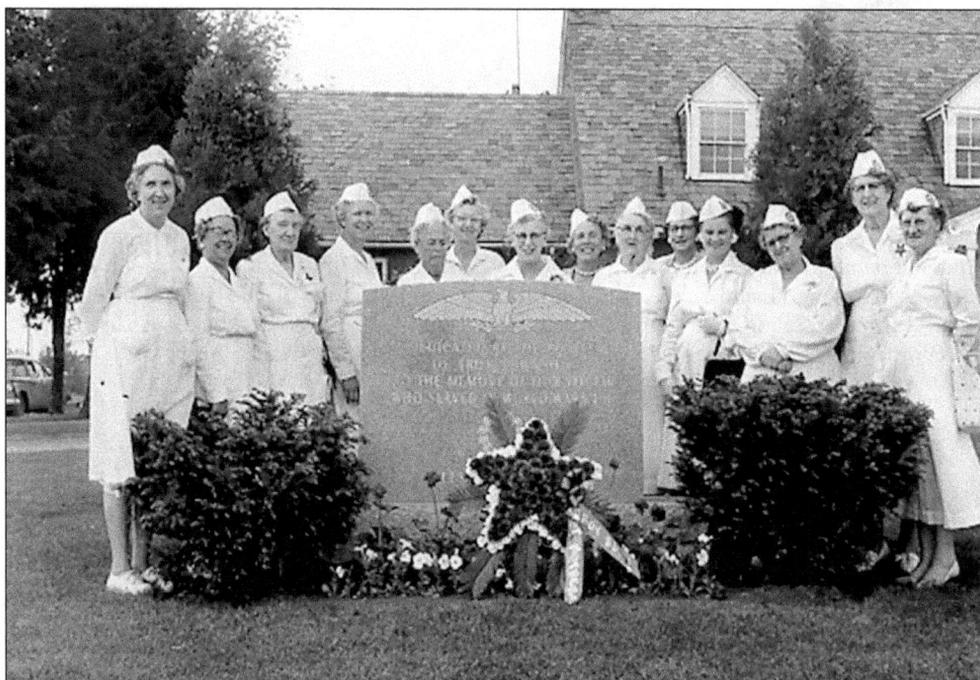

BLUE STAR MOTHERS, 1955. Chapter 37 of the Blue Star Mothers paid tribute to the 35 local youths who died defending their country during WWs I and II. Following their annual ceremony, the women posed around the granite monument they had erected in front of the Township Hall.

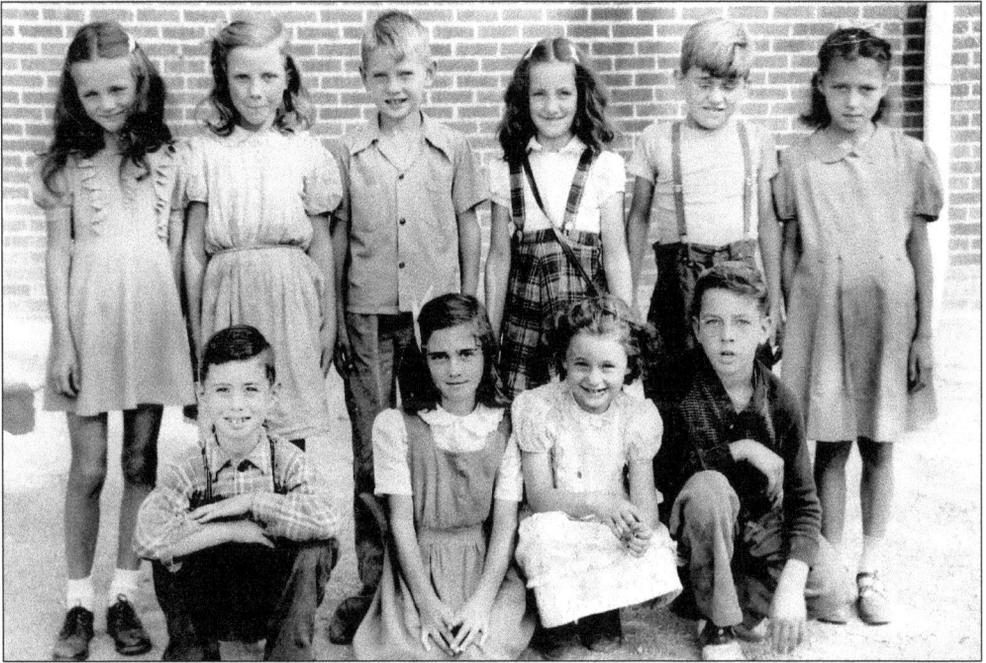

MRS. VANINBURG'S CLASS, c. 1949. The ten pupils pictured here comprised an entire third grade class at the Smith Elementary School in the late 1940s. As the student population exploded with the development of new subdivisions, the old school was torn down and the new Martell Elementary School was built on the site. The new Smith Middle School was constructed adjacent to Martell. (Image donated by John H. Northey Jr.)

MR. WALTER BEMIS, 1978. In September of 1978, Troy Public Schools opened the doors on the new Bemis Elementary School. The building on Northfield Parkway south of Wattles Road replaced the old Poppleton School. It was named in honor of Walter Bemis, then 79 years old. Mr. Bemis was a beloved custodian at Poppleton School for 30 years and active in the PTA. He paid after-school student helpers a few cents each week from his own pocket. (Image donated by Barbara Harris.)

THE TROY DRIVE-IN, 1984. Constructed in 1955, the Troy Drive-In was a landmark at Maple Road and Stevenson Highway. One of the largest in the country, the 33-acre theater parked 3,000 cars. In December of 1984, the giant blue screen was dismantled with steel cutting torches and replaced by a restaurant and a five-building office park. (Image donated by James Bonkowski.)

FLOATS AND FRIES, c. 1950s. Marilyn Miller recalled that local teens taking driver's education always stopped at Bill's Drive-In after class. The cars pulled into the A&W on Rochester Road and the student drivers, with their instructor, ordered burgers, fries, and floats. Carhops took the orders and brought food trays to the cars. Arby's, another fast food outlet, now occupies the site of the old root beer stand. (Image donated by James Bonkowski.)

BILL'S

A&W

DRIVE-IN

TROY, MICHIGAN

LAST OF THE ORIGINALS

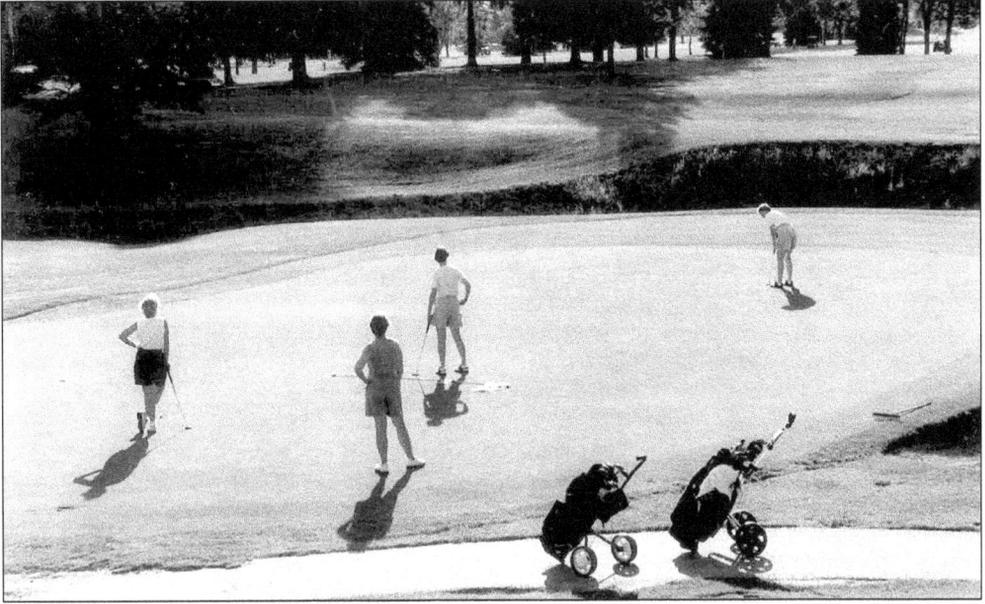

SYLVAN GLEN GOLF COURSE. On April 2, 1823, Henry Blount of Troy, New York purchased 160 acres at the southwest corner of Square Lake and Rochester Roads. Blount moved to Troy, Michigan in 1825, cleared the land and, with his wife Elizabeth, raised seven children. His descendants lived on the farm until May 13, 1924, when it was sold and developed as Sylvan Glen Golf Course. Today the City of Troy Parks and Recreation Department operates the popular course.

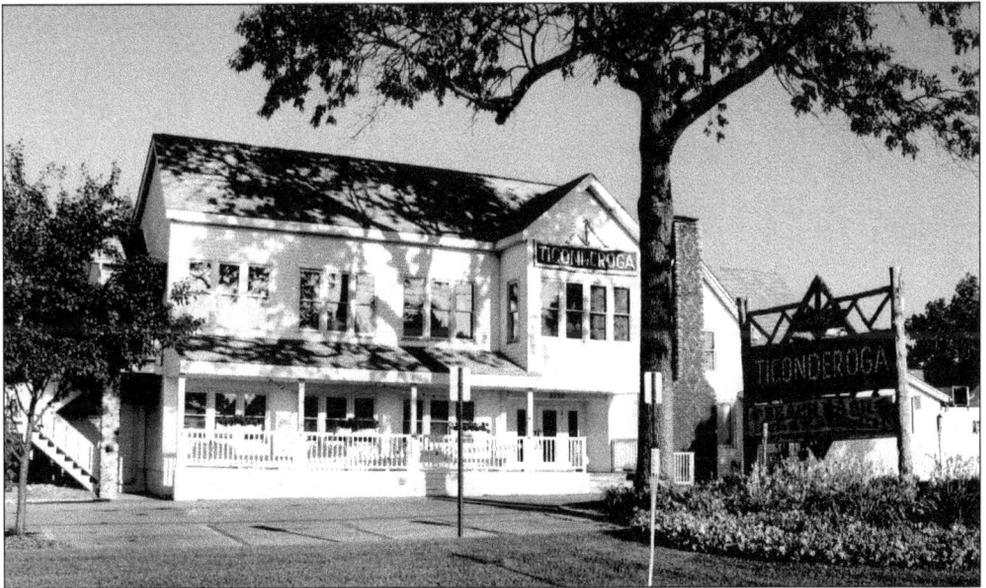

CAMP TICONDEROGA, c. 2000. The clubhouse restaurant, Camp Ticonderoga, now occupies the old Blount family home. The sprawling, two-story house was modified in the early 1900s when three maiden aunts and the Blount family lived in separate quarters in the home. Additional modifications were made to both the interior and exterior when it was adapted for use as a restaurant. (Photo by Laura Freeman.)

111

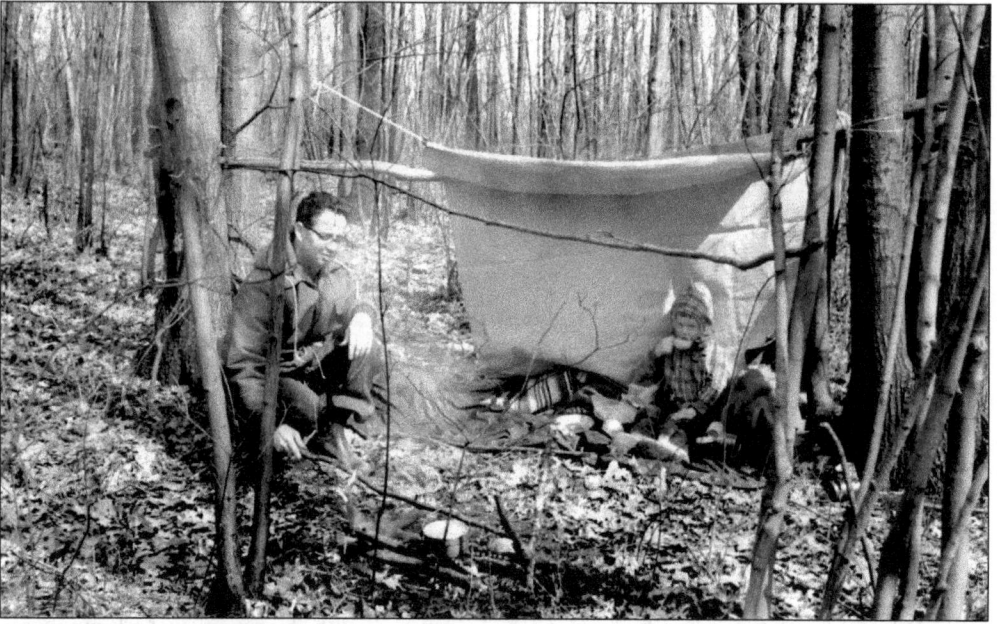

TROY CAMPOUT, c. 1963. Not too long ago, a father and son could still experience wilderness living in Troy. One chilly spring day, Henry Barnes and his six-year-old son Ken made camp at the end of Lanergan Street between Wattles and Big Beaver Roads just east of Adams. As the last recorded bear sighting in Troy occurred in 1829, the campers were not concerned about encountering wild animals! (Image donated by Eve Barnes.)

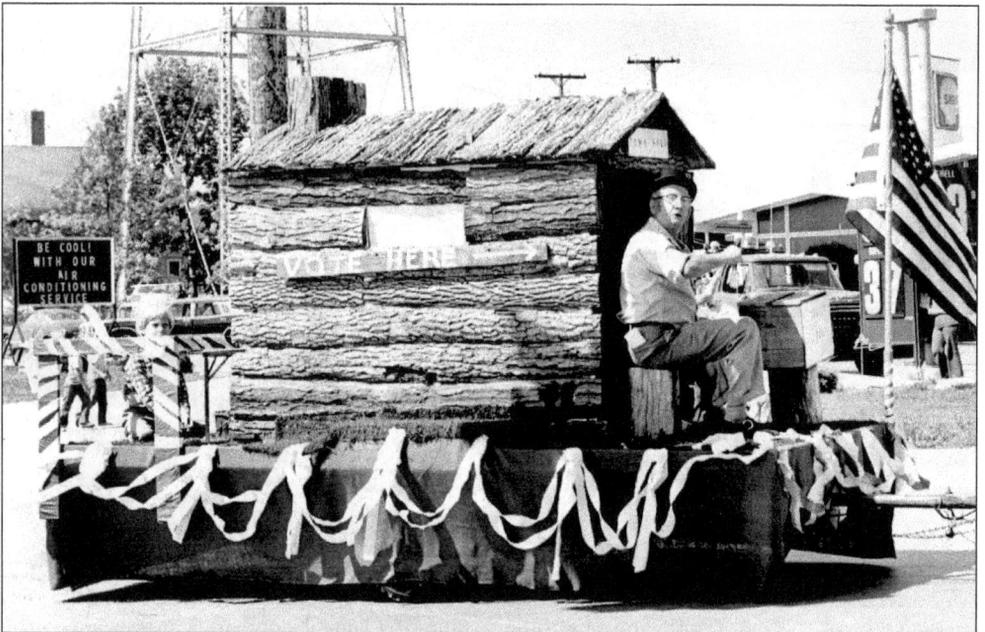

TROY DAZE TRADITION, 1972. The City of Troy initiated the Troy Daze Festival in 1957. Each year the community gathered for family fun, food, entertainment, and a parade. The 1972 parade included this float sponsored by the Troy Historical Society. It featured a log cabin and Bernard Haag as a pioneer election official. The entry won first prize.

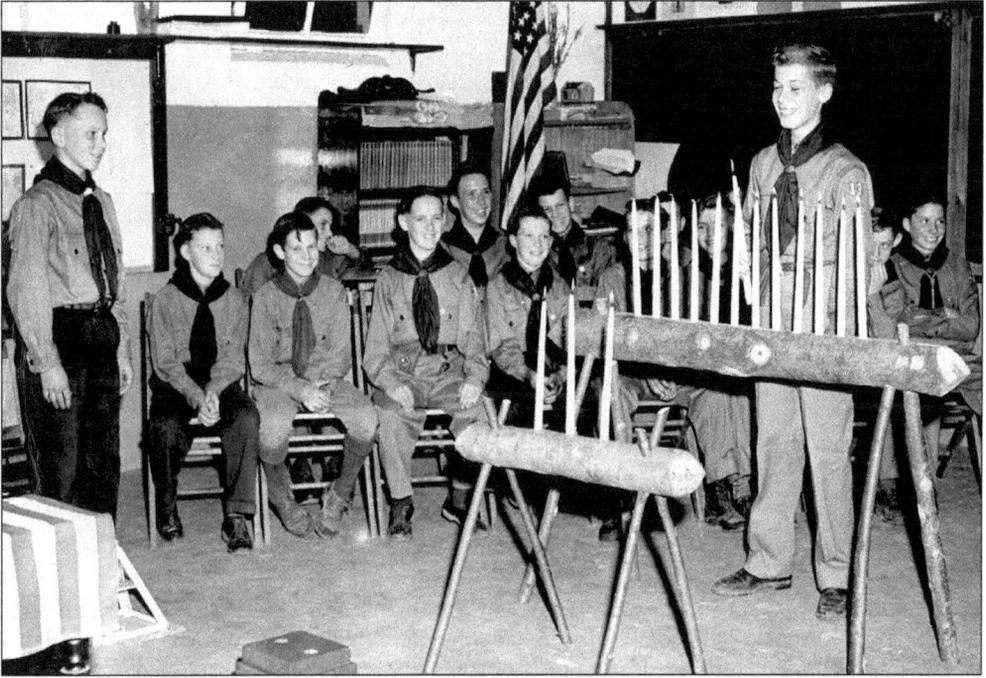

BOY SCOUT CEREMONY, c. 1950. For decades, boys in Troy have participated in Boy Scouts. During the township years this troop met in the basement of the remodeled Poppleton School. Lewis Bernath is pictured lighting the candles in this ceremony. (Image donated by Bonnie Jean Hensleigh.)

ENJOYING THE OUT-OF-DOORS, c. 2000. Amid the numerous corporate and residential developments, the city set aside 100 acres of woods, meadows, and wetlands at the Lloyd A. Stage Nature Center. Residents of all ages have enjoyed the quiet trails and wildlife since the park's dedication in October of 1981. Each year, thousands of school children are introduced to the natural world at the nature center. (Photo by Laura Freeman.)

SUBURBAN LANDSCAPE, c. 1962. The population of Troy climbed from 10,087 in 1950 to 19,058 in 1960. Old cornfields sprouted new ranch homes as new subdivisions were constructed at a phenomenal rate. This view of Walker Farms was typical of the new look in the young city. The development is located south of Big Beaver Road between Coolidge and Crooks Roads. (Image donated by Donald Walker.)

MAYOR JULE FAMULARO, 1968–1974. The city's fourth mayor, Jule Famularo, experienced the "building boom" in Troy. Born in 1913 in London, Ontario, he attended law school at the University of Detroit. Mr. Famularo was active in business and civic organizations including the Elks, Kiwanis, Boys and Girls Club of Troy, and Knights of Columbus. His neighbor, Jeanne Stine, recalled that their conversations about politics piqued her interest in local government. She became Troy's sixth mayor. Mayor Famularo died in 2001.

MAYOR JEANNE STINE, 1992–2001.
Long-time Troy resident Jeanne Stine has the distinction of being the first woman elected to the Troy City Council, and as mayor. She won her seat on council in 1976 and served 16 years. She then won three mayoral elections. Term limits prohibited a fourth term. Mrs. Stine also worked as a schoolteacher and counselor for 33 years, and served on the boards of over 40 public service organizations.

MINORU YAMASAKI, 1963. This architect of the World Trade Center was associated with Troy for many years. Yamasaki and Associates had offices in a building the architect designed on Big Beaver Road immediately east of City Hall. Much of the work for the design and construction of the World Trade Center, which took more than ten years, was done there. (Image donated by Virginia Bollinger.)

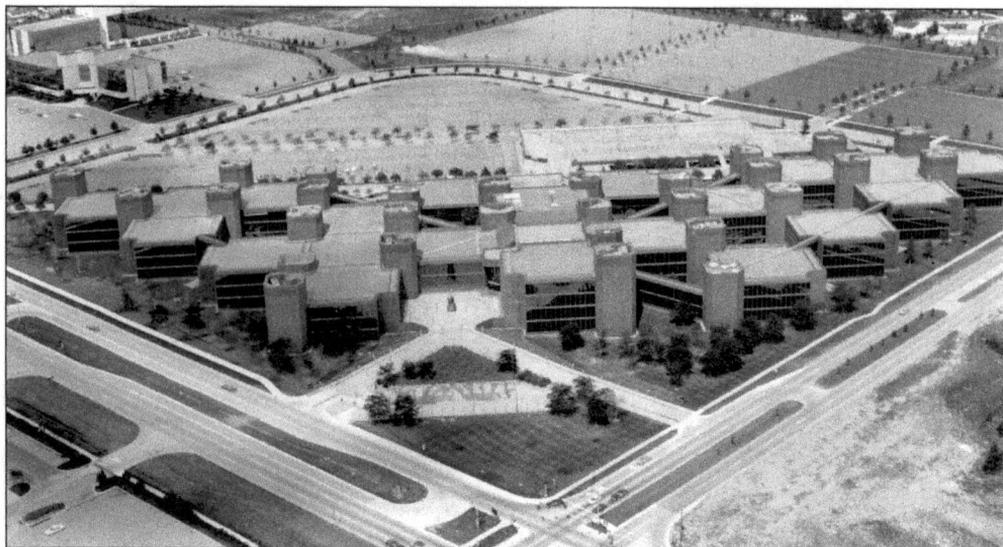

KMART WORLD HEADQUARTERS, c. 1972. Troy Township never had a downtown, but the City of Troy built a "Golden Corridor" of impressive high-rise office buildings on Big Beaver Road. In the early 1970s, six gleaming structures were added to the three-mile stretch between Rochester Road and Coolidge. This headquarters complex of S.S. Kresge (renamed Kmart Corporation in 1977) was the most impressive. This geometric array of service towers and bronze-toned office buildings covers twelve acres on the northwest corner of Big Beaver Road at Coolidge. (Image donated by Kmart Corporation.)

THE CORPORATE HEAD, 1972. The bronze and reflecting glass sculpture created by Michael Ayrton represents the integrated operations of the Kresge Company. The large head is divided by a mirrored surface that completes the design through reflections. One side of the head is open to reveal smaller heads inside, symbolizing teams within teams that create the corporation. This distinctive artwork was originally located in the forecourt of the headquarters building. In the future, it will be relocated to the Civic Center. (Image donated by K-mart Corporation.)

SOMERSET INN, c. 1973. Developer Sam Frankel led the group of architects and investors who built the Somerset Inn complex in the early 1970s. Frankel acquired the four-acre building site in the Golden Corridor through a land and cash swap with the City of Troy. At the time of construction, the fashionable 14-story hotel, nestled between Somerset Mall to the east, and the Somerset Apartments to the south, was the tallest building in Troy. (Image donated by Somerset Inn.)

TOP OF TROY RISES, 1974. The steel skeleton of the 25-story Top of Troy office building created a striking image for motorists on I-75 and Big Beaver Road in 1974. The unique, triangular building designed by Rossetti and Associates and developed by Robert Sosnick, usurped the distinction of being the tallest structure in Troy. (Image by Larry Sullivan, donated by Della Sullivan.)

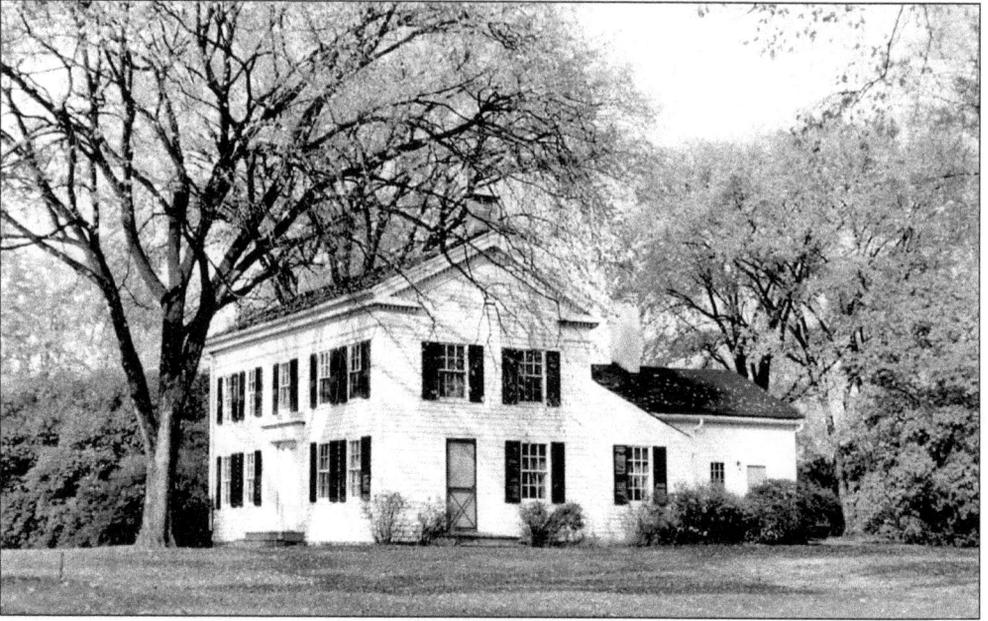

SOLOMON CASWELL'S HOME, c. 1965. Until 1965 the direct descendants of pioneer Solomon Caswell occupied the Greek Revival home he built in 1832. When Solomon's last grandson, William S. Caswell, died a bachelor, he willed the estate to a friend who sold the property to the North Hills Christian Reformed Church. They donated the home to the Troy Historical Society, which paid to move the house to city-owned property on Wattles Road.

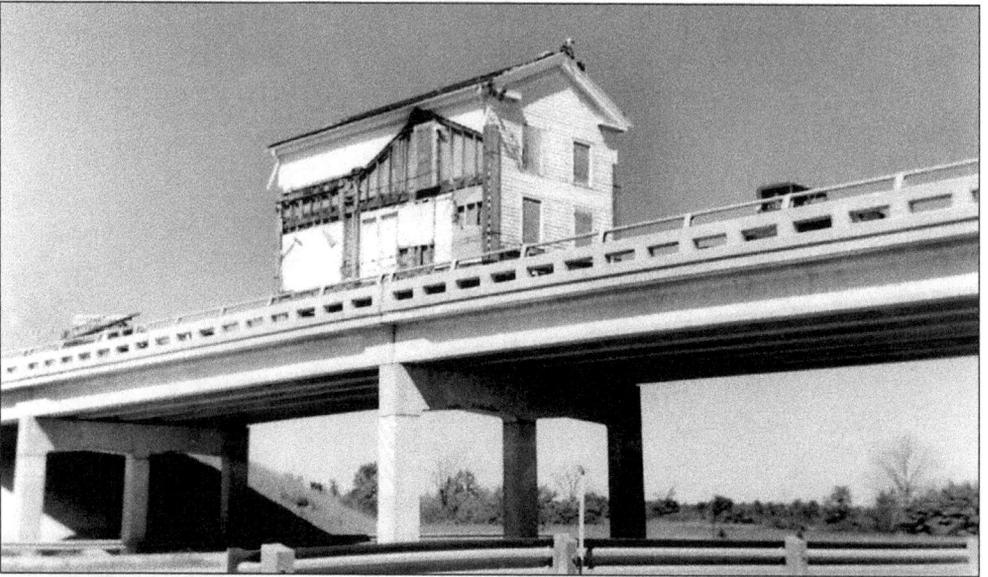

ON THE MOVE! 1968. On September 29, 1968, the Troy Historical Society successfully moved the original section of the Caswell House to the two-acre site behind the old City Hall. The small group financed the move through fundraising efforts that generated $8,646 and restored the interior and exterior with volunteer labor. This project initiated the 40-year development of the Troy Museum & Historic Village. The photo shows the house crossing the Wattles Road overpass on I-75.

POPPLETON AT THE VILLAGE, 1980.
Between 1970 and 1980, city officials, the Historical Society, and citizens with fond memories of Poppleton School debated the future of the building. The red brick one-room schoolhouse built in 1877 stood in the way of office development on Big Beaver Road. Grants, municipal and corporate donations, and the fundraising efforts of local historians generated the money required to dismantle, move, and rebuild the school. It was too heavy to move over I-75 and too tall to fit under the overpass.

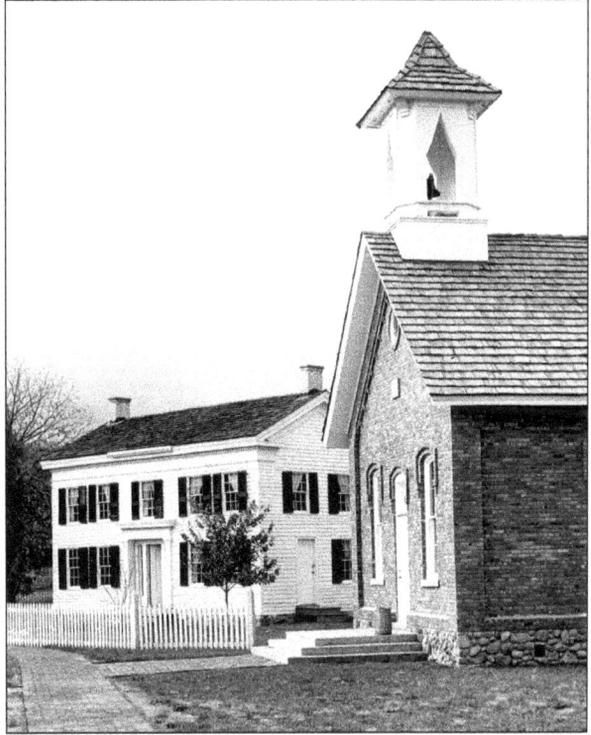

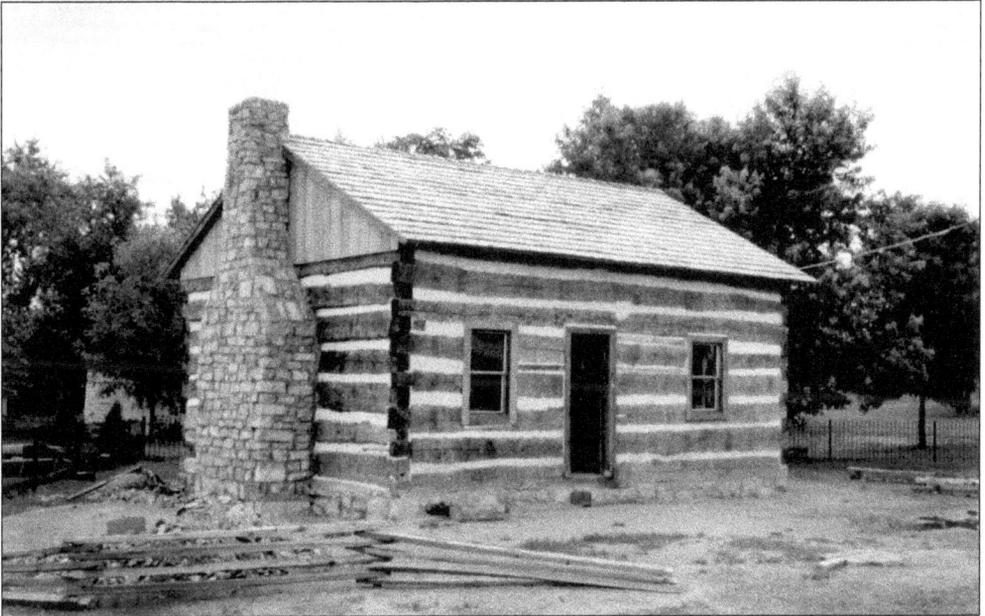

LOG CABIN, 1982. Each building moved to the Troy Museum & Historic Village told part of the history of the community. In addition, the relocation projects preserved historic structures scheduled for demolition. In 1982, Matilda Doederlain donated a cabin built in the 1840s in Frenchtown Township near Monroe. The hand-hewn logs pictured here were moved to the Museum and reassembled by City of Troy employees. The cabin is the only structure in the Village not originally built in Troy. (Image donated by A.L. Kassabean.)

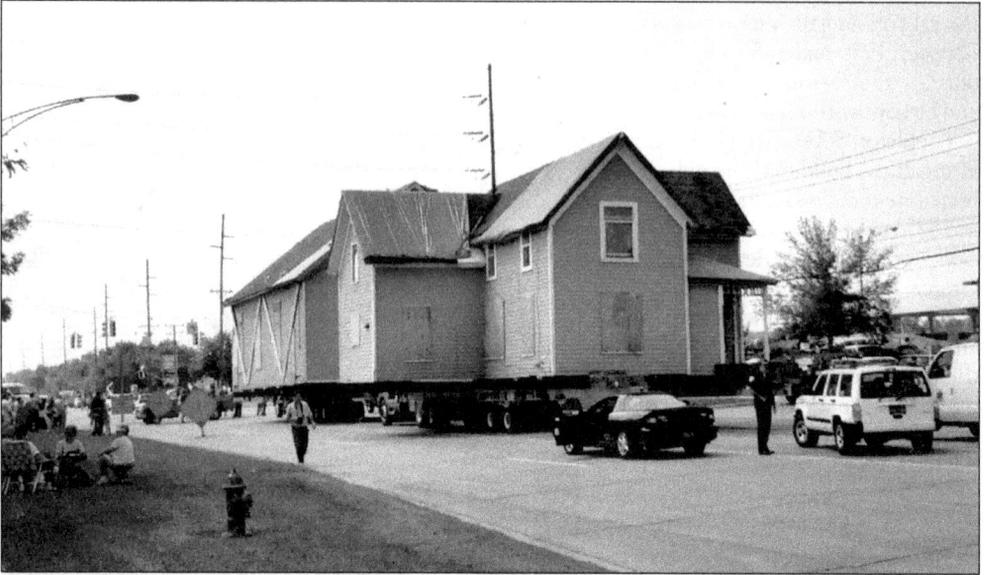

CHURCH AND PARSONAGE MOVED, 2003. After six years of negotiations, legal disputes, and careful planning, the Old Troy Methodist Church and its Parsonage were relocated from Troy Corners to the Troy Museum & Historic Village. The two-mile, six-hour move required months of planning, line crews from seven utility companies, engineers, architects, the support of city workers, and the Troy police. Hundreds of people watched as the buildings moved down Livernois Road. (Image donated by Ward Randol.)

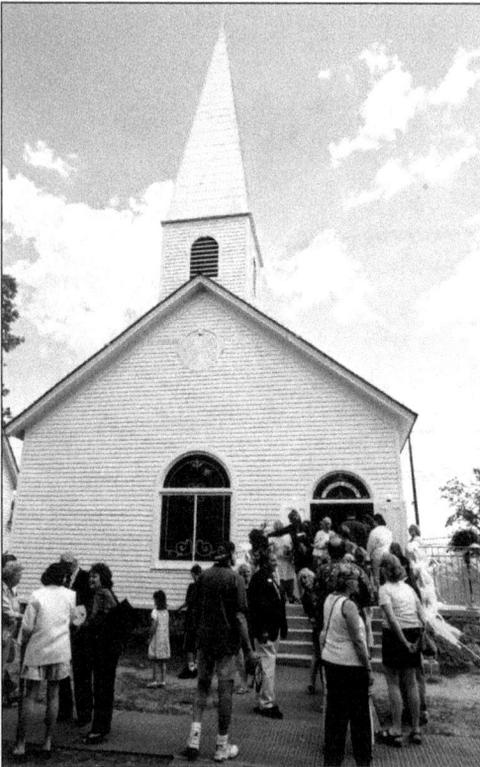

RESTORED, 2004. After ten months of work, the interior and exterior of the Church, including the original stained glass windows, were restored to their 1900 appearance. The refurbished parsonage was furnished as a 1910 rural home. Like the other structures in the Historic Village, the church and parsonage remain important components of Troy's heritage. Each year nearly 20,000 people, including 11,000 schoolchildren, visit the Museum that is operated by the City of Troy. (Photo by Laura Freeman.)

THE TROY COMMUNITY CENTER, c. 2002. In 1996 the City of Troy purchased the old Troy High School. Portions of the building were incorporated into a new 130,000-square-foot Community Center that includes an indoor swimming pool, exercise rooms, gymnasiums, meeting rooms, dance and aerobic facilities, dining and conference center, and a catering service. The Parks and Recreation Department operates the Community Center. (Photo by Laura Freeman.)

LITTLE LEAGUE, c. 2003. In 2003, Troy was named *Sports Illustrated*'s No. 1 Michigan Sports Town. The award was based on the city's commitment to quality athletics, education and training programs, and opportunities for youth. Each year thousands of boys and girls participate in youth leagues and classes offered through Parks and Recreation. (Photo by Laura Freeman.)

TROY AQUATIC CENTER, c. 2003. This outdoor facility, located in the Civic Center, was completed in 1992. It includes a main pool, water slides, a children's spray pool, sand play area, and volleyball courts where kids of all ages have great summer fun. To the south of the Aquatic Center is Troy's Golden Corridor of corporate offices. (Photo by Laura Freeman.)

NEW INDUSTRY, 2003. SSV (Saleen Special Vehicles) acquired the former Stanley Door Company site on Maple Road between Stephenson Highway and Rochester Roads. It began production of the Saleen GT racer and other high performance vehicles in early 2003 in its newly designed, first-class assembly plant.

122

ROUGE RIVER CLEAN UP, 2003. Councilwoman Robin Beltramini lends rubber-gloved hands at the annual Rouge River Clean Up. Each year dozens of Troy volunteers remove trash and debris from the Rouge that winds through the Nature Center and Firefighters Park in the northwestern part of the city. The City of Troy and Friends of the Rouge sponsor the yearly event. (Photo by Laura Freeman.)

SCOUTS VOLUNTEER, 2003. Members of Scout Troop 1701 grabbed rakes and wheelbarrows and helped with a fall clean-up at the Troy Museum & Historic Village. Members of the troop also direct traffic during special events at the museum and assist with other community service projects in Troy. (Photo by Laura Freeman.)

BILL PRICE, 2003. A Marine Corps veteran, Bill Price served in the United Nations Caribbean Force in the 1950s. Following military service, Mr. Price attended college on the GI Bill. He then moved to Troy in 1956 and opened the Price Funeral Home. Between 1956 and 1974, the funeral director also supplied emergency ambulance service to Troy and the surrounding communities. The Price Funeral Home, established in 1956, has been at its present location on Rochester Road since 1963. (Photo by Laura Freeman.)

THE BARNES FAMILY, 2003. Henry Barnes, a decorated WW II veteran, posed with his wife, Eve, and son Ken, who served in the Air Force, at the 2003 Memorial Day ceremony at the Veterans Memorial Plaza in front of City Hall. This father and son are shown camping in Troy 40 years earlier on page 112. (Photo by Laura Freeman.)

VETERANS MEMORIAL PLAZA, 2003. A memorial to American service men and women was the dream of Sgt. Major Jack Turner, a distinguished veteran of WW II and the Korean and Vietnam Wars. He worked diligently with the Troy Veterans Memorial Committee for over six years to raise the funds for the impressive plaza in front of City Hall. The Plaza was dedicated on October 6, 2001. (Photo by Laura Freeman.)

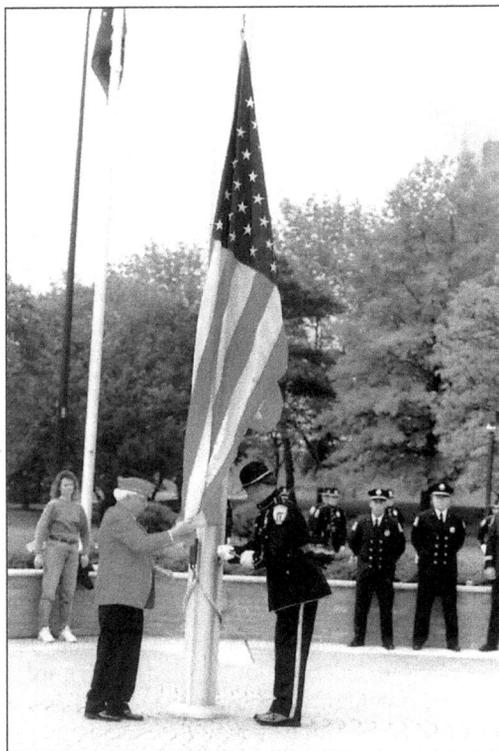

PEACE GARDEN, 2003. Originally envisioned as a children's reading garden, Troy's beautiful Peace Garden was developed through the efforts of the City of Troy and community volunteers. City Council approved plans for the garden in 1996. It features landscaped flowerbeds, a small pool, park benches, and a statue of a girl releasing a dove. On the base of the statue the word "peace" is engraved in many languages. The garden is located between the Troy Public Library and City Hall in the Civic Center. (Photo by Laura Freeman.)

TROY DAZE PARADE, 2003. In 2003, the city held its 34th annual Troy Daze Festival. Each year the event includes a colorful parade with a special theme. The procession of bands, floats, civic leaders, community organizations, and clowns follow a route down Livernois Road to Boulan Park. Compare this parade to the one pictured on page 112. (Photo by Laura Freeman.)

HAVING FUN, 2003. These girls were among the 100,000 people who enjoyed Troy Daze in 2003. Amusement rides, games, entertainment, fireworks, children's activities, and the EthniCity Tent of special foods and music all provided entertainment during the four-day event. (Photo by Laura Freeman.)

FAMILY FEST, 2003. The 12th annual Family Fest at Boulan Park provided a special evening for children of all ages. These kids enjoyed a great picnic and carnival complete with puppets, jugglers, clowns, games, music, and tasty treats. (Photo by Laura Freeman.)

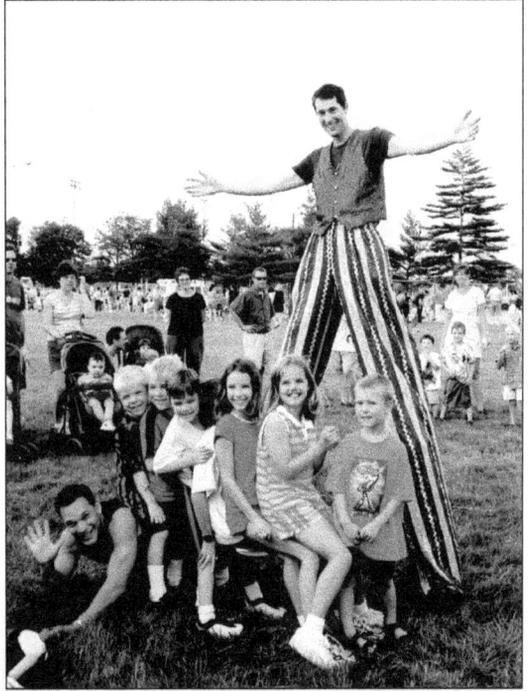

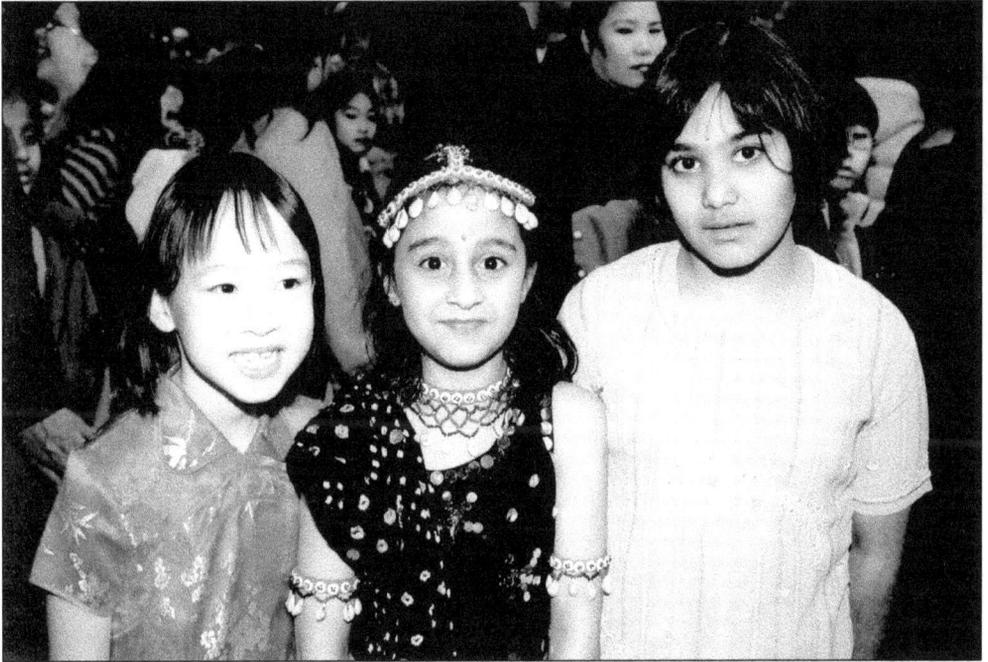

CELEBRATION OF FREEDOM, 2003. As the City of Troy grew, so did the community's ethnic and cultural diversity. Today 83 languages are spoken in Troy. Every January, on Dr. Martin Luther King Day, city officials, Troy schoolchildren, and community volunteers gather at Athens High School for a Unity Walk around the school. A breakfast, inspirational program, and essay contest awards ceremony are also part of this special event that celebrates cultural diversity and community unity. (Photo by Laura Freeman.)

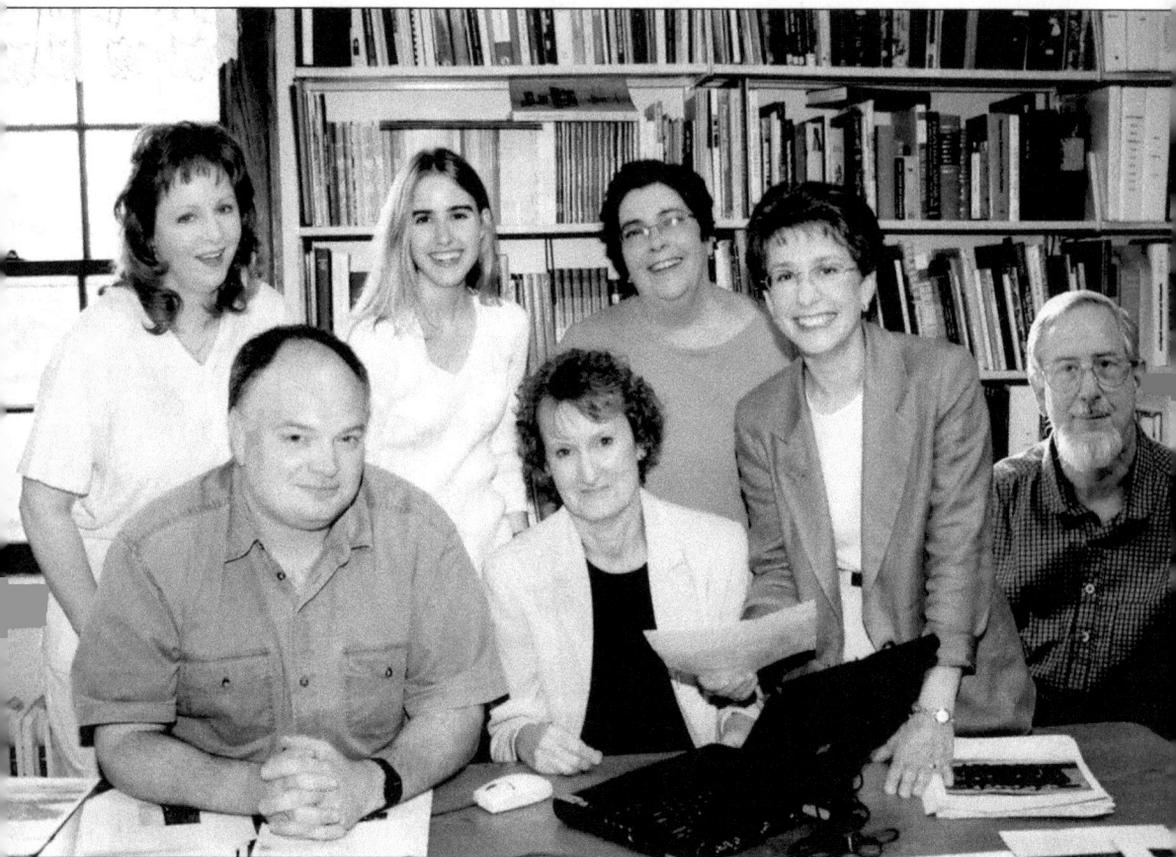

EDITORIAL STAFF, 2004. This book represents the combined efforts of, from left to right: (front row) William Boardman, Gillian Ellis, Loraine Campbell, and Ray Lucas; (back row) Teresa Henry-Saigeon, Elizabeth Pellirito, and Anne Partlan. Viola Aspinwall Smith is not pictured. (Photo by Laura Freeman.)

www.ingramcontent.com/pod-product-compliance
Lightning Source LLC
Chambersburg PA
CBHW050704150426
42813CB00055B/2450